WATCH ME MOVE

WATCH ME MOVE

THE ANIMATION SHOW

EDITED BY GREG HILTY AND ALONA PARDO

MERRELL

LONDON · NEW YORK

FOREWORD

Animation is to evoke life.
Eadweard Muybridge

The power and potential of animation have inspired artists and film-makers alike since the late nineteenth century. Under the guise of pseudo-scientific research, such early pioneers of the pre-cinema age as Eadweard Muybridge and Étienne-Jules Marey made great strides in the development of the nascent medium, swiftly followed in the early twentieth century by such maverick figures of early cinema as Winsor McCay and the Lumière brothers. This fascination for the limitless possibilities of animation has continued unabated to this day, from the introduction of computer-generated imagery in the 1980s to the appropriation of animation by a number of contemporary artists, including Kara Walker and Nathalie Djurberg.

Tracing the history of animation over the last 150 years, *Watch Me Move: The Animation Show* brings together, for the first time, cut-out, collage, puppet, clay and stop-motion animators, auteur film-makers, contemporary artists and exponents of experimental film alongside the creative output of the commercial studios, from Fleischer to Walt Disney, from Hanna-Barbera to Aardman, and from Ghibli to Pixar. Presenting animation as a distinctive and highly influential force in the development of visual culture, this exhibition – together with the accompanying publication – explores the contentious hierarchy between animation and film, and offers a timely insight into animation as an important and all-pervasive cultural and socio-political phenomenon.

An exhibition of this scale and complexity would not have been possible without the generosity and support of many organizations, studios, collections and individuals, including Aardman Animations, Bristol; Anthology Film Archives, New York; Association Frères Lumière, Paris; Ligia Borowczyk; Marilyn Brakhage; British Film Institute, London; Center for Visual Music, Los Angeles; Cinédoc – Paris Films Coop; Cinémathèque Française, Paris; CNC – Archives Françaises du Film, Paris; Dominique Duvergé-Ségrétin, Paris; Filmform – The Art Film & Video Archive, Stockholm; Filmoteka Narodowa, Warsaw; Gaumont Pathé Archives, Saint-Ouen; Halas & Batchelor Collection, Lewes; Harry Smith Archives, New York; Inkwell Images, Morley, Michigan; iotaCenter, Los Angeles; Kingston Museum and Heritage Service, London; Krátký Film Praha, Prague; Library of Congress, Washington, D.C.; Light Cone, Paris; Lobster Films, Paris; LUX, London; Manga Entertainment, London; L.B. Martin-Starewitch, Paris; Fabrizio Modina, Turin; Mushi Production, Tokyo; National Film Board of Canada, Montreal; National Media Museum, Bradford; NBC Universal, Universal City, California; Tamara Pappé, Paris; Pixar Animation Studios, San Francisco; Ray & Diana Harryhausen Foundation, London; Paul Shoefield, London; Soyuzmultfilm, Moscow; Studio Ghibli, Tokyo; Thunderbean Animation, Ann Arbor, Michigan; Toei Animation, Tokyo; 20th Century Fox Films, Los Angeles; Walt Disney Animation Research Library, Los Angeles; and Warner Bros., Burbank, California.

We are indebted, as ever, to the artists and film-makers who have generously agreed to participate in this ambitious exhibition, including Francis Alÿs, Martin Arnold, Ralph Bakshi, Jiří Barta, Patrick Bokanowski, Christian Boltanski, Robert Breer, Tim Burton, Cao Fei, Nathalie Djurberg, Harun Farocki, Ari Folman, Terry Gilliam, igloo (Ruth Gibson and Bruno Martelli), William Kentridge, Caroline Leaf, Ruth Lingford, Frank and Caroline Mouris, Yuri Norstein, Julian Opie, the Brothers Quay, Zbigniew Rybczyński, Bob Sabiston, Marjane Satrapi, Semiconductor, Jan Švankmajer, Jim Trainor, Ryan Trecartin, Kara Walker, Tim Webb, Run Wrake and Zhou Xiaohu. Our special thanks extend to their representatives, who have made these loans possible: Elizabeth Dee, New York; Galerie Martin Janda, Vienna; Gió Marconi, Milan; Lisson Gallery, London; Long March Space, Beijing; Marian Goodman Gallery, New York; and Sikkema Jenkins & Co., New York.

We would like to extend our personal gratitude to Greg Hilty, who has worked tirelessly on this project from the outset. His vision of the place of animation in contemporary culture, both past and present, has resulted in a unique ensemble of works that brings together artists, film-makers and studios from across generations and cultures.

We have greatly benefited from an ongoing dialogue with a number of scholars who have helped to shape and crystallize our thinking around this subject. Paul Wells, who has also contributed an insightful text to this publication charting the technological development of animation over the last 150 years, has willingly offered up his vast wealth of knowledge in this area. Equally, Gareth Evans's expert guidance has been invaluable throughout the course of both the research for and the development of the project. David Curtis's unparalleled knowledge of the history of British and international experimental and expanded film has been instrumental in shaping the 'Structures' section of the exhibition, for which we are deeply grateful. As an adviser to the exhibition and essayist, we are indebted to Suzanne Buchan both for entering into a lively dialogue at a crucial stage in the life of the project and for considering the viewer's experience of animation at the heart of her text. Clare Kitson has been instrumental in securing the active participation of the celebrated Russian film-maker Yuri Norstein, for which we are very thankful. Last but not least, Adam Pugh, who came on board as Research Curator early on in the development of the exhibition, has greatly informed the project.

The design of a predominantly moving-image exhibition was a challenge that the critically acclaimed Berlin-based designers Chezweitz & Roseapple tackled from the outset with great flair. At Merrell, we would like to extend our thanks to Hugh Merrell, Claire Chandler, Mark Ralph, Nicola Bailey and Alexandre Coco for their skill and professionalism, as well as their creative approach to the design of this publication.

We would also like to thank our event partners, notably Assemble CIC. Its off-site project in east London, Folly for a Flyover – supported by Create 11 and inspired by Watch Me Move – extends the Barbican Art Gallery's commitment to working beyond its own walls. Our collaboration with IdeasTap has provided us with an opportunity to work with recent graduates and budding animators, for which we are thankful. We are indebted to the Adam Mickiewicz Institute and the Polish Cultural Institute for their continued support of our ambitious public programme.

Finally, this project would not have been possible without a dedicated team. In particular, our thanks go to Exhibition Assistant Juliette Desorgues, Curatorial Assistant Zofia Trafas and Inspire Fellow Sunny Cheung, who have organized the exhibition so expertly and diligently; curatorial interns Alicja Grabarczyk, Annabel Potter and Marina La Verghetta for their support; our Barbican Cinema colleagues Robert Rider, Emma Watkins, Moira McVean and Cathy John, who have generously shared their expert knowledge of the film world with us over the course of the last twelve months; Neil McConnon, Head of Barbican International Enterprises, and Gemma Hollington, Exhibition Co-ordinator, for working closely with our touring partners in Canada and Asia to ensure the exhibition's smooth transition; Peter Sutton and his team for producing the exhibition with their customary skill, dedication and calm; Senior Manager Katrina Crookall; and Barbican media-relations and marketing colleagues Ann Berni, Jess Hookway, Kate Ballard and Rachel Taylor, who have worked tirelessly to ensure that the exhibition reaches as broad an audience as possible.

Jane Alison
Acting Head of Art Galleries / Senior Curator
Barbican Centre

Alona Pardo
Curator
Barbican Art Gallery

OBJECT, DREAM AND IMAGE IN ANIMATION

GREG HILTY

The animation film is not an 'interpretation of dreams' from the perspective of Freudian reality, but rather an interpretation of reality from the perspective of the dream.

Richard Weihe

Animation's products are so varied in origin and form that few generalizations about the medium hold up to serious scrutiny. One paradox, however, seems to assert itself: that animation is both very light and very dense.

Animation delights in its insubstantiality and transience. Winsor McCay's short film *Little Nemo Moving Comics* (1911), from the opening sequence of which this exhibition takes its title, depicts a playful promenade of archetypal figures – the prince, the clown, the primitive, the dragon, the princess – who do little more than parade their own essences and demonstrate the tricks of their maker's relatively new trade: they squat and stretch and morph into other forms. Yet these simple repetitive actions – inconsequential as they are – still bear watching over and over again, and stay imprinted on the brain. Most of the works gathered in this exhibition are far from simple in either conception or execution, yet like McCay's film they share many of the qualities of dreams: seemingly emerging from nowhere, eccentric yet strangely familiar, often ending as if interrupted rather than resolved, and leaving a residue of uncanny unease. Like dreams, they begin to make sense only when considered together over time, in context, rather than as unique occurrences. It is the purpose of *Watch Me Move* – both the exhibition and the accompanying catalogue – to attempt a sustained and cumulative consideration of animation. If the animated film can be likened to a dream, then the world of animation as a whole can be viewed as an image of the collective unconscious.

The subjects of the simplest to the most sophisticated animated films are indeed often primal: animals, children, accidents, tricks, slapstick, transformations, violence, repetition, wonder. Within this exhibition alone, the following animals make at least one, and in many cases more than one, appearance: cat, dog, mouse, bear, wolf, bull, rabbit, owl, goose, duck, fish, fox, tiger, boar, elephant – not to mention the dragon and the dinosaur. These are not merely individual presences; rather, they add up to a universe of animals-as-people. David Lewis-Williams, writing about the animals depicted in the cave paintings of Lascaux in south-west France, notes that 'The symbolic associations of animals are all interrelated; they constitute a richly affective spectrum rather than a conglomeration of separate meanings.'[1] What may seem light or even trivial as an individual cameo takes on deeper significance as part of an animal pack that appears to inhabit our collective dreaming. The character of Little Wolf in Yuri Norstein's *Tale of Tales* (1979) exhibits a childish naïveté, yet this is but one dimension of Norstein's richly layered, multidimensional study of a place and period filtered through the imagination of a man who feels the weight of having been a child.

Animals appear frequently in fairy tales and fables. Such stories were readily appropriated by the maturing technologies and emerging industry of animation in the phase of development that followed the early experiments in technique and content carried out by McCay and his contemporaries. This is partly because they could be: the representational possibilities of animation could portray worlds of fantasy and myth far more convincingly than either fine arts or motion pictures – not least through anthropomorphism. But it is also because such stories were increasingly in demand, precisely as Western society began to move away from the rural roots of its folk traditions. The early decades of the twentieth century, which saw the growth of fantasy narrative animation – culminating in Disney's *Snow White and the Seven Dwarfs* (1937) and *Pinocchio* (1940) – also saw the most rapid

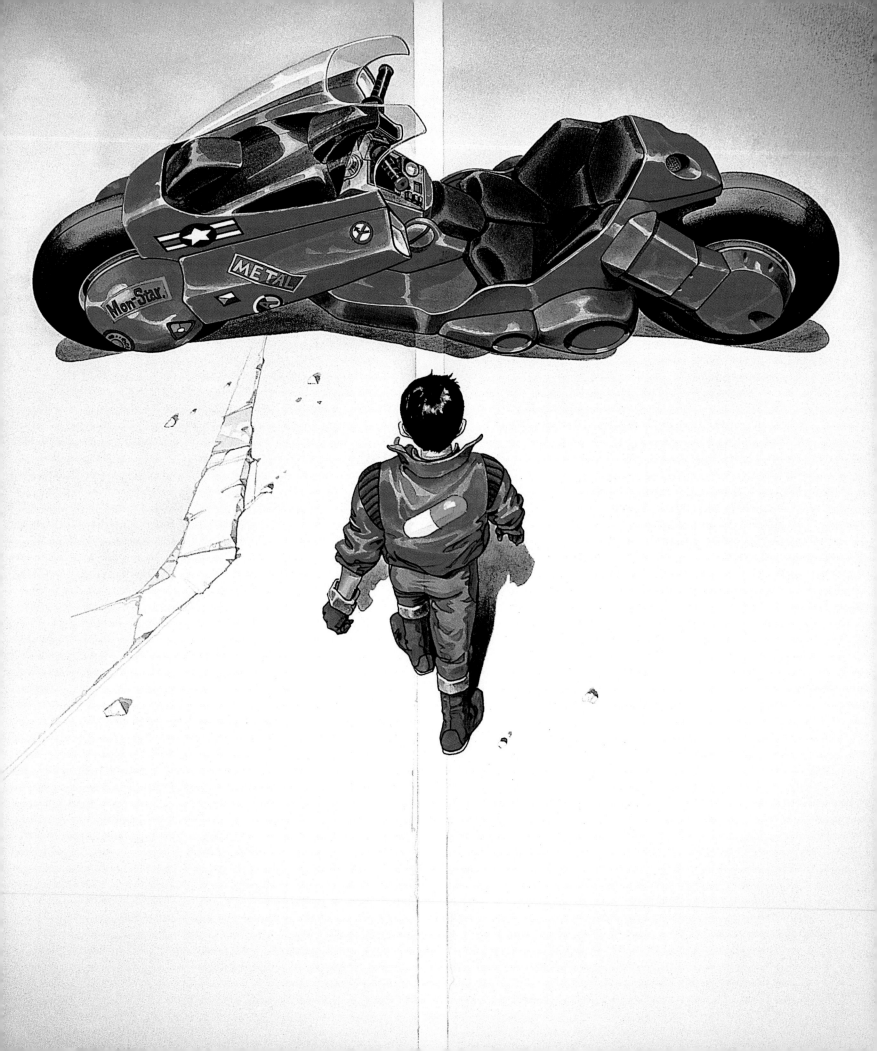

period of urbanization in the history of the United States, with 50 per cent of Americans living in cities by 1920 compared to only 15 per cent half a century earlier. This was popular entertainment, certainly, but it was also deeply embedded in the psyche and cultural memory of populations of European origin.

Japan, during this same period, witnessed a similar growth of a native animated-film industry, which in the 1960s would burst into the phenomenon known as 'anime'. Also drawing from the beginning on centuries-old storytelling and graphic-art traditions, Japanese animation continues to demonstrate its roots in collective memory. The *yōkai*, or 'monstrous figures', and *yurai*, or 'ghosts', of deep tradition have direct descendants in the most advanced contemporary horror-genre anime. Artist Takashi Murakami, in a project exploring the apparently superficial tendencies of phenomenally popular Japanese subcultures, gave the resulting exhibition and book of 2005 the title *Little Boy*.[2] The term not only evokes the childish characteristics of the anime, manga and toys presented, but also of course directly references the name given to the atomic bomb that the United States dropped on Hiroshima in 1945. What can be pejoratively seen as a catastrophic infantilism imposed on post-war Japanese culture is re-presented by Murakami as full of meaning and a vehicle for progressive imagination.

'Lightness' and 'density' seem more usable as attributes of cultural production than 'skill' or 'seriousness' or other characteristics determined by status rather than significance. Far from opposites, they support each other. The Brothers Quay's short film *In Absentia* (2000) features a lengthy shot of the walls and ceiling of a room – their studio, in fact – that seems constructed expressly to capture the passing effects of daylight, with one frame taken every five seconds. Nothing could be simpler, or more direct. Yet the dreamlike layering of energy and form, of time and space, evoked by this apparently straightforward process is little short of miraculously rich. The artists, talking about this film on a DVD of their work produced by the British Film Institute, discuss the points of contact between what the viewer sees and what is imagined in the mind of the film's subject, a woman based on the early twentieth-century German psychiatric patient Emma Hauck. As the brothers describe it, the light shines through the room as if it were a prism, but simultaneously as if it were the subject's brain, as if 'the back of her skull had been removed, and she was open to the slightest flickerings or movements of light'.[3] While this essay proposes that animation cumulatively, almost inevitably, builds a picture of the collective unconscious, the Quays' work is one of the strongest examples of the animator quite consciously using his or her art for that purpose.

Part of animation's force as a medium lies in the ease with which it shifts between 'fiction' and 'reality'. Compare the techniques of two works of parallel intention. Ari Folman's feature film *Waltz with Bashir* (2008) tells the story of an Israeli traumatically reliving his role in Israel's invasion of Lebanon in 1982. Folman famously opted for a (deceptively) simple-looking technique of animated storytelling to recount the quotidian present, heightened memories and surreal dreams of the narrator, shifting to documentary film only in a final, tragic retrospective flourish. Harun Farocki's installation *Immersion* (2009) tells the story of an American soldier's experience in Iraq through a staged therapy session, simultaneously showing, on one screen, the subject recounting his traumatic tale and, on an adjacent screen, a crude, Second Life-style animated visualization of what the scene stands for in his subconscious.

WINSOR MCCAY

Little Nemo Moving Comics, 1911

35mm, hand-coloured, silent, 2 min., 18 sec.

Courtesy of Ray Pointer, Inkwell Images Inc.

Both works, in other words, employ deliberately simple artifice to convey emotions and experiences too strong for more conventional or consciously richer forms of depiction. The depth of feeling and density of memory achieved by these two works depend significantly on their lightness of touch.

Alternatively, compare the parallel impact of two apparently dissimilar projects, from altogether alien cultures and intentions. Étienne-Jules Marey's pioneering filmed studies of body motions from 1890 individually aim at the objective recording of human movement, using technical means that had not previously existed. Yet these short studies – fingers opening and closing; a hand repeatedly writing the name 'Demeny'; a bare arm flexing or an arm outstretched, its hand holding an ice pick – cumulatively conjure an almost hallucinatory world of obsessive but disconnected action. At the other end of the historical and aesthetic spectrum, Ryan Trecartin's film *(Tommy-Chat Just E-mailed Me)* (2006) plays out the equally obsessive, equally disconnected actions of a cast of characters caught between virtual and real-world personae and behaviours. Marey's objective fragments, shaped into an imaginative whole, strangely mirror Trecartin's wildly subjective individual scenarios, which are lent a kind of objective verisimilitude by their collation into a psychic portrait of American mores in the early twenty-first century. It is thought that the apparent narrative sense we have of dreams is imposed only as we wake, as our minds try to give meaning to the mass of disconnected image fragments that have been randomly generated during sleep. Marey's and Trecartin's works operate on similar principles.

The lightness and the density of animation both derive from the fact that the animator's injunction to 'watch me move' is really an invitation to 'watch me be', with all the banality and profundity that that implies.

The physical experience of an exhibition highlights powerfully and poignantly some of the distinctive qualities of animation's representational and imaginative devices. Two very different but equally exemplary animation exhibitions show legitimate grounds for bringing animation back into the realm of the physical. *Once Upon a Time Walt Disney*, a major undertaking staged in Paris and Montreal in 2006–07, constructed a rich historical perspective of the creative sources of Walt Disney's filmic vision, from the castles of Ludwig II of Bavaria to the expressionist cinema of Fritz Lang and F.W. Murnau, and the paintings and illustrations of such visual artists as Gustave Doré and Arthur Rackham. The exhibition carefully amassed key artefacts from the history of visual culture to make specific iconographic points about the inspiration for Disney's unique world view. Another exhibition, *Trickraum : Spacetricks*, held in Zurich in 2005, looked at the relationship between contemporary animation and space, through the work of twenty-six animators from around the world. It included sketches and material from the process of animation, aiming 'to reveal the artists' specific creative imagination, from the spatial concept to preliminary designs and its cinematic result'.[4]

While highly respectful of these, and other, achievements in the recent history of animation exhibitions, *Watch Me Move* has different intentions. It does not set out to be a chronological history of animation, although historical landmarks of achievement and innovation are included, and multiple chronological paths can be traced through it. Instead, it is presented as a cumulative experience of what

makes animation work as an affective cultural medium. Both the exhibition and this catalogue are divided into seven thematic sections: 'Apparitions', 'Characters', 'Superhumans', 'Fables', 'Fragments', 'Structures' and 'Visions'. Since animation is primarily a moving-image medium, the majority of the works are presented as such, as distinct from the frequent strategy of displaying objects related to the making or presentation of the films. This latter approach is reasonable enough, because such objects are intrinsically interesting and important to an understanding of the processes and meanings of animation. It is also something of a museological reflex, and a factor of the difficulty of presenting film convincingly in an exhibition context. We have tried to address these difficulties head-on, believing that encountering a multiplicity of animated films from different times, countries and aesthetic intentions within a single conceptual and physical space is an informative and meaningful – and hitherto largely untried – approach. We have aimed in most cases to present films as integral works, shown where possible and sensible in their entirety. The total viewing time is likely to be beyond the capacity of most single visits, and we hope that viewers will accept the following condition of the project: that the works shown are presented as products of individual and collective cultural consciousness on the assumption that such consciousness is, in some sense, always present. The viewer walks among the works as through a room full of distinctive personalities or portraits, stopping to engage closely with old friends or new acquaintances.

A significant part of the appeal of animation derives from its complex relationship with the 'real'. For a medium so strongly associated with the illusory or the fantastic, with remembered or virtual reality, animation is highly dependent on the physical world. This world is evident in the often transparent production methods of the work: the mobilization, for example, of puppets, clay figures, cut-out images or sand, to name but a few of the techniques employed to make the pieces presented here. Having laid claim to a mainly filmic exhibition experience, we have of course included a wide selection of objects designed to throw that experience into relief, to allow the viewer the sensation of passing through the screen to circulate among the physical constituents and setting of the imaginative realm. What we have tried to avoid is presenting objects as some sort of 'solution' to the genuine puzzle of animated films. As Dan North rightly puts it, changes in the techniques of animation 'occur in response to the specific contexts in which they are necessitated by the competences and preoccupations of particular artists or by the properties of the available equipment – they do not emerge as pre-determined steps towards a long-term goal'.[5] Thus, while technological innovation is crucial to the imaginative growth of the form, techniques are seldom abandoned or drained of their significance. Such century-old techniques as stop-motion animation and rotoscoping are still used today for their emotive and conceptual power, not because they are the latest thing.

What is most interesting in the context of this exhibition is the slippage between different states of objectness. We have tried to emphasize this by grouping physical artefacts in a single presentation – a version of the cabinet of curiosities – to stress their variety of status and presence, rather than placing them in illustrative proximity to the films to which they relate. Early magic-lantern projectors, for instance, were themselves regularly given referential forms, enhancing their

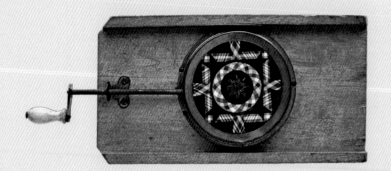

Magic-lantern chromatrope slide

c. 1870

© National Media Museum/SSPL

A chromatrope slide consists of several discs of coloured glass that rotate when the exterior handle is turned, producing kaleidoscope-like patterns.

magical function of shining light through a slide. Eadweard Muybridge's scientific photographic documentation of human and animal locomotion later provided the source material for glass slides bearing hand-painted image sequences. These were designed to be set in motion with the aid of Muybridge's zoopraxiscope projector, in travelling magic-lantern shows that were at once instructive and wondrously entertaining. Many animated films – including Hayao Miyazaki's *Nausicaä of the Valley of the Wind* (1984) and Marjane Satrapi's *Persepolis* (2007) – began life as comic strips or graphic novels before being adapted for the screen. Some of the more popular and iconic of the characters from these stories – for example, Astro Boy from Japan and the Hulk from the United States – have appeared in many forms, from comic or anime to graphic animation, toys and other merchandise, CGI (computer-generated imagery) feature films, and renewed graphic franchises. The term 'franchise' of course betrays the commercial motivation behind much of this presence, but this is not to deny the strength of feeling and association engendered by these complex personae. The Hulk and Astro Boy are two of the timeless tropes of folk mythology that animation has appropriated and kept alive: in the former, we see an ordinary man transformed into a tragic figure of superhuman powers; with the latter, we see the classic puppet/golem/robot that has figured in folklore and literature throughout the centuries, reshaped for the space-age fantasies of its era.

The multidimensionality of such figures is no less resonant for all that it is easily explained by the systems of commerce and popular culture. Sometimes, the objects generated by animation re-enter its circuitry, albeit with a tinge of irony. Kenneth Anger's *Mouse Heaven* (2004) proposes a subculture – indeed counterculture – of Mickey-

related objects and memorabilia from the 1920s and 1930s, while the characters of *Toy Story* (1995) display all the attributes and quirks of their original toy sources, despite the fact that in their CGI context they could have behaved in any way they or their animators wanted.

While the large grouping of objects mentioned above forms a centrepiece to the exhibition, it is further punctuated by points where film and object merge, in spatial and sculptural installations by visual artists into which viewers can physically and conceptually project themselves. The first of these, *Shadow Cinema* (2011) by French artist Christian Boltanski, references film only by association, since it consists principally of cut-out shadow puppets – the forms of which are viewed indistinctly through the glass frame of their light-box container – trembling in the ambient air currents. This work, at the very start of the exhibition's first section, 'Apparitions', reduces animation to its simplest and earliest configuration: object, light and imagery derived from the deepest recesses of the collective unconscious and recollections of involuntary dreams.

The 'real' is of course not always strictly object-based, but can have an indexical link with objective forms of representation. Here, too, animation plays between states of reality and imagination. One strand of the Lumière brothers' early experiments with film was dedicated to documenting the rapidly changing face of contemporary Paris. Their short film *Démolition d'un mur II* (1896) precisely captures workmen with sledgehammers knocking down a wall. The film has a compelling integrity in its clarity and focus, and in the fact that the duration of the incident it documents was only as long as the longest piece of film they could use. Furthermore, in public presentations of this work, after screening it as shot they regularly wound the film backwards, so that

WINSOR MCCAY

Gertie the Dinosaur, 1914

35mm, black and white, silent, 5 min., 38 sec.

Courtesy of Ray Pointer, Inkwell Images Inc.

the wall's ruins would seem to jump miraculously back into shape. A simple technical manipulation could turn a dry document of social observation into a little fantasy of matter having a life of its own – a theme that would recur repeatedly in animation in the decades that followed.

A small selection of the short films included in *Watch Me Move* take this play between the document and the inner life of the imagination in another direction. Bob Sabiston's *Snack and Drink* (2000) is perhaps the clearest example of this. Sabiston filmed a young autistic man as he tried to buy a drink from a vending machine. The subject's mental gymnastics around this apparently simple act are given visual form in the expressive, playful rotoscoping that the director subsequently applied to the film. (Max Fleischer, decades earlier, rotoscoped Cab Calloway and then turned him into the cartoon figure of Koko the Clown, deliberately invoking a dream/nightmare scenario.)

So far we have looked at a selection of the works included in *Watch Me Move* from the perspective of their source material, whether cultural, documentary or imaginary, or a combination of all three; their content, always in some way determined by physicality and technology in spite of its virtual appearance; and their meanings, either intended or accrued. A common characteristic, and therefore perhaps another generalization with which we can conclude as we began, is that the structures and artifices of animation are more often than not intimately tied to its meanings.

This seems true of both the most popular – to our eyes, most innocently entertaining – outputs of animation and the most overtly experimental. In the early, live-action scenes of *Gertie the Dinosaur* (1914), Winsor McCay bets his companions 'that he can make the Dinosaurus live again by a series of hand-drawn cartoons'. Six months pass, and McCay makes good on his bet, having drawn by hand and photographed 10,000 illustrations to create the illusion of the dinosaur in motion. Part of the thrill of early animation – and it has hardly abated since – is the fascination with the process that leads to the outcome. In this instance, there is also a tacit awareness that the dinosaur could not be made to come alive through any other means (that is, until the potential of genetic engineering became popularly debated, when Steven Spielberg was ready with a new generation of animation technologies – CGI – to give body to that dream). From its earliest days, animation had functions that were part entertainment and part educational. Underlying these, however, was its unique ability to satisfy a deep human craving to witness those aspects of the collective unconscious that could not otherwise be seen.

The construction of meaning is regularly enough part of animation's subject-matter that we can adduce it as a primary meaning in itself. Marina Warner, writing about Lotte Reiniger's version of 'Aschenputtel' (or Cinderella) from 1922 (she made another in the 1950s), speaks of how 'With pleasant, witty self-reflexiveness, [Reiniger] draws attention from the very start to the work of her scissors: the title sequence and intertitles and story panels brilliantly strike one visual pun after another between happenings in the story and the technique of the filmmaker.'[6] Again and again, in all kinds and periods of animation – from the Fleischer brothers to the Brothers Quay – we see overt evidence of the maker, whether that be the image leaping off the easel or the hands crafting the image that will come to life.

The visual sophistication, not to mention sheer enjoyment, that such knowing artifice engenders in its audience may help to explain how animation has become one of the most pervasive and perhaps defining visual art forms. Two advances in technological capabilities are now changing the face of animation, but in ways that build strongly on its past. First, CGI is creating an ever-higher degree of verisimilitude, to the extent that animation is regularly used in films that are not overtly animated to enhance or multiply real-life depictions. Secondly, the widespread availability of the same technology means that the boundaries between creators and consumers of animation are becoming increasingly fluid. Both these tendencies seem likely only to fulfil the potential of a medium that has, from its earliest origins and rapid development over the past century and a half, created imaginative bridges between the 'real' and the 'imaginary' world, and between the individual and the collective unconscious.

Epigraph: Richard Weihe, 'The Strings of the Marionette', in *Animated 'Worlds'*, ed. Suzanne Buchan, Eastleigh (John Libbey) 2006, p. 47.

[1] David Lewis-Williams, *The Mind in the Cave: Consciousness and the Origins of Art*, London (Thames & Hudson) 2002, p. 44.

[2] See Takashi Murakami, ed., *Little Boy: The Arts of Japan's Exploding Subculture*, New Haven, Conn., and London (Yale University Press) 2005.

[3] Brothers Quay, commentary on *In Absentia*, Disc 2, *Quay Brothers: The Short Films 1979–2003*, London (British Film Institute) 2006.

[4] *Trickraum : Spacetricks*, exhib. cat., ed. Suzanne Buchan and Andres Janser, Museum of Design, Zurich, August–November 2005, p. 4.

[5] Dan North, *Performing Illusions: Cinema, Special Effects and the Virtual Actor*, London and New York (Wallflower Press) 2008, p. 3.

[6] Marina Warner, 'Silhouettes and Shadow Puppets: Active Imagination and Lotte Reiniger', unpublished lecture given at 'Shadows/Ombre', 10th Synapsis European School of Comparative Literature, Bertinoro, 6–13 September 2009. A revised version of the lecture appears in *Stranger Magic: Charmed States in the Wake of the Arabian Nights*, London (Chatto & Windus) 2011.

THE TOOLBOX OF TECHNOLOGY AND TECHNIQUE

ANIMATION IN 100 OBJECTS

PAUL WELLS

As photographer Richard Nicholson has recently remarked, 'Even a few years ago every profession had its own machinery, its tools; now we all have computers.'[1] The digital shift has fundamentally revolutionized all production processes; for many creative practices, this has seen the analogue become a marker of some past era of technologies and techniques. There is some irony, then, that animation has benefited from such progress, with the digital era bringing its definition into question but, as a consequence, reclaiming it from the margins of arts practice, and placing its significance right back at the heart of debates and discourses about moving-image production and cinema itself.

In *The Language of New Media*, Lev Manovich makes the following observation:

> Once the cinema was stabilized as a technology, it cut all references to its origins in artifice. Everything that characterized moving pictures before the twentieth century – the manual construction of images, loop actions, the discrete nature of space and movement – was delegated to cinema's bastard relative, its supplement and shadow – animation. Twentieth-century animation became a depository for nineteenth-century moving image techniques left behind by cinema.[2]

These same moving-image techniques have become what animator Don Hertzfeldt has called the 'toolbox', to which animation (despite the crisis at the Walt Disney Company when it temporarily closed its 2D classical animation division in response to what appeared to be the hegemony of CGI) constantly refers, and uses.[3] In turn, this toolbox of techniques and approaches maintains animation's status as the most progressive and experimental of the various forms of moving image, both at the margins and in the mainstream.

It is pertinent, then, to look at animation through one hundred objects, tools and technologies, many of which are present in the *Watch Me Move* exhibition – and are indicated throughout the following text in **BOLD**. As the world is increasingly mediated through screens and keyboards, and as virtual environments prevail, the seemingly lost world of the material past takes on an increasing fascination, especially in the ways in which the physical elements of previous processes and practices have been re-mediated in the contemporary era. Essentially, the history and definition of animation have been rewritten through the objects, applications and mechanisms that it employs, and these are traced here.

Object number one is Charles-Émile Reynaud's **THÉÂTRE OPTIQUE** of 1888. The first device capable of presenting moving images to an audience, it made its public debut in 1892 during a show given by Reynaud in Paris. Preceding the public premiere of the Lumière brothers' first film by three years, Reynaud's show, billed as *Pantomimes lumineuses*, featured three early **CARTOONS**, *Pauvre Pierrot*, *Un bon bock* and *Le Clown et ses chiens*, displayed using a device that was a sophisticated development of Reynaud's own praxinoscope. The Théâtre Optique projected more than 500 individually painted sequential images embedded within a leather band; each narrative was accompanied by a piano piece. Reynaud's use of technology demonstrates the preoccupation of the cinema pioneers with self-consciously presenting both the mechanism and its creative outcomes simultaneously, a condition that has existed in animated film throughout its history. While Georges Méliès developed optical tricks in his early cinematic work, and

Restoration of Charles-Émile Reynaud's
Pauvre Pierrot (pages 54–55) by
animator Julien Pappé. It took Pappé
ten years, from 1986 to 1996, to restore
the original reel and to transfer the
animation to film.

sometimes employed stop-motion animation, animation as a form in its own right developed in other hands.

In 1899, using **MATCHES**, Briton Arthur Melbourne-Cooper created stick-figure stop-motion puppets for such films as *Matches Appeal*, *Animated Matches Playing Volleyball* and *Animated Matches Playing Cricket*.[4] Melbourne-Cooper's experience as a newsreel cameraman and particular interest in sport inspired him to engage with movement for its own sake. He rejected the moving corporeal body, already the key fascination of the early cinema, replacing it with a more symbolic representation of the body as it played out deliberately choreographed motion. The Spaniard Segundo de Chomón took this to its logical and often surreal extreme in a body of work made between 1905 and 1912 in Paris, which partly echoes the approach of Méliès, and also anticipates the playfulness of such film-makers as Charles Bowers.

This playfulness also featured on Anglo-American J. Stuart Blackton's **CHALKBOARD**, common to many live performances given by **LIGHTNING SKETCH** artists across Europe and the United States at the turn of the century. In theatrical settings, artists would rapidly draw amusing and topical caricatures on a blackboard or large paper pad. In the context of early film, this process was recorded and made yet quicker through frame-by-frame editorial intervention: figures and forms would magically emerge on screen as animations, the blank background suddenly revealing its graphic images. Blackton's *The Enchanted Drawing* (1900) and *Humorous Phases of Funny Faces* (1906) both included stop-motion chalk-drawn illusions, and prompted him to use more extensive stop-motion effects in *The Haunted House* (1907). This was the film that essentially convinced US film culture that

animation might be a further verification of both early cinema's possibilities and its popularity.

In St Petersburg, however, the development of Hollywood cinema was the least of the concerns of Alexander Shiryaev, Deputy Ballet Master of the Mariinsky Theatre. Shiryaev's early interest in cinematography, as well as his desire to preserve the fast-disappearing national folk dances of Russia, led him to draw and animate on rolls of **PAPER** in 1905, and to make 3D stop-motion **PUPPET** versions of character choreography in 1906.[5] In France, Émile Cohl – protégé of political caricaturist André Gill and member of the 'Incoherent' movement – drew the first acknowledged cartoons on paper for Gaumont. *Fantasmagorie* (1908), a surreal sequence of transforming images, illustrated the narrative potential in metamorphosis, and cited the ephemeral image-making of the 'fantasmograph' of the 1850s.[6] Like Blackton's *Humorous Phases of Funny Faces*, Cohl's film featured a clown, and presented the figure of the animator as the creator of the work. The very illusionism of animation always suggests the presence of such an author, even if not literally in the frame, and equally points up the degrees of constructed-ness in the image. Thus every animation, even from its earliest conception, also plays formally with time and space.[7]

This was of major concern to American illustrator and comic-strip artist Winsor McCay, whose observation of a **DINOSAUR SKELETON** led to the creation of *Gertie the Dinosaur* (1914). Gertie was a playful character who hurled mammoths into the far distance and 'interacted' with McCay in his vaudeville-style shows and lectures. As well as anticipating both gaming interaction and tensions between 2D and 3D space in later cartoons, Gertie also prefigured and

GEORGES MÉLIÈS

Le Mélomane, 1903
35mm, black and white, silent, 3 min.
BFI National Archive

influenced Disney's personality-led animation. Furthermore, Gertie was the first of a whole series of animated dinosaurs, from the creations of Willis O'Brien in *The Lost World* (1925) to those of Ray Harryhausen in *One Million Years B.C.* (an example of Harryhausen's **DYNAMATION**, the seamless integration of 3D animated creatures into a live-action context; 1966) and Steven Spielberg in *Jurassic Park* (1993). Interestingly, when Spielberg worked on his dinosaur film, he used a combination of stop-motion animation; **SCULPTED MAQUETTES**, which were digitized into a **COMPUTER**; and **ANIMATRONICS**, made by Stan Winston Studios. *Jurassic Park* thus demonstrated a **MIXED MEDIA** approach, now common in mainstream film-making, which used animation in its traditional form, as a special effect, and as the very condition of a central character, something that became increasingly important in such films as *Hulk* (2003) and *King Kong* (2005).

It was of course Disney's pioneering efforts in the development of animated characters and narratives, the application of new technologies, and the creation of an animation industry that enabled these later developments. Disney's contributions, however, were anticipated by those of Raoul Barré. Born in Canada, Barré was first associated with 'animation' in the 1890s, when, as a student and political cartoonist in Paris, he clashed with caricaturist Émile Cohl over the Dreyfus affair. Barré's real impact on animation, however, came in 1912, when he became an animator at the Edison Studios in New York. There, he and noted animator-producer William C. Nolan introduced **PEG BARS**, the still-used 'technology' where hole-punched paper is aligned on pegs on a **DRAWING BOARD**; and **SLASHED PAPER**, also known as the 'slash and tear' system, where the part of a drawing

that needs to 'move' is torn out and then redrawn, in its new position, on the underlying sheet of paper. Barré also created some of the first animation for advertising, and, in 1914, established the Barré-Nolan Studio, the first dedicated animation **STUDIO**, in the United States. Bray Productions emerged at almost the same time, and its founder, John R. Bray, without doubt moved studio practice forward by creating a more streamlined process of production, having four units working at the same time. Bray produced such series as *Colonel Heeza Liar* and *Bobby Bumps*, topical inserts, and pilot work, crucially deploying **CELLULOID OVERLAYS** (cels) as a way of developing painted and drawn animated sequences while keeping the same illustrated backgrounds. He created the process with Earl Hurd, and the Bray Hurd Process Company issued the **LICENCE** by which the cel production system could be used, encouraging the rapid industrialization of the animated form. Licences and copyrights are important aspects of the development of creative technologies, and in the history of animation they signalled the early need for studio **ARCHIVES**.

It was the emergent Disney and Fleischer studios, however, that effectively advanced animation at the technical and aesthetic levels. Fleischer Studios, founded by brothers Max and Dave in 1921 as Inkwell Studios, was more interested in the technologies of the form, experimenting with sound – before Disney – in the shape of Lee De Forest's 'phonofilm' system, which recorded sound directly on to film. De Forest, however, was unable to patent and exploit the system, even though it was used on Max Fleischer's *Song Car-Tunes* (1924–27), sing-along cartoons featuring a **BOUNCING BALL** that helped audiences to follow on-screen lyrics. De Forest's failure to copyright and exploit his process enabled Pat Powers effectively to copy the

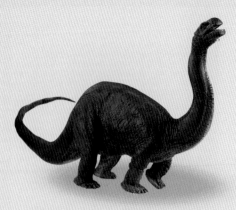

RAY HARRYHAUSEN

Original model brontosaurus from

One Million Years B.C., 1966

Latex body with internal metal armature

© The Ray & Diana Harryhausen Foundation

incomplete technology, invest in it, and market it as the **CINEPHONE SYSTEM**. Powers was able to persuade Walt Disney to use the system on his first sound cartoon, *Steamboat Willie* (1928), featuring the later-iconic Mickey Mouse. This promoted the **SYNCHRONICITY** of Carl Stalling's soundtrack, and led to the use of fragments of sound, song and music to add a distinctive narrative, emotional and comic dimension to a cartoon. The Fleischer brothers' later *Talkartoons* shorts (1929–32) embraced full **SCRIPTED DIALOGUE**, and made Betty Boop a flirtatious, innuendo-inflected star. Their key innovations, however, proved to be the **ROTOSCOPE** (1914) and the **STEREOPTICAL PROCESS AND APPARATUS** (1933). The rotoscope allowed animators to trace over live-action figure motion, and was used, for example, for the dance-walking, ghost-styled figure of orchestra leader and singer Cab Calloway in the Fleischers' *Snow White* (1933). It was later adapted by Bob Sabiston for his **ROTOSHOP** software, and used in Richard Linklater's *Waking Life* (2001). The stereoptical apparatus, essentially a large turntable, was designed to create depth in the environment of a 2D cartoon, and, like the rotoscope – surprisingly, perhaps, given the Fleischers' surreal story constructions and the full animation of many aspects of their *mise en scène* – sought to respect the theatrical proscenium and codes of realist representation.

Ironically, the Fleischers had already challenged the material fixity of the real world in the animated figure of Koko the Clown, who, in the *Out of the Inkwell* series (1918–29), leaves his animated world to cause havoc in the studio environment, a perspective Disney reversed by placing a live-action **ALICE** in an animated 'wonderland' (1924–27). Disney recognized, however, that such graphic freedoms and comic

vignettes – epitomized by Otto Messmer's extremely popular and Chaplin-influenced *Felix the Cat* cartoons (1919–28) – could service the cartoon form only to a limited extent. They did not facilitate animation in an extended narrative or, indeed, as art. Disney thus used its technological innovations to move towards a hyperrealism, one that authenticated the conviction and believability of the cartoon environment itself. This also enhanced the appeal and authority of the characters, even in the light of their over-determined theatricality and the prominence of slapstick and physical comedy. To this end, Disney was more successful than the Fleischers, creating a 'reality' in the cartoon, which allowed for both broad humour and more emotive, sentimental expression.

The Disney studios embraced **LIFE-DRAWING** and developed the use of **STORYBOARDS** in order to advance visual storytelling, and to prepare what needed to be animated and shot. It invested in the **TECHNICOLOR** process for *Flowers and Trees* (1932), even though part of the film had already been made in black and white, and it deployed (William) **GARRITY AND** (Roger) **BROGGIE'S MULTIPLANE CAMERA** for *The Old Mill* (1937). Consisting of a camera positioned above five separate planes of glass, each one holding a different element of the animated scene, this device allowed animators to create a greater sense of depth by 'moving' the camera between each plane. The first and second were used for animation in the foreground, the third and fourth for backgrounds, and the fifth mainly for sky and distant landscape; four of the planes could also be moved laterally. Ub Iwerks, the extraordinary draughtsman responsible for the style of early Disney cartoons, was the technical genius behind the **XEROGRAPHIC FUSING/DEVELOPING APPARATUS** for inking cels, later used in

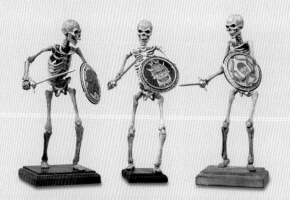

RAY HARRYHAUSEN

Three of the seven skeleton warriors
from *Jason and the Argonauts*, 1963
Internal metal armature covered with cotton
wool and dipped in latex
© The Ray & Diana Harryhausen Foundation

the making of *One Hundred and One Dalmatians* (1961). He also developed the ***SODIUM TRAVELLING-MATTE PROCESS***, which helped to fuse live action and animation more effectively, but his early experiments were with the multiplane camera.[8] However, it was the sophistication of Garrity and Broggie's version of the camera, together with its ability to represent shifting depth perspective and figures apparently moving through receding and foregrounded space, that was crucial in persuading Disney that an animated film could be made at feature length and echo live-action narratives. The milestone of *Snow White and the Seven Dwarfs* followed in 1937, ensuring animation's recognition as both a headlining and a mainstream form of entertainment.

Inevitably, the success of Disney, even in the contemporary era, tends to obscure the achievements in animation elsewhere. The studio's *Silly Symphonies* of the 1930s were essentially a set of experimental films leading to the creation of *Snow White*, similar in nature to the Pixar shorts of the 1980s and 1990s that led to *Toy Story* (1995). However, the *Silly Symphonies* ran parallel to a different kind of experimental tradition in Europe, one that has left behind its own Proustian objects: Lotte Reiniger's exquisite ***CUT-OUTS*** from her silhouette film *The Adventures of Prince Achmed* (1926), which is preceded as the world's first known animated feature only by Quirino Cristiani's *El apóstol* (1917); Alexandre Alexeieff and Claire Parker's ***PINSCREEN***, which rendered engraving-like images through the shifting tones of layered pins set at different heights in such films as *Night on Bald Mountain* (1933); and Oskar Fischinger's stop-motion ***MARCHING CIGARETTES*** from the advertisement *Muratti Marches On* (1934). Inspired by German film director Walter Ruttmann, as well

as by his own desire to create 'visual music', Fischinger developed a ***WAX-SLICING MACHINE***, which synchronized the slicing of a cylinder composed of melted and hardened multicoloured wax with the shutter on a camera; the resulting frame-by-frame record of the randomly swirling colours and forms present in the cylinder could then be turned into an animated sequence. Fischinger continued to experiment with colour, shape and form, creating an abstract masterpiece, *Composition in Blue* (1935). His formalist preoccupations were echoed by Norman McLaren, who noted in a series of ***VISUAL SCRIPTS*** the technical and aesthetic considerations of his approach. McLaren employed a number of optical effects, including ***PIXILATION***, the frame-by-frame recording of staged physical actions, which he used to particular effect in his brutal anti-war parable, *Neighbours* (1952). He also used an ***OPTICAL PRINTER*** – a device for re-photographing strips of film – to achieve an almost stroboscopic effect in *Pas de deux* (1968), a study of ballet dancers Margaret Mercier and Vincent Warren played out in stark lighting with lyrical precision.

Since its early days, animation has been characterized by the simultaneous development and consolidation of the 'cartoon' and a more 'experimental' tradition, essentially preoccupied with the manipulation of materials, space and time in the communication of emotion. However, at the heart of many creative solutions remain technical solutions. In the early 1930s Hungarian-born George Pal used ***REPLACEMENT HEADS*** for his 3D characters in order to address the labour-intensive aspect of the animation process; as early as 1912, in the dark, fairy-tale world of *The Cameraman's Revenge*, Polish-Lithuanian animator Ladislas Starewitch used ***INSECTS*** as 3D characters; and in 1916, in Japan, Oten Shimokawa, failing to animate

HALAS & BATCHELOR
Animal Farm, 1954
35mm, colour, sound, 74 min.
Courtesy of the Halas & Batchelor Collection

chalk drawings, drew directly on to film using ink. Shimokawa's **INKPOT** anticipated not only the Fleischers' inkwell but also, more importantly, Len Lye's use of a **PAINTBRUSH** and **FILM STOCK** as he worked in a more self-consciously personal style on such vibrant abstract films as *A Colour Box* (1935). This more direct, 'under the camera' style was extended by Caroline Leaf in her under-lit **SAND-ON-GLASS** film *The Owl Who Married a Goose: An Eskimo Legend* (1974); her **PAINT-ON-GLASS** film *The Street* (1976); and her **SCRATCHED-ON-FILM** drama *Two Sisters* (1990), in which the means used to make the film are reflected in its themes of light and dark, hidden and revealed, controlled and controlling – and, arguably, the generic qualities and conditions of the animator.

So often, then, the talent emerges through its tools and processes: the **PENCILS** of Joanna Quinn, Bill Plympton and Frédéric Back; the **POSTCARDS** decorated by Robert Breer; the **SCRATCHED PLASTER** of Piotr Dumała; the myriad **OBJECTS** that have had their voices and histories revealed by Jan Švankmajer; the **DETRITUS** reanimated by the Brothers Quay; Jiří Trnka's puppets, esteemed as **ACTORS**, rather than merely material things; Nick Park's mute but gesture-rich **CLAY** dog, Gromit; Karel Zeman's assorted **MINIATURE AIRSHIPS**; Terry Gilliam's **STOLEN FOOT** from Agnolo Bronzino's *Venus, Cupid, Folly and Time*; Yuri Norstein's and Andrey Khrzhanovsky's challenging personal, religious and political **ICONS**; Bob Godfrey's **FELT-TIP PENS**; Vera Neubauer's **KNITTING WOOL** figures; Viking Eggeling's **SCROLLS**; Zbigniew Rybczyński's **MULTIPLE MATTE MANIPULATIONS** (a matte being a mask used to obscure one part of an image so that another can be put in its place) in *Tango* (1980); or Berthold Bartosch's diffusive **LIGHT SOURCES** in the never-

released *L'Idée* (1934). But what are these but a means to draw on and represent memory; the 'muscles and bones' of physical expression; the fantasy, dream and solipsistic preoccupation of interior states recalled?

Animation is effectively one long expression of recollection and response, a re-interrogation and representation of alternative realities and preferred worlds. For example, even as Disney had lyricized animation and perfected its enclosed pastoral idyll with quasi-gothic undercurrents – a radical perspective and approach in the eyes of Soviet film-maker Sergei Eisenstein[9] – the emergent auteurs of **TERMITE TERRACE** (the Warner Bros. studio), Tex Avery, Chuck Jones, Bob Clampett and Frank Tashlin, were reinventing the cartoon, constantly breaking the cherished **FOURTH WALL**, sharing the illusion with the audience. This spirit of reinvention and acknowledgement of the audience have been characterized by a persistent interrogation of the language of expression animation permits. From the use of **GRAPHIC DESIGN** idioms by United Productions of America (UPA) and Halas & Batchelor's use of **MODERN ART** codes and conventions, as well as **TENSION SHEETS** planning the emotional development of the story in relation to its aesthetic shifts, to the Wan brothers' **CALLIGRAPHIC** approach and Priit Pärn's profoundly influential **CARICATURES**, conventional notions of the cartoon have always been challenged.

In Zagreb, between 1956 and 1970, the artists of the former Yugoslavia deployed **LIMITED ANIMATION**. In the made-for-television era in the United States, largely defined by Hanna-Barbera, this was known as **REDUCED ANIMATION**; in Japan, it was pejoratively called 'overexpressionism' by Hayao Miyazaki.[10] Each approach used less full animation, focused on many rapidly cut single shots and **REPEATED MOVEMENT CYCLES**, and privileged minimum

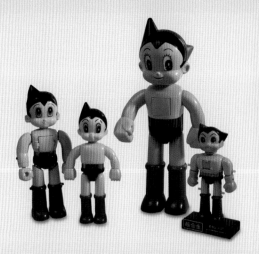

Toys based on the character of Astro Boy (originally known as Tetsuwan Atomu) from the animated television series by Osamu Tezuka
First three from left: Takara, Japan, 1980, plastic; right: Popy, Japan, 1976, die-cast metal and plastic
Courtesy of Fabrizio Modina

sound and imagery to gain maximum symbolic suggestion. In Zagreb this achieved a model of political metaphor resistant to authoritarian oppression; in the United States it foregrounded the work of such talented **VOICE ARTISTS** as Daws Butler and June Foray; and in Japan it prompted Studio Ghibli to maintain its powerful model of emotive storytelling in the face of **MERCHANDISE** and such **GAMING**-related phenomena as *Pokémon* (1997–present). The relationship between animation and the commercial marketplace is a well-established one, of course, producing a myriad of artefacts, among them the **3D MOVING ADVERTISEMENT** in London's Piccadilly Circus featuring George Studdy's Bonzo the dog (1925); **MICKEY MOUSE DOLLS**; Popeye's **SPINACH**; and the Transformers **TOYS**. Cels, storyboards, **LAYOUTS**, **MODEL SHEETS** (on which a single character is depicted from a range of angles and perspectives), **DEVELOPMENT SKETCHES** and even **SETS** have in themselves become animation art and, like the spin-off products, highly collectable – a facet of animation culture explored to brilliant effect in the narrative of *Toy Story 2* (1999).

Perhaps one of the most important collectables from the history of animation, however, is Ed Catmull's **SIGGRAPH PAPERS**, academic discourses that were instrumental in the development of computer animation. In 1986, together with Alvy Ray Smith from Industrial Light and Magic (ILM), ex-Disney animator John Lasseter and Apple's Steve Jobs, Catmull formed Pixar Animation Studios, a company committed to making fully computer-generated animated films. George Lucas did not want to invest in this possibility, focusing instead on animated digital effects for his *Star Wars* series (1977–2005).[11] Thereafter, Hollywood increasingly prioritized the use of animation in its post-production suites, creating **DIGITAL DOUBLES**, **CROWD** **SIMULATIONS**, **SCENE EXTENSIONS** and **3D ENVIRONMENTS**, while also using **MOTION CAPTURE** to deploy physical performances by actors, dancers and martial-arts experts in the service of animated characters. If Roger Rabbit shared a **2½D** space with human characters in *Who Framed Roger Rabbit* (1988), and the eponymous hero of *Tarzan* (1999) swung through a jungle created using **DEEP CANVAS** (a means of rendering 3D environments for 2D animation), then Gollum fully shared 3D space in *Lord of the Rings: The Two Towers* (2002). The development of the Na'vi for James Cameron's *Avatar* (2009) was informed by the use of **REAL-TIME MOTION CAPTURE** technology, and proved the most advanced use of immersive **POLARIZED 3D**. Such worlds are our worlds.

So all we have now are computers. The **LIGHT CYCLES** from *Tron* (1982), the **STAINED-GLASS KNIGHT** from *Young Sherlock Holmes* (1985), *Toy Story*'s **VIRTUAL PULL-STRING COWBOY AND ASTRONAUT**, the **DIGITAL HAIR AND CLOTH** from *The Incredibles* (2004) – all gathering dust in a **DATABASE**, the new museum space, the store for exhibition.

But animation has always insisted that when it has nothing left, it has something more. As Canadian Rose Bond projects moving images on to town-hall windows, or Italian artist Blu moves subjects on walls, or American film director and animator PES reinvents old objects to exhibit on the Internet, the world is refreshed and re-imagined. Animation always bellows, 'Watch me move!'

PAGE 19
OSKAR FISCHINGER
Radio Dynamics, 1942
35mm, colour, silent, 4 min.
© Fischinger Trust; courtesy of Center for
Visual Music

RIGHT
NICK PARK AND STEVE BOX
Set from the film *Wallace & Gromit
in The Curse of the Were-Rabbit*, 2005
Wallace & Gromit Curse of the Were-Rabbit
© 2005 Aardman Animations Ltd

[1] Richard Nicholson, quoted in
Sean O'Hagen, 'Elegy to the Ghost
in the Machine', *The Observer*,
26 December 2010, p. 31.

[2] Lev Manovich, *The Language of
New Media*, Cambridge, Mass., and
London (MIT Press) 2001, p. 298.

[3] Paul Wells and Johnny Hardstaff,
*Re-imagining Animation: The
Changing Face of the Moving Image*,
Lausanne (AVA Academia) 2008, p. 60.

[4] See Tjitte De Vries and Ati Mul,
*'They Thought It Was a Marvel':
Arthur Melbourne-Cooper (1874–
1961) – Pioneer of Puppet Animation*,
Amsterdam (Pallas) 2009.

[5] See Birgit Beumers *et al.*, eds,
*Alexander Shiryaev: Master of
Movement*, Gemona (Le Giornate
del Cinema Muto) 2009.

[6] See Donald Crafton, *Émile Cohl,
Caricature and Film*, Princeton, NJ
(Princeton University Press), 1990.

[7] See J.P. Telotte, *Animating Space:
From Mickey to WALL-E*, Lexington,
Ky. (The University Press of Kentucky)
2010.

[8] See Leslie Iwerks and John
Kenworthy, *The Hand Behind the
Mouse*, New York (Disney Editions)
2001.

[9] See Jay Leyda, ed., *Eisenstein on
Disney*, London (Methuen) 1988.

[10] Hayao Miyazaki, *Starting Point:
1979–1996*, tr. Frederick L. Schodt
and Beth Cary, San Francisco (Viz
Media) 2009.

[11] See Michael Rubin, *Droidmaker:
George Lucas and the Digital
Revolution*, Gainesville, Fla. (Triad)
2006.

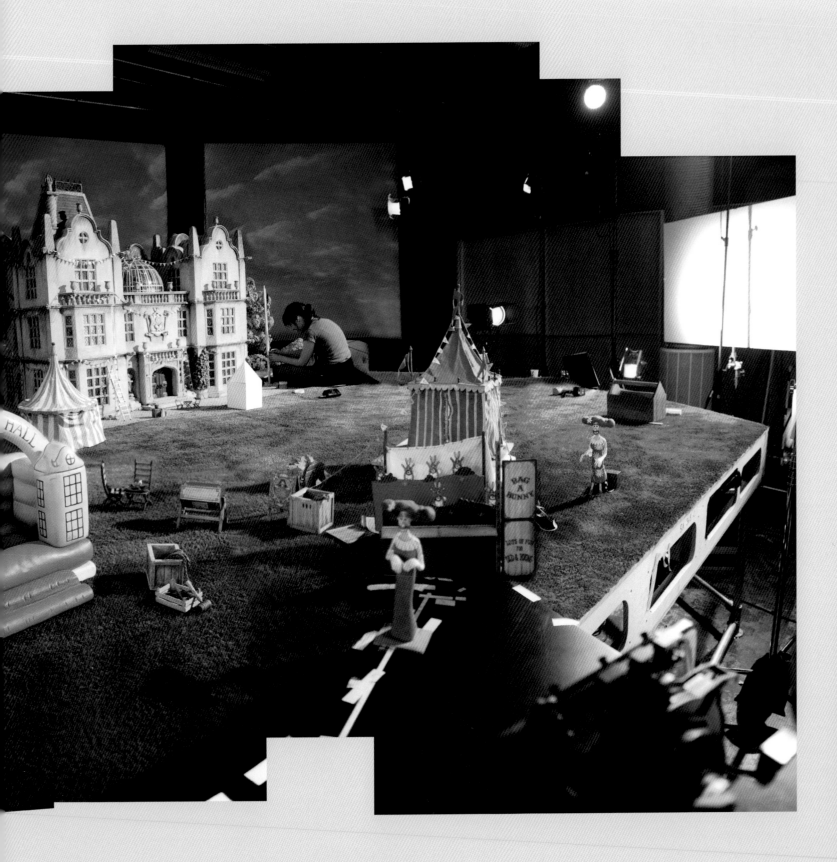

GHOSTS IN THE MACHINE

EXPERIENCING ANIMATION

SUZANNE BUCHAN

Most of us today are aware of the many ways in which animation has infiltrated our visual culture, occupying, informing and politicizing many public and private spaces. It has long had a constitutive role in the dissemination of ideologies with a mind to shaping public attitudes. Animation is ubiquitous: smartphone and Web interfaces, computer modelling in science and technology, architectural design, computer games, distance learning and feature films starring synthespians are all examples of forms of animation in public, private and working environments that expand what the word 'animation' usually calls to mind – entertainment. In its visualizations of physically and phenomenally impossible yet strangely credible worlds, animation will continue to have a serious impact, not only on visual entertainment but also in relation to our personal experience.

There are many stories, and histories, of animation. Some reach back to Egyptian hieroglyphs and Chinese scrolls; others begin with the Victorian optical experiments that became popular entertainment in parlours and nurseries (Joseph Plateau's phenakistoscope, Charles-Émile Reynaud's praxinoscope), or commence with photographic interstitial-image experiments (Étienne-Jules Marey, Eadweard Muybridge); a few locate the beginnings of animation in Émile Cohl's *Fantasmagorie* (1908), describing it as the 'first true animated cartoon'.[1] All of these are valid starting points for recounting and reflecting on a vast wealth of animated films and film-makers stretching back for more than a century. Histories can account for technological developments, studios, production systems, techniques and developmental relationships with other creative forms (sculpture, painting, comic art), artistic periods (Futurism, surrealism, Pop) and cultural upheavals (fascism, communism, glasnost, the digital shift). These are often the contexts

in which animation has been curated in museums and galleries; today, meanwhile, exhibitions are increasingly dedicated to a single artist (Muybridge, the Brothers Quay, Tabaimo), a group of animators based around a curatorial theme (*Trickraum : Spacetricks*, *Animated Painting*) or a studio (Pixar, Disney, Aardman).

Yet there are other ways of telling a story of animation that peel back and go below the material, historical and factual surface of this cinematic technique. Because the seven thematic concepts of *Watch Me Move* have a specific thematic focus, it allows permeation between different animation techniques and historically and stylistically discrete canons. This essay concentrates on the four themes that consider the viewer's *experience* of animation: 'Apparitions', 'Fragments', 'Structures' and 'Visions'. For the viewer, many works in these themes share certain features, properties and experiential phenomena. They tend to undermine conventional narrative; lack dialogue, and be sound- and music-driven instead; feature imaginative, impossible worlds and non-anthropomorphic figures; offer philosophical/perceptual concepts that diverge from our everyday experience of 'reality'; and be self-reflexive. Through an animated character in *Big Heel-Watha* (1944), Tex Avery, one of the most radical of the Hollywood cartoon directors, suggested that, 'in a cartoon, you can do anything'. Looking beyond the cartoon, this essay reveals the fabulous experimentation behind some of the works in the exhibition that fall outside the realm of commercial popular culture, foregrounding the viewer's experience of the creative imagination that the animated form presents.

Vachel Lindsay's early twentieth-century reflections on animation – or the 'trick film', as it was known in his era – remain valid proposals for animation as a complex, special power of film:

PERCY SMITH

The Birth of a Flower, 1910

35mm, black and white, silent, 6 min.

BFI National Archive

The ability to do this kind of a thing is fundamental in the destinies of the art. … Now the mechanical or non-human object … is apt to be the hero in most any sort of photoplay while the producer remains utterly unconscious of the fact. Why not face this idiosyncrasy of the camera and make the non-human object the hero indeed? … Make the fire the loveliest of torches, the water the most graceful of springs. Let the rope be the humorist. Let the stick be the outstanding hero, the D'Artagnan of the group, full of queer gestures and hoppings about. Let him be both polite and obdurate. Finally let him beat the dog most heroically.[2]

Besides eliciting pleasure, smiles and a sense of wonder, what do these images affect in our perception that the filmic actions and dialogues of living, sentient beings do not? How can a piece of metal be endowed with a gesture that moves us emotionally? In what kind of world does a stick 'live'?

SPECTRES AND HEROES

In early cinema, Lindsay's 'heroes' had a darker undercurrent: turn-of-the-century culture was fascinated with the occult, with spectres and with supernatural visions. In 'To Scan a Ghost: The Ontology of Mediated Vision', Tom Gunning describes the 'phantasm' that 'denotes an image that wavers between the material and immaterial and was used by premodern philosophy and science to explain the workings of both sight and consciousness, especially the imagination (*phantasia*).'[3] Early cinema is replete with phantasms, and these apparitions took on a new visual form in animated cinema. Early film tricks were created 'in

camera'; for instance, by stopping cranking, replacing one object in front of the camera with another, and starting filming again. In the famous example from a film by Georges Méliès, as if by magic, a bus transubstantiates into a hearse. This technique was a cinematic paradigm shift that transformed representations of both objects and humans, from diabolical, anarchic tricksters (Méliès, *Le Mélomane*, 1903) to the metamorphosing characters of filmed lightning sketches (J. Stuart Blackton, *Humorous Phases of Funny Faces*, 1906).

Discussing Méliès, Gunning acknowledges that 'many trick films are, in effect, plotless, a series of transformations strung together with little connection and certainly *no characterization*'.[4] This argument does not hold for such films as the Lumière brothers' *Le Squelette joyeux* (c. 1897–98), a fully animated *danse macabre* of a dancing skeleton exuding intent, mischief and vitality. Segundo de Chomón's *El hotel eléctrico* (1908) is mainly live action, but makes use of the 'trick' effect of stop motion. Unnoticed, a bag and rolled blanket make their way to a hotel room, where they cavort and prepare for their owners' arrival. The human figures are involved and complicit. The man claps his hands, and a drinks trolley moves itself within reach; as he prepares some drinks, a close-up shows a brush polishing his boots. The woman's outer clothes take themselves off, and a hairbrush and comb detangle her hair, which then re-braids itself and completes its own upswept coiffure. The man's toiletries are also animated: shaving brush, razor and comb tidy up the dishevelled traveller. Not simply tricks, these 'silent servants' are Lindsay's 'heroes', the stars of the piece. In such films, the viewer is confronted with a naturally impossible yet comprehensible vision of objects that move, have intent and personality, and can be cunning. This animated cinematic 'ghost in the machine'

does what theatre could not: it endows inanimate objects with a vital life and character of their own.

But there were other wonders, too, which originated in scientific investigation. Marey's *Body Motions* (c. 1890) is a series of chronophotographic studies of moving body parts, including flexing arms and perambulating legs. It commences with a clenching and unclenching hand, sequestered from its arm and body, free-floating. This ghostly effect and fragmentation of body parts created a tension in the viewer of the 1890s that may be hard for us to imagine today. Percy Smith's *The Birth of a Flower* (1910) documents a natural phenomenon using the basic principle of animated illusion, cinematic or otherwise: metamorphosis. Smith's film is of a blossom's cycle: swelling nascence, full bloom and withering atrophy. Setting the camera to record a series of single frames over a period of days (instead of twelve to eighteen frames per second used for live action), he accelerated time via time-lapse photography to allow viewers to experience a natural process otherwise invisible to human perception.

While many 'trick' films used objects from the everyday world, drawn and painted animation provided audiences with cinematic experiences of other natural histories. Dinosaurs, for instance, have long been an object of fascination for young and old alike. Winsor McCay gave turn-of-the-century viewers a chance to experience what had previously been seen only as illustrations and immobile museum skeletons. The star of his *Gertie the Dinosaur* (1914) is a graphic, 'fleshed out' gargantua who moves and frolics with both a mammoth and a live (off-screen) and animated McCay. Gertie is an astonishing example of the special power of animation to present an illusion of life no longer extant in the natural world. Yet Cohl's earlier *Fantasmagorie*

remains one of the most stunning graphic animated films ever made. Its simple design – white lines on a black background – creates a hallucinatory graphic universe that exploits the principle of metamorphosis essential to all non-object animation.

ANIMATION, MODERNISM AND ABSTRACTION

Animation has been coextensive with modernism's thrust for experiences of flux, impermanence, movement and exploding space to a degree unthinkable in static art or the live-action photorealism of the typical modernist canon. To make their films, animators have almost the entire range of artistic media at their disposal, from oil paint, charcoal and watercolour to pastels, etching, sculpture and more. Modernism generated a new avant-garde animation practice that had many affinities with Futurist, surrealist and cubist painting, which aimed to depict movement and dynamism within a single work. But animation was able to add elements of duration and change to these flux dynamics via time-based metamorphosis. Animation's arts-based production, profilmic (before-the-camera) materials and methods, and single-frame shooting technique allowed artists – particularly the 'Absolute' film-makers – to move from static to dynamic, time-based, manipulated moving-image art.[5]

Radical concepts comparable to Arnold Schoenberg's twelve-tone technique and El Lissitzky's attempts to create a universal art form found expression in painter Viking Eggeling's singular 'universal language'. Eggeling initiated engagement with the artistic implications of abstract film to unite the static (painting) and the dynamic (film/movement) in a single, visual language. His *Symphonie Diagonale* (1924) is one attempt at realizing this language. Other Absolute films

in the exhibition firmly in the canon of experimental animated film include *Rhythm 23* (1923) by Hans Richter, an architect, film-maker and painter who worked with Eggeling and became a prolific, if occasionally polemical, author on film and art. Esther Leslie describes his films as 'animations that showed twenty-odd Mondrians a second'.[6] Oskar Fischinger, a painter and a film-maker, can be associated with the non-cinematic 'colour music' experiments of the eighteenth to twentieth centuries, and with Wassily Kandinsky's painting; his *Radio Dynamics* (1942) is a brilliant example of 'visual music'. These works are all instances of how modernism's preference for colour and form over natural depiction and mimetic representation found its way into animation.

The same animated films are also exemplars of what José Ortega y Gasset in 1925 critically described as 'the dehumanization of art' in modern painting that privileged form over content and deliberately avoided the pre-modernist emphasis on the human figure.[7] Yet the moving figures in many of these films – abstract geometric forms – subvert natural laws and simultaneously create new forms of 'life', confirming Jean Mitry's statement that '[o]ne might say that *any object presented in moving images gains a meaning* (a collection of significations) *it does not have "in reality", that is, as a real presence*'.[8] Christine Noll Brinckmann suggests that these geometric forms can also elicit identification and empathy. Describing how movement creates alliances and choreographies between the forms, she then queries the audience's engagement: 'In light of such cinematic processes, the temptation is there both to identify the moving forms and to animate them with characteristics and intentions.'[9] Contrary to Ortega y Gasset's claim, the virtuosity of a line (Len Lye's *A Colour Box*,

1935), a smear of paint (Stan Brakhage's *The Dante Quartet*, 1987) or a rhomboid (Jules Engel's *Train Landscape*, 1974), often choreographed to music, can move us emotionally and elicit the very human feeling of empathy.

The aesthetic representation of different worlds – imaginary, phenomenal, poetic or otherwise – has been thematized in philosophical, aesthetic and psychoanalytic discourses, with an impact on almost all areas of the arts and humanities. Writing in 1898 on pre- and early cinema, Charles Francis Jenkins mused, 'To give life to inanimate things has been the dream of philosophers for ages, but to paint pictures and imbue them with animation is the ambition of more practical investigators.'[10] His idea that cinema is painting pictures gives a sense of the newness of the cinematic experiences of the time, while the 'practical investigators' of the animated technique are the instigators of some of the most remarkable animated worlds in the exhibition. Later, as modernism seceded to new art forms and practices, some of these continued to employ modernism's aesthetic strategies, including self-reflexivity, disorientation, flux, impermanence, the shift away from depicting human subjectivity to an interest in form, and an emphasis on disrupting audiences' narrative expectations. A more contemporary painter whose works use such visual strategies was Francis Bacon; in *La Plage* (1992), film-maker Patrick Bokanowski uses similar aesthetics to create a ballooning, painterly vision of an unfamiliar world. Movement added to the already complex Baconesque distortion – created using specially made lenses of varying degrees of thickness – further challenges the viewer to comprehend that the geometric elements add up to human figures. Once they have understood the visual laws of the film's world, they can engage with

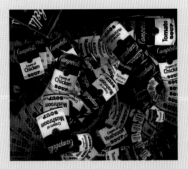

FRANK AND CAROLINE MOURIS

Frank Film, 1973

16mm, colour, sound, 9 min.

© Frank and Caroline Mouris

the undramatic action and enjoy the flow of images as moving paintings; occasionally, moments of stillness transform the screen into a canvas. Although technically *La Plage* is not an animated film – each sequence having been shot in real time, as in conventional, live-action cinema – Bokanowski's painterly imagery is effectively animated by the lenses.

ANIMATED COLLAGE

While Bokanowski visually complicates the natural world, there are animation techniques that achieve condensation, metaphor and simultaneity between distinct spaces and times. Besides drawing and painting, there are techniques that create a barrage of imagery: collage and cut-out animation, which use materials separated from their original purpose. Originating in photoindexicality, whereby the photographic image represents what is in front of the camera, (photo)collage aligned itself with modernism's interest in flux and deconstruction, with its aesthetic and political manifestos, and with its aim to break with classical visual narrative traditions. The photo- and graphic collages of such artists as Georges Braque, El Lissitzky, Kazimir Malevich, Hannah Höch and Alexander Rodchenko had multiple purposes: to challenge traditional art forms, to generate social and political change (often in the service of ideologies) and to demonstrate the communicative possibilities of mixing media. The collage technique was also an abandonment of the (entrenched) aesthetics of painting and representation, a move that was central to the modernist rejection of tradition to create radically new forms of art.

Collage in the moving image – a layering technique that usually remains on a single profilmic plane – allows the manipulation and

combination of actuality and photoindexical still and moving imagery, as well as graphic intervention in the same frame. The collage technique has a long tradition in pre-digital animation, and typically involves the arrangement of image fragments and materials spanning a wide range of media, from fabric, consumer packaging and photographs to cut-out images, typography and newspaper clippings; it can also include objects, and many works serve experimental narrative or fiction. It is distinct from the layering used in cel animation, and from multiplane set-ups.[11] One of the appeals of collage is that it can be a 'low-tech' form of animation, as it often relies on extant imagery, rather than each image being generated by an artist.

Collage animation literally works with fragments to tell its stories: tangible artefacts, fragments of paper, photographs and pieces of other films or artworks. Ed Tan describes two generators of aesthetic fascination in film: fictional emotion, which is stimulated by the fictional events of the story; and artefact emotion, which originates in an admiration for the film's construction and formal parameters.[12] Artefact emotion is usually deemed to be secondary, but in such films as Frank Mouris's Academy Award-winning *Frank Film* (1973), it can be the primary emotional stimuli. Mouris cleverly combined thousands of images cut out from glossy magazines – artefacts of the consumer culture from the worlds of fashion, architecture, design and art – to create an animated temple of conspicuous consumption. Using a multiplane camera, he was able to create a dense and uninterrupted flow of thematic collages. But the ingeniousness of the film lies in its dual soundtrack of Mouris's voice: one is an uninterrupted recitation of words, the other a monologue. The latter was unscripted; it was a last-minute decision with the sound artist, and involved Mouris sitting in

front of the film and free-associating the story of his life and development as an artist (the film is, after all, called *Frank Film*). The words and monologue often align with the thematic collages, which add a humorous and endearing sense of irony to the narcissism of the speaking voice(s).

Because the images used in animated collage can change, transform and develop new visual metaphors, they sometimes produce a dense and complex overload of visual information. For *Science Friction* (1959), Stan Vanderbeek created a cautionary Cold War tale using radically colliding intermedial stylistics: a combination of ephemeral and iconic images and photographs from magazines, newspapers, films, television and advertisements. They have an embedded cultural currency obvious only to those with political, social and historical expertise in still and moving images, and in the popular culture of the period on which Vanderbeek drew. His satirical films make heavy use of visual puns and hyperbole, and are as politically and socially compelling as when they were made. Darryl Chin suggests that Vanderbeek's collage films 'retain an enormous vitality, a bounding inventiveness, an incendiary wit which was shared by such other film collagists as Robert Breer, Bruce Conner and Dick Preston'.[13] Viewers seeking causality, narrative and coherence may be stumped, irritated or overwhelmed; some may be stimulated by the poetry of the work; still others may revel in sensory overload, discovering different themes, visual alliances and associative linkage in each viewing, or metaphorical and political allusions in the disjunctive combinations. To quote Vanderbeek himself: 'In my opinion the audience cannot be considered as the final target for [film-makers'] work, but it may be implicated.'[14] Many of his films operate at a more fundamental level of gender, power, spatial politics

and consumption, but this does not detract from their thoroughly enjoyable visual surfaces.

MANIPULATING THE REEL, 'REAL' WORLD

Reflecting on the film experience, philosopher Stanley Cavell wrote:

> [T]here is one whole region of film which seems to satisfy my concerns with understanding the special powers of film but which explicitly has nothing to do with projections of the real world – the region of animated cartoons. If this region of film counters my insistence upon the projection of reality as essential to the medium of the movies, then it counters it completely.[15]

In human experience, the 'real' world – the one we inhabit and phenomenally access through the senses – is complemented by other, inner worlds of imagination, pre-verbal thought, dreams and memory, but these metaphysical worlds cannot take on physical form. Besides the drawn world of 2D cartoons, animation has a remarkable capacity to visualize these worlds in combination with images from the real world. Many artists in the exhibition make remarkable use of light for this purpose, albeit with very different techniques. In graphic and painted animation, shadows and light are created by the artists using pen, ink, paint or pixels. One aesthetic treatment of light is chiaroscuro (literally, 'light-dark'), a widely used compositional technique that originated in sixteenth-century Renaissance painting. In common parlance, chiaroscuro has come to mean an emotional, often sombre mood evoked by the use of shadows and light, and the relationship between painting and photography has continued such explorations

FLEISCHER BROTHERS

Out of the Inkwell: Modeling, 1921
35mm, black and white, silent, 5 min.
Courtesy of Ray Pointer, Inkwell Images Inc.

of mood. Many of Jerzy Kucia's works, including *Przez pole* (Across the Field; 1992), are based on live-action sequences shot on film, but Kucia manipulates the mostly black-and-white images and adds animated layers to create ghostly afterlives of farmers scything, windswept cornfields and candlelit rooms. Kucia's works are often described as nostalgic, since they are an emotionally laden, idealized vision of Poland's singular rural culture, which is giving way to the European Union's norms of agricultural modernization.

In 2D animation, everything – including light and shadow – is drawn or painted; in puppet animation, by contrast, the sets and puppets are lit using lighting set-ups that are similar to those used in live-action film. As a consequence, puppet animation can expand our cinematic experience of light and shadow. In 2000, in collaboration with Karlheinz Stockhausen, the Brothers Quay made *In Absentia*, a film based on the avant-garde composer's *Zwei Paare* (Two Couples). The brothers have described some of the concepts and techniques behind the lighting for the film: 'Stockhausen's music felt as if it was saturated in electricity, and consequently we decided to give the film a very particular type of lighting, almost divine.'[16] While the brothers were shooting in their studio, an 'epiphany of light' occurred: they discovered unexpected brilliant, moving flashes of light on the animated sequences they had shot – beams of sunlight that had been caught on film and unknowingly animated while on their daily trajectories past the studio's windows. *In Absentia* makes dramatic use of this epiphany. In the film, a woman (based on Emma Hauck, and played by Marlene Kaminsky) sits at a desk and, in a microscopic script, writes dense, frenzied letters to a long-absent husband.[17] Shot in crisp black and white, streams of light, shafts, beams, bright spots and liquid incandescence move

through the puppet and full-scale sets, taking advantage of every opportunity to reflect off the many sheets and panes of glass. This brilliant, shattered world – the perceptual world of the protagonist – is interspersed with animated colour sequences of an unsettling, hooved, insect-like figure, a visual depiction of the beast of imagination that haunts her. The merging of scintillating animated sunlight with Stockhausen's intense electronic score creates a compelling cinematic environment suggestive of Hauck's tortured inner world. *In Absentia* is a wonderful example of how animation can present us with visual interpretations of subjective experience – in this case, psychosis – that are rarely equivalently possible in live-action film.

In addition to being combined with animation, live-action film can be invaded with graphics, manipulated by digital technology or physically altered with holes and scratches. An exquisitely simple example of this is Kathy Joritz's *Negative Man* (1985). Working with a piece of found footage from the 1950s – an instructional film for social workers – Joritz used the 'scratch', or 'direct', method of animation, where a sharp object is used to remove the emulsion from a piece of film frame by frame. Using what I call 'visual portmanteau' and 'cinematic palimpsest',[18] Joritz rewrote the film text with a deconstructivist flair and punk aesthetic to create a hilarious, fast-paced critical commentary on what we would now regard as rather naïve psychology. Another widely used technique that draws on images from live-action film is rotoscoping, where selected outlines and elements from a piece of such film are traced on to either a blank film strip or a piece of tracing paper. Developed by Max and Dave Fleischer, this technique results in a series of images that, when projected, have an uncanny resemblance to human movement. The Fleischer brothers'

Out of the Inkwell animated films (1918–29) were some of the first – and remain some of the best – to use rotoscoping to blur the boundaries between nature and artifice, between indexical truth and animated fiction. *Out of the Inkwell: Modeling* (1921) melds elements of live-action footage with animation in two ways. First, in a series of animated single frames, Max Fleischer's hand inks Koko the Clown into life on a white page; the liquid, graceful movements of Koko skating are based on live-action sequences of Dave Fleischer. Secondly, Koko escapes from the graphic world to the real world of Max's studio, and in a self-reflexive *tour de force*, his hijinks interact with the world of objects and people, a 2D figure in a 3D world.

A contemporary, minimalist example of rotoscoping is kinetic sculptor and painter Robert Breer's *Fuji* (1974). During a railway journey in Japan, Breer filmed the famous mountain through the window of the moving train. He then rotoscoped minimal elements from the film – the other people in the carriage, the outline of the mountain, fragments of passing landscapes – while being careful to maintain his original, parallax view of the mountain, which, distant, stays in the centre of the image as the closer objects appear to move by 'more quickly'. Intercut with images taken from his imagination, including abstract shapes, figures and letters, and underlain with the rhythmic sounds of the train, this meditative film of subjective perception is a remarkable demonstration of how the mind's inner vision can wander. Recent developments in computer technology have allowed artists to merge the principles of rotoscoping with computer-based image manipulation. Rotoshop, for example, a piece of software developed by Bob Sabiston, has been used to great effect in Sabiston's own *Snack and Drink* (2000), and in Richard Linklater's films *Waking Life* (2001)

and *A Scanner Darkly* (2006). The grace and physicality of the humans in these works, which so far have been impossible to achieve in drawing or with motion capture, retain the uncanny effect of the earlier, traditionally rotoscoped films.

FROM TRICK HEROES TO ONES AND ZEROS

While it is still created frame by frame, much of animation is now 'born digital', and Vachel Lindsay's prescient comments made almost a century ago – about 'this kind of a thing', animation, being fundamental to the destinies of film – have been abundantly confirmed. A century on from Percy Smith's time-lapse revelations of blooming flowers, animation continues to provide us with unparalleled visualizations of science, nature and the built (and unbuilt) environment. In Semiconductor's *Matter in Motion* (2008), the artists explore the architecture of Milan on a molecular level. The film's title refers to seventeenth-century French philosopher René Descartes ('Give me matter and motion, and I will construct the universe'[19]), who posited that the mind was a non-material entity that could control the physical body ('I think, therefore I am'). The film's digitally animated sequences, which show the city trembling and dissolving, are based on the concept of entropy (defined by the second law of thermodynamics). Like the turbulent, ghostly forms of desert mirages, pointillist-like parts of Milan dissolve and reassemble, reminding us of the ephemerality of human creation compared to the durability of the Earth.

As CGI improves, its representations of worlds in narrative cinema are becoming more visually convincing, a far cry from the simple 'flying camera' roller-coaster effects of the 1980s. Steven Lisberger's dystopic, futurist *Tron* (1982) heralded the explosion in film of computer

games-based spatial aesthetics; almost thirty years later, James Cameron introduced another paradigm shift in visual effects with *Avatar* (2009). While much has been made of the aesthetic pleasures of the film's 3D world and its commercial success, on closer inspection it is a profoundly philosophical and political film that blurs the borders of myth and fiction with the highly topical themes of environmental science and rampant natural resources-based neocolonialism. Its imaginative, deeply detailed computer-generated depiction of flora and fauna on the planet Pandora – especially the human-like Na'vi synthespians – is so visually convincing that it has had a viral effect on the efforts of our own planet's indigenous peoples to defend their own threatened habitats. *Avatar* is a recent addition to an extensive lineage of animated films used for socio-cultural and political purposes, and the *Watch Me Move* exhibition features some of the best fine arts-based and digital examples of such films: *Who Framed Roger Rabbit* (1988; workers' rights), *Serious Games III: Immersion* (2009; war reportage), *Maus* (1986; anti-fascism), *Animal Farm* (1954; anti-Stalinism), *Snack and Drink* (disability), *Science Friction* (the Cold War) and *Waltz with Bashir* (2008; the Israel–Palestine conflict). These and other works of animated spatial politics ensure that we are able to experience visually what often goes unseen or undiscussed, or is marginalized or suppressed by dominant ideologies.

In the myriad films included in *Watch Me Move*, the animators' creative use of materials to conjure their animated worlds – whether paint, light, objects or digital ones and zeros – often results in visual metaphor. Erkki Huhtamo suggests that 'metaphors imply a transition, a "passage", from one realm to another, from the immediate physical reality of tangible objects and direct sensory data to somewhere else'.[20]

With regards to any of the films in the exhibition, the perceptual, emotional and cognitive transition from one realm to another requires a co-creative, complicit viewer. The 'something else' of animated worlds is often also deeply immersive; Oliver Grau points out that immersion is not a 'simple relationship of "either-or" between critical distance and immersion … in most cases immersion is mentally absorbing and a process, a change, a passage from one mental state to another. It is characterised by diminishing critical distance to what is shown and increasing emotional involvement in what is happening.'[21] This immersion, our perceptual transition from the phenomenal world to an animated realm, is central to how we understand what it is that we are seeing: things that we know cannot exist in the real world – the ghosts in the machine, the trick heroes, the digital ones and zeros – but which can move us to the very human reactions of laughter, astonishment, delight and joy.

SEGUNDO DE CHOMÓN

El hotel eléctrico, 1908

35mm, black and white, silent, 7 min.

Still taken from 35mm copy of film stored

at the Cinémathèque Française, Paris;

© 1908 Production Pathé

PATRICK BOKANOWSKI

La Plage, 1992

35mm, colour, sound, 14 min.

© Patrick Bokanowski and Light Cone

1 Donald Crafton, *Before Mickey: The Animated Film, 1898–1928*, Cambridge, Mass., and London (MIT Press) 1984, p. 60.

2 Vachel Lindsay, *The Art of the Moving Picture* [1915, rev. edn 1922], New York (Liveright) 1970.

3 Tom Gunning, 'To Scan a Ghost: The Ontology of Mediated Vision', *Grey Room*, no. 26, Winter 2007, p. 98.

4 Tom Gunning, 'The Cinema of Attraction: Early Film, Its Spectator, and the Avant-Garde', in *Film and Theory: An Anthology*, ed. Robert Stam and Toby Miller, Malden, Mass. (Blackwell) 2000, p. 231 (emphasis added).

5 'Absolute film' refers to a kind of abstract film-making that uses only cinematic arts-based media, *i.e.* graphics and painting. The first public screening of a film made in this way was at Berlin's UFA theatre on 3 May 1925.

6 Esther Leslie, *Hollywood Flatlands: Animation, Critical Theory and the Avant-Garde*, London and New York (Verso) 2002, p. 46.

7 José Ortega y Gasset, 'The Dehumanization of Art' [1925], in *The Dehumanization of Art and Other Essays on Art, Culture, and Literature*, Princeton, NJ (Princeton University Press) 1968.

8 Jean Mitry, *The Aesthetics and Psychology of the Cinema*, tr. Christopher King, Bloomington (Indiana University Press) 1997, p. 45 (emphasis in original).

9 Christine N. Brinckmann, *Die anthropomorphe Kamera und andere Schriften zur filmischen Narration*, Zurich (Chronos) 1997, p. 265 (author's translation).

10 Charles Francis Jenkins, *Animated Pictures* [1898], New York (Arno Press) 1970, p. 1.

11 Multiplane set-ups are distinct from the single-plane technique used in collage animation because they create the effect of depth in layered imagery. Different elements, including photorealistic space and shifting relational perspectives, are placed on separate layers of glass, which are then stacked vertically and separated from one another at varying distances.

12 Ed S. Tan, *Emotion and the Structure of Narrative Film: Film as an Emotion Machine*, tr. Barbara Fasting, Mahwah, NJ (Erlbaum) 1996, p. 2.

13 Daryl Chin, 'Down Memory Lane: Found Forms' [Stan Vanderbeek Retrospective, Anthology Film Archives, 1977], available online at guildgreyshkul.com/VanDerBeek/_PDF/ArtistInResidenceToTheWorldPDFLORES.pdf (accessed February 2011).

14 Stan Vanderbeek, 'RE: Vision', *The American Scholar*, 35, 1966, p. 337.

15 Stanley Cavell, *The World Viewed: Reflections on the Ontology of Film*, enlarged edn, Cambridge, Mass. (Harvard University Press) 1979, pp. 167–68.

16 Quoted in Roberto Aita, 'Brothers Quay: In Absentia', tr. Donato Totaro, *Off-Screen*, 2001, available online at horschamp.qc.ca/new_offscreen/quay.html (accessed February 2011).

17 Emma Hauck (1878–1928) was a German psychiatric patient. Diagnosed with dementia praecox, she was eventually committed to an asylum. Her letters can be found in the University of Heidelberg's Prinzhorn Collection, which consists of art made by psychiatric patients in the early twentieth century.

18 For an extended description of these terms, see Suzanne Buchan, 'Graphic and Literary Metamorphosis: Animation Technique and James Joyce's *Ulysses*', *Animation Journal*, 7, Autumn 1998, pp. 21–34.

19 Although this quotation is commonly attributed to Descartes, its actual provenance is uncertain.

20 Erkki Huhtamo, 'Encapsulated Bodies in Motion', in *Critical Issues in Electronic Media*, ed. Simon Penny, New York (State University of New York Press) 1995, p. 159.

21 Oliver Grau, *Virtual Art: From Illusion to Immersion*, Cambridge, Mass. (MIT Press) 2003, p. 13.

APPARITIONS

The origins of animation date back to the birth of visual representation. Christian Boltanski's shadow theatres (pages 42–43) are not animation in the conventional sense (moving images reproduced through photographic, film-related media), but they do evoke the primal, quivering essence of the animated figure: the cave drawing, the shadow puppet or the marionette, sequential illustrations aiming to give external shape to life in ways that illuminate our own. Traditional animation was born out of the scientific observations of human and animal locomotion made by the 'chronophotographers' Eadweard Muybridge and Étienne-Jules Marey at the end of the nineteenth century. Muybridge's method of breaking action down into individual frames allowed him to reassemble still images into life-like portrayals of movement, which he then took on the road as educational entertainment with his travelling zoopraxiscope (page 48), a device he invented to display moving images; Marey continued this work with the added innovation of sequencing the individual images on photographic film (page 47). Percy Smith was a pioneer of time-lapse photography, which had the reverse effect of speeding time up (page 58). These developments led to the creation of 'film time', effectively bringing the world into a single frame of capture, comprehension and communication.

Technological progress brought film from its observational origins into narrative formats, used to both objective and imaginary ends. Unseen realities, such as Smith's blossoming flowers, led to unfathomable fantasies, such as the Lumière brothers' dancing skeleton of 1897 (page 64). These films had traceable roots in the Victorian music hall, where the border between science and spectacle had always been blurred. Ub Iwerks's *The Skeleton Dance* of 1929 (page 65), the first of Walt Disney's highly imaginative *Silly Symphonies* series, shows how quickly animation developed in terms of technical possibility and narrative complexity. In *Gertie the Dinosaur* (1914; page 67), Winsor McCay used his pen to breathe life into a sketch of a long-extinct animal; the drawing coming to life – a frequent conceit in early cinema – retains its power for wonder and comedy, as seen in Zhou Xiaohu's short film *The Gooey Gentleman* (2002; page 51). Willis O'Brien, in *The Dinosaur and the Missing Link* of 1917 (page 66), initiated a long history of using special effects to recreate whole worlds of prehistory or mythology. Nearly eighty years later, Steven Spielberg's *Jurassic Park* (1993; pages 68–69) took up the theme, applying the nascent technologies of computer-generated imagery to bring denizens of different eras into imagined contact with one another. The ambition to give shape to the unknown and unseeable remains a central concern of animation today.

The animated film has given form to the hidden lives of mundane objects, ever present but overlooked. Cecil M. Hepworth's *Explosion of a Motor Car* (1900; page 59) turned a quotidian suburban scene into a comic tragedy, while Segundo de Chomón's *El hotel eléctrico* (1908; page 60) dramatically upped the stakes by depicting a hotel in which everything seems to move of its own accord. The Brothers Quay combined live-action and manipulated moving images in their film *In Absentia* (2000; page 71), in which a simple room becomes a site of psychic exploration, and even daylight appears to have purposeful agency. One of John Lasseter's earliest works, and Pixar Animation Studios' first production, *Luxo Jr.* (1986; page 65), attests to the abiding power of the apparition – the simple visual image laying claim to life and emotional resonance – just as the technology of film is beginning to cede to that of the computer.

CHRISTIAN BOLTANSKI

Théâtre d'ombres (Shadow
Theatre), 1986
Cardboard figurines, brass,
wire, projectors and ventilator
Dimensions variable
Courtesy of the artist and
Marian Goodman Gallery, Paris/
New York; © 2011 AGAGP, Paris,
and DACS, London

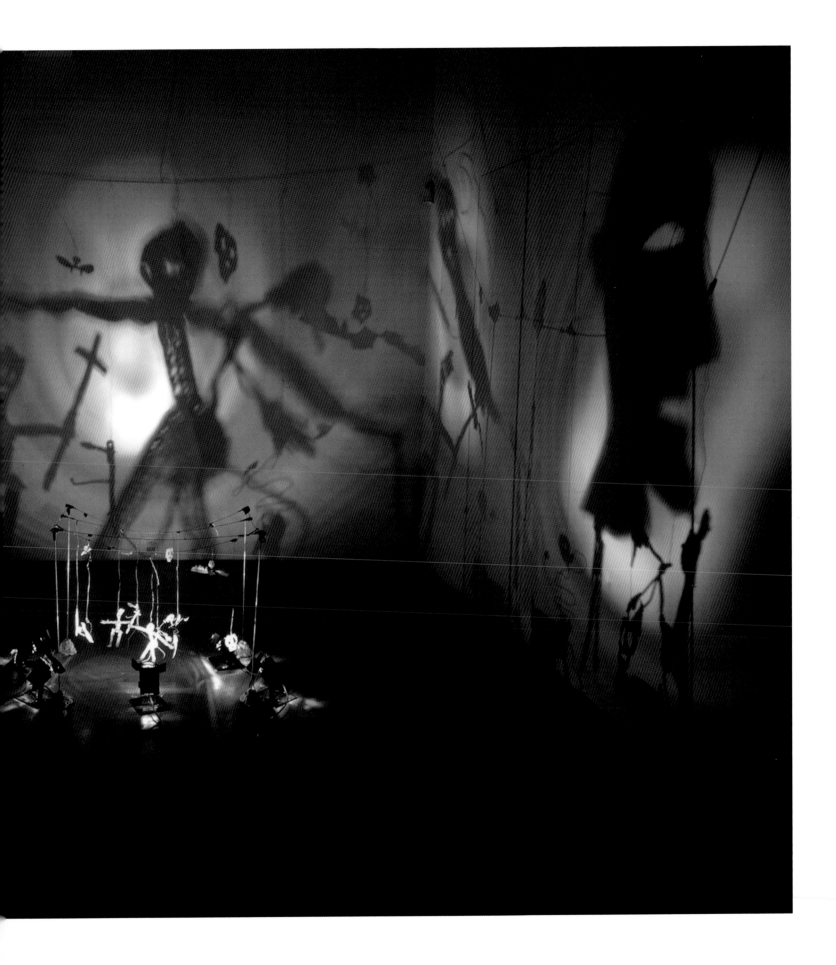

Zoetrope, c. 1860

© National Media Museum/SSPL

A zoetrope is a cylindrical device – featuring a number of vertical slits – in which paper bands showing a series of sequential images (see below) are placed. When viewed through the slits with the cylinder rotating, the images appear animated, giving an impression of continuous motion.

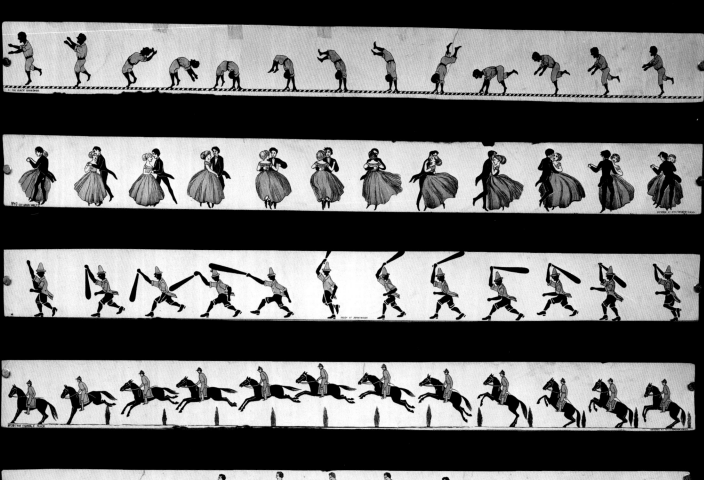

OPPOSITE

Original zoetrope picture bands, c. 1860s

© National Media Museum/SSPL

RIGHT

NEWTON & CO.

Winter Scene in the Mountains, c. 1880

Pair of hand-coloured dissolving

magic-lantern slides

© National Media Museum/SSPL

Such 'dissolving' slides as these were shown using
magic-lantern projectors with two or three lenses.
As one lens was covered, another was opened to
effect a transformation.

ÉTIENNE-JULES MAREY

Top: *Body Motions*, c. 1890; bottom: *Successive Positions of a Cat Turning on Itself Whilst Falling*, c. 1882–1900

Black-and-white chronophotographs

© Étienne-Jules Marey

ÉTIENNE-JULES MAREY

Model of a Zoetrope, 1886

© National Media Museum/SSPL

Alongside such pioneers of the moving image as Eadweard Muybridge, the self-styled 'chronophotographer' Étienne-Jules Marey is a key figure in the history of the medium. Straddling still photography and film, and dedicated to the representation of movement, Marey developed Muybridge's studies of human and animal locomotion by investigating the means not only of producing an image but also of reproducing it. His innovation was to replace the glass plate of photography with a strip of sensitized paper (later celluloid), which could reproduce the movement of the original subject. Crucially, by virtue of its transitional status – more than photography, but not quite film – Marey's work demonstrates not only the fundamental, 'atomic' principles of animation but also that the history of animation is the history of cinema; that 'film', as we understand it now, developed from animation, not the other way round.

Body Motions is a series of studies of human movement that illustrate the maturation of Marey's process. More importantly, perhaps, the manner in which they studied, recorded and reproduced movement paved the way for character animation, which depends on a knowledge of (human, animal) locomotion that had previously been difficult, if not impossible, to codify. Although ostensibly scientific – or at least taxonomic – in aim, the studies possess a gestural, poetic quality that arguably surpasses Muybridge's studies, and, in its formal concerns, was echoed in avant-garde film more than half a century later.

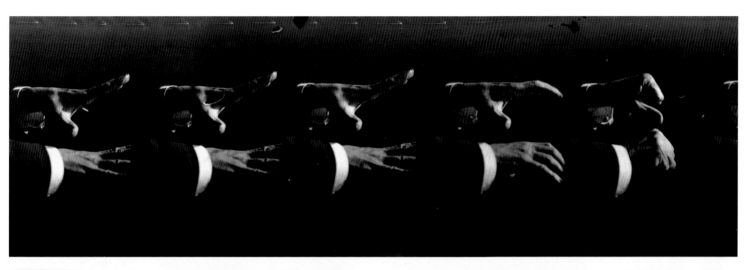

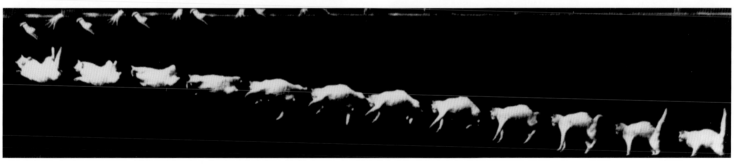

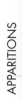

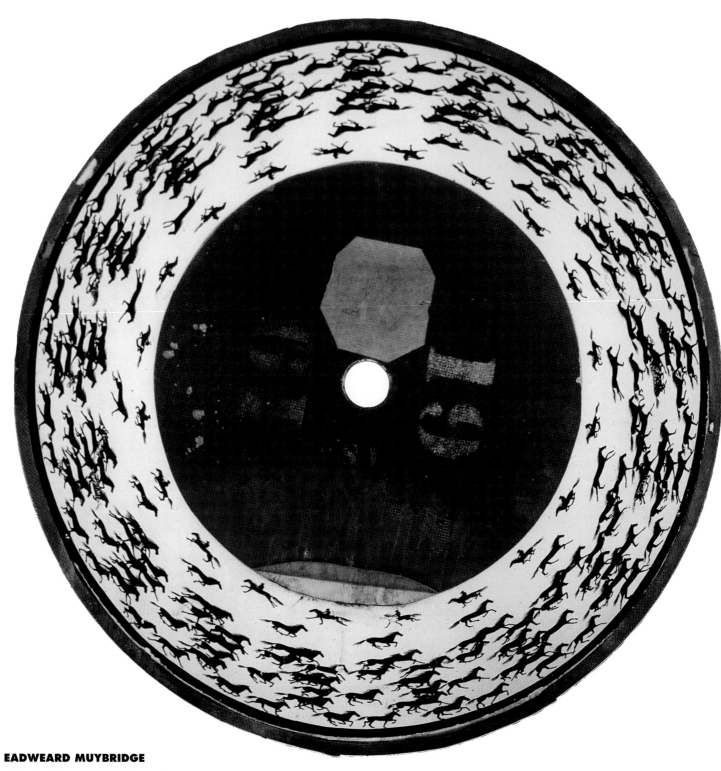

EADWEARD MUYBRIDGE

Galloping Horses, Multiple Phases, 1879

Zoopraxiscope disc; glass, paint

Kingston Museum and Heritage Service

EADWEARD MUYBRIDGE

Left: *Running Horses*, c. 1879;

right: *Pigeons in Flight*, c. 1879

Lantern slides; collodion positives on glass

Kingston Museum and Heritage Service

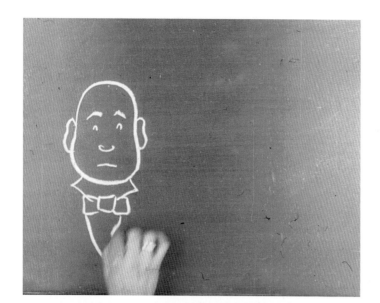

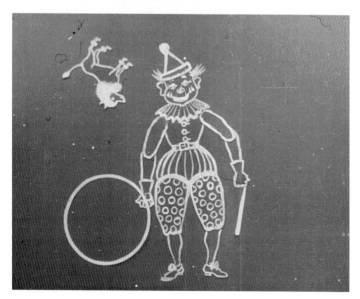

LEFT
J. STUART BLACKTON
Humorous Phases of Funny Faces, 1906
35mm, black and white, silent, 3 min.
Courtesy of the Motion Picture and Broadcasting Division
of the Library of Congress

OPPOSITE
ZHOU XIAOHU
The Gooey Gentleman, 2002
Single-channel video, colour, sound, 4 min., 40 sec.
Courtesy of Long March Space

WINSOR MCCAY

Little Nemo Moving Comics, 1911

35mm, hand-coloured, silent, 2 min., 18 sec.

Courtesy of Ray Pointer, Inkwell Images Inc.

MAX FLEISCHER

Out of the Inkwell: The Tantalizing Fly, 1919
35mm/16mm, black and white, silent,
3 min., 50 sec.
Courtesy of Ray Pointer, Inkwell Images Inc.

Max Fleischer is arguably the father of modern
character animation. His wide-ranging career,
much of which was spent working with his brother
Dave, encompassed such technical invention and
innovation as the rotoscope; a prolific and ever-
inventive artistic output, including the creation of
several characters that are now household names;
and the establishment of not only many of the
conventions of 'modern' animation but also the
link with the studio system. Fleischer's intuitive
understanding of his medium, his virtuosic
technique and – at least early on, before the limiting
effects of the studio and the state censor were
applied – his surreal, wry and often racy sense of
humour set him apart from many of those who
succeeded him.

 Out of the Inkwell (1918–29), an early
animated series of the silent era, allowed Fleischer
not only to introduce such characters as Koko the
Clown and Betty Boop, but also to present sketches
and experiments that developed his style and
technique. Two episodes in particular, *Modeling*
(page 35) and *The Tantalizing Fly*, illustrate
Fleischer's maverick mix of live action and animation,
which, thanks to the use of the rotoscope, brought
a fluidity and believability to films that, to this
day, remain technically impressive. They also
further illustrate the sense of experimentation
that accompanied early silent film-making.

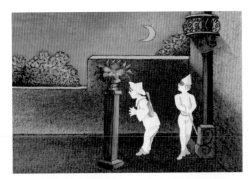

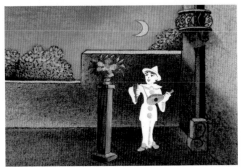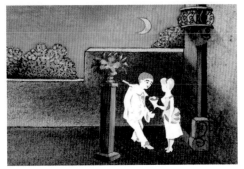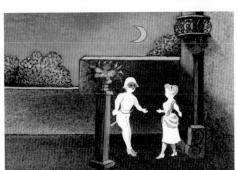

CHARLES-ÉMILE REYNAUD

Pauvre Pierrot, 1892

65 × 65mm, hand-coloured, sound, 6 min.

© CNAM/Restauration CNC AFF; Julien Pappé,

Magic Film Productions

ÉMILE COHL

Fantasmagorie, 1908

35mm, black and white, silent, 1 min., 18 sec.

© Lobster Films Collection

PERCY SMITH

The Birth of a Flower, 1910
35mm, black and white, silent, 6 min.
BFI National Archive

Early endeavours in the nascent moving-image medium were invariably of a scientific nature. This was no doubt partly driven by an urge to record – for the first time – the unseen, as in the case of Eadweard Muybridge's studies of the then-contentious subject of horse locomotion. However, it must also be understood in the context of photography, from whence the innovators in moving images had sprung, and which had always been seen as a science first and an art later.

The English film-maker Percy Smith focused on processes in nature, developing early time-lapse techniques that enabled him to achieve the opposite of Muybridge's and Étienne-Jules Marey's split-second studies of motion; namely, the speeding-up of time. In this case, the 'birth' of a flower is captured in real time and re-presented as a fluid and realistic motion, conjuring a scene of magic and spectacle from something already in existence but invisible.

Whether stopping time or accelerating it, the techniques of early film-making demanded an intimate understanding of the structure of time itself, or at least the representation of it: although different in realization, both Smith's film and the studies of Muybridge and Marey originated with the single frame. In this way, the common thread that runs through many of the early experiments in film-making is the attempt to master time itself, with its capture, modification and reinterpretation standing as metaphors for the wider history of cinema – and, of course, animation.

CECIL M. HEPWORTH

Explosion of a Motor Car, 1900

35mm, black and white, silent, 1 min., 37 sec.

BFI National Archive

SEGUNDO DE CHOMÓN

El hotel eléctrico, 1908
35mm, black and white, silent, 7 min.
Still taken from 35mm copy of film stored at the
Cinémathèque Française, Paris; © 1908 Production Pathé

The Spanish film-maker Segundo de Chomón produced a varied body of work in the earliest days of cinema. His films are marked by a playfulness and sense of experimentation, which often saw him seamlessly incorporate animation techniques into ostensibly 'straight' live-action footage for entirely the same reason that sequences of computer-generated animation are now invisibly interwoven into an outwardly 'real' live-action film; that is, with the aim of suspending disbelief and making real the impossible. This alchemical process, still dewy from its association with the old-world magic of theatre, light, music – the magic of the illusion of movement – perhaps serves as a useful cipher for the wider mood at the dawn of cinema, in which the 'experimental' was the rule rather than the exception.

El hotel eléctrico presents an all-electric hotel, in which everything is automated; even the luggage makes its way across the floor and up the stairs unaided. Mischievous yet sophisticated, the film belies the sense not only that experimentation was central to early film-making practice but also that it was by no means

primitive. In so doing, it also undermines the conception that cinema has 'progressed' from its arrival in the late nineteenth century. Such early works as this are important and interesting in themselves, not merely as historical documents.

Most importantly, perhaps, *El hotel eléctrico* – like many of its contemporaries – portrays a moving image that is not divided and contained by notions of 'animation', 'live action' and so on. Rather, it is a true hybrid, in which divisions of discipline or technique are not important; a much richer idea of what 'animation' could be (have been) capable of. The parallels between this early thirst for experimentation and the moving-image practices of current artists are strong. Yet what was the height of popular culture at the time now operates on the fringes of a largely moribund popular moving image.

Although it is perhaps sobering to concede that any understanding of an 'evolution' of cinema through the twentieth century may be misguided, it is at once enlightening and a source of hope that the wild kernel of the moving image might yet be accessible, intact, in such early works as this.

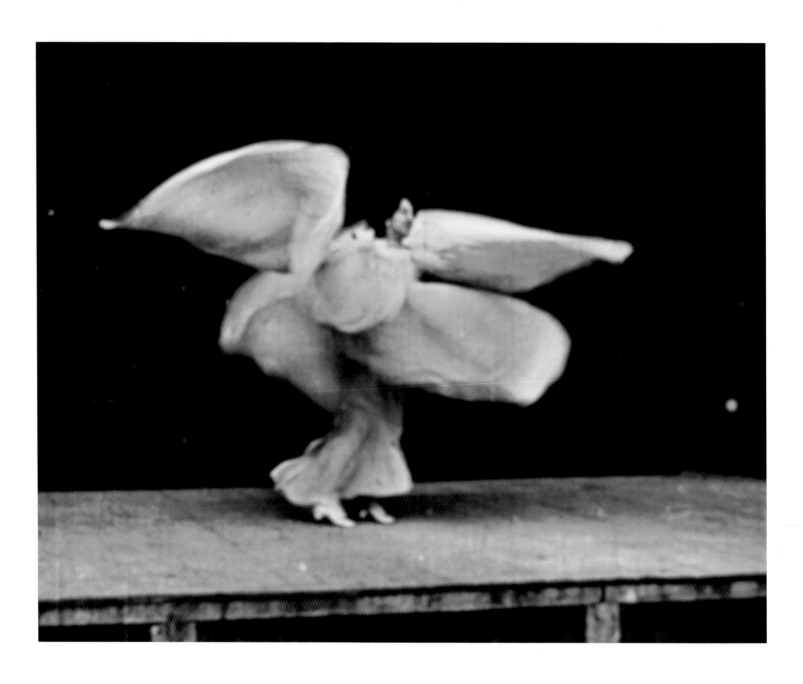

LUMIÈRE BROTHERS

Serpentine Dance (II), 1897–99

Produced by Lumière brothers; cameraman unknown

35mm, nitrate copy, hand-coloured black and white,

silent, 45 sec.

© Association Frères Lumière (Lumière Film No. 765-1)

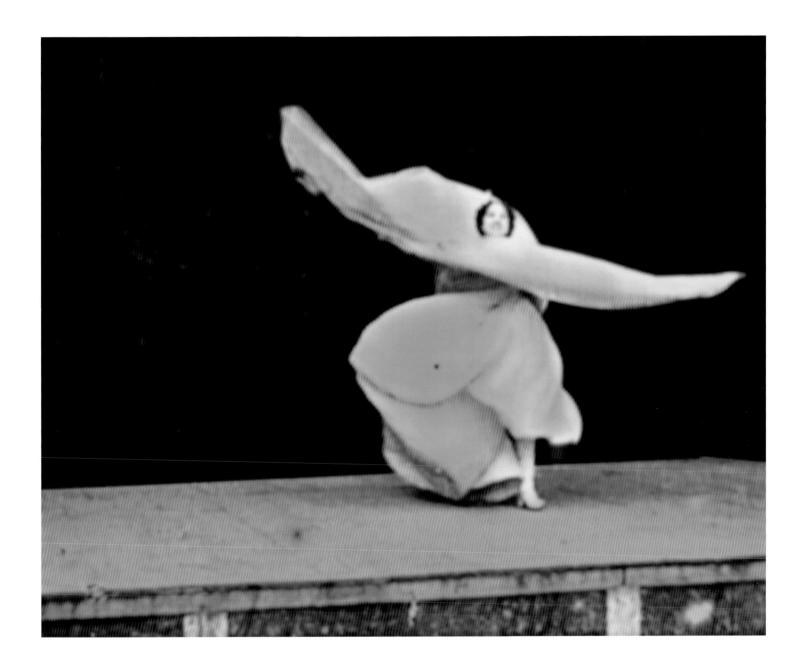

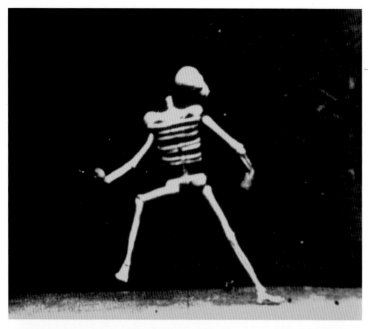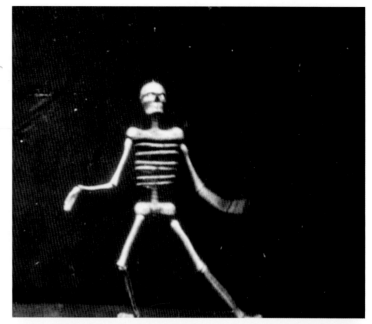

LUMIÈRE BROTHERS

Le Squelette joyeux, c. 1897–98

Produced by Lumière brothers; cameraman unknown

35mm, nitrate copy, black and white, silent, 33 sec.

© Association Frères Lumière (Lumière Film No. 831)

JOHN LASSETER/PIXAR

Luxo Jr., 1986

35mm, colour, sound, 2 min.

© 1986 Pixar

WALT DISNEY/UB IWERKS

Silly Symphonies: The Skeleton Dance, 1929

35mm, black and white, sound, 6 min.

© Disney

WILLIS O'BRIEN

The Dinosaur and the Missing Link:
A Prehistoric Tragedy, 1917
16mm, black and white, silent, 8 min., 45 sec.
Courtesy of the Motion Picture and Broadcasting Division
of the Library of Congress

WINSOR MCCAY

Gertie the Dinosaur, 1914

35mm, black and white, silent, 5 min., 38 sec.

Courtesy of Ray Pointer, Inkwell Images Inc.

PAGES 68–69

STEVEN SPIELBERG

Jurassic Park, 1993

35mm, colour, sound, 127 min.

Courtesy of Universal City Studios LLC

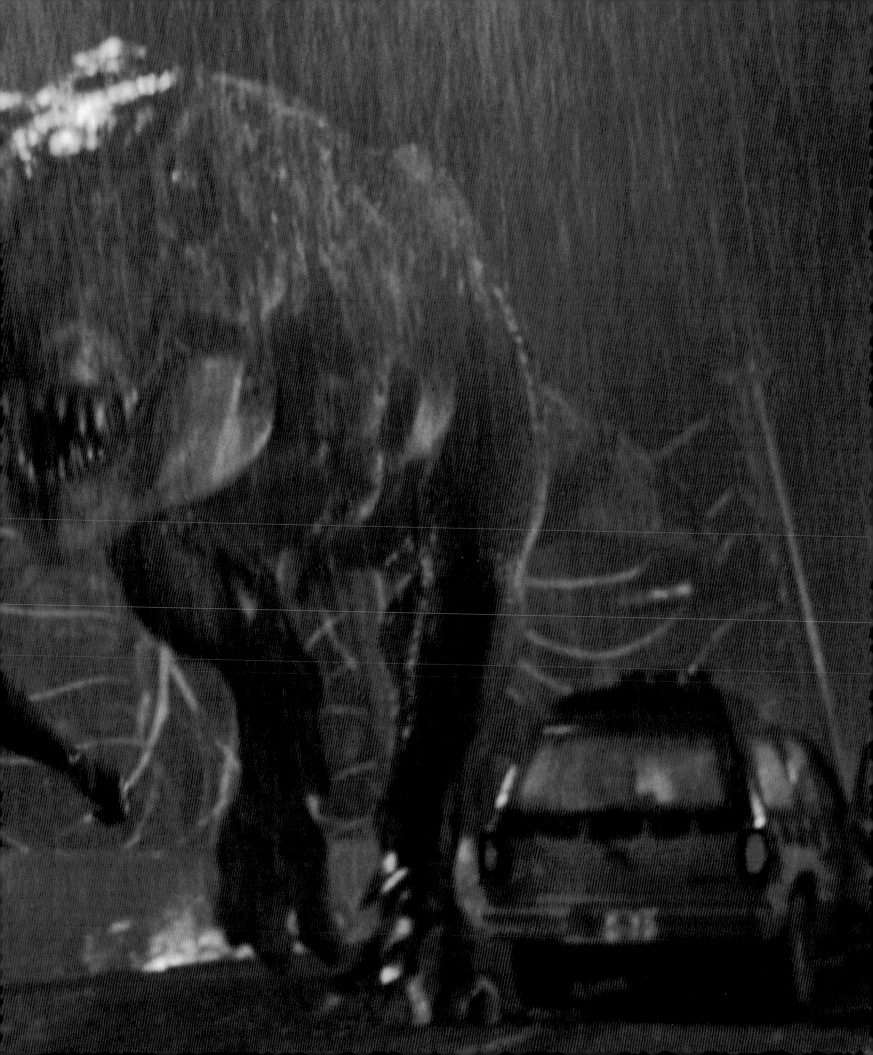

WILLIAM KENTRIDGE

Shadow Procession, 1999

35mm, colour, sound, 7 min.

Courtesy of the artist

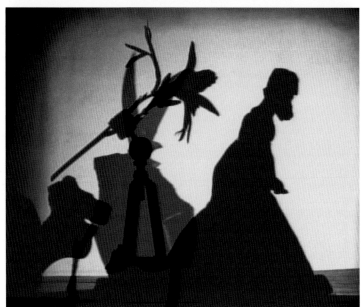

BROTHERS QUAY

In Absentia, 2000
35mm, black and white with colour, sound,
19 min.
BFI National Archive

A miasmal, chiaroscuro half-world of memory, madness and obsession, *In Absentia* is arguably the Brothers Quay's finest work. Fragmentary, illusory and deliberately abstruse, the film summons the spectre of madness via gesture, repetition and transfiguration.

Light sweeps across a monochromatic tundra of smoke and mist, briefly inscribing enigmatic structures on the landscape before returning all to gloom. Through a blurred and weary eye, the form of a large building is described, its upper windows hanging open; and while the light continues to pass back and forth, now creeping, now flashing, so too does a pair of feet, dangling from a high balcony.

In the room behind the window, charcoal-stained, pupae-like fingers twitch and scuttle across a page, leaving feverish words behind them like a trail. Portentous images – a reversed clock face, the bristling legs of a monstrous insect, autokinetic objects that twist and scurry – join snatches of actions, a gestural taxonomy: the writer getting up, the neck lifting. The light reveals and takes away. And everywhere the sounds: modulated voices, rasps, shrieks, scrapes, laughter; the workings of a terrible machine, distant and close at the same time. Indeed, it is the Quays' use of Karlheinz Stockhausen's fractured, disjunctive *Zwei Paare* (Two Couples) as a soundtrack – or rather, the skill with which they use it as a source around which to choreograph the action – that, disorientating, alienating, seals the film's recondite world of memory, madness and obsession.

That *In Absentia* has a real subject is alluded to in a postscript, which dedicates the film to 'E.H.'. The E.H. in question, Emma Hauck, was admitted to a psychiatric clinic in Heidelberg in 1909, from where she would write, obsessively, to her long-since-departed husband, her letters lengthy and illegible.

CHARACCTERS

The 1930s witnessed a distinct shift from the diversity of early, experimental animation to a series of more standardized formats designed to attract larger and more loyal audiences. Key among these was the short film built around identifiable characters. Although Disney's *Silly Symphonies* had introduced Donald Duck and Pluto, the ensemble still reigned over the development of individuals. When United Artists became Disney's distributor in 1932, however, it insisted on an explicit link with Mickey Mouse, who had grown in popularity since his introduction in *Steamboat Willie* four years earlier (page 76). A similar story occurred with Max Fleischer's character Betty Boop (page 75), who first appeared in the *Talkartoons* series (1929–32). She shot to cartoon stardom in an intriguing evolution: from French poodle, she morphed into an all-too-human sex symbol before being adapted to suit tamer tastes after legal restrictions on sexual innuendo in film were introduced in 1934.

The format most suited to television series was the clearly delineated character with recognizable attributes and strong audience identification who is repeatedly introduced into new situations. Koko the Clown, Mickey Mouse, Felix the Cat (page 74), Tom and Jerry (page 78) and Bugs Bunny (page 79) all fall under this umbrella, together with a plethora of variations on the theme introduced in the affluent 1960s, such as Yogi Bear (page 79), the Flintstones (page 80) and the Jetsons (page 81). These were the cartoon equivalents of the stars of 'sitcom', entertaining audiences by reassuring them of their resilience and endless cheerfulness in the face of all kinds of trivial adversity. Their altogether more knowing progeny, the Simpsons (page 83) and the cast of *South Park* (page 85), not only introduced a reflexivity and social commentary to the format, but also allowed for the development of themes over time.

The second type of character to flourish in animation was the more sustained personality whose motivations could mature over the course of a longer film. Perhaps the first of these was Disney's Pinocchio, who appeared in the studio's second animated feature. *Pinocchio* (1940) utilized the familiar story of a puppet brought to life as a believable little boy – the archetype of the animated character. Half a century later, Pixar played the same trick on an expanded scale with the first of the *Toy Story* films (1995–2010; pages 87–89). The protagonist Woody is famed for his complexity, and the number of distinct facial movements he was programmed to make speaks to the technological innovations that were designed to satiate a new audience appetite for more astute virtual beings. The market for animation has traditionally been 'family', although there are notable exceptions: Ralph Bakshi, for example, has sought to use the potential of animation to develop works as uncompromising as any adult feature. His *Heavy Traffic* of 1973 takes a picaresque and unflinching look at 1970s urban culture through the lives of a set of supremely dysfunctional characters.

A third type of characterization – the in-depth single portrait – is less mainstream, by definition, but just as suited to the medium. Peter Lord pioneered this kind of portrayal in *Going Equipped* (1989; page 93), in which he used clay animation to give body to a young petty criminal, the man's actual recorded voice providing the narrative. Similar semi-documentary animations have been made by Tim Webb (page 92) and Bob Sabiston (page 94), whose collaboration with Richard Linklater resulted in *A Scanner Darkly* (2006). Lord also brought experimental animation into the mainstream as co-founder, with David Sproxton, of Aardman Animations. The company's short films, such as Nick Park's *Creature Comforts* (1989) and the subsequent television series of the same name (page 90), remain unmatched for their humour and humanity.

PAT SULLIVAN

Feline Follies, 1919

35mm, black and white, silent, 5 min., 39 sec.

Courtesy of Ray Pointer, Inkwell Images Inc.

MAX FLEISCHER

Betty Boop, 1932–39

Black-and-white animated television series

BFI National Archive

Both actress Clara Bow and singer Helen Kane have been cited as the inspiration for the character of Betty Boop – created by Dave Fleischer's brother Max – which resonated strongly with the 'flapper' culture of the day. The early episodes of the *Betty Boop* series, unhindered by the state censor (which, when it intervened, turned her from vamp to prude and toned down the wilder aspects of the series), see the character's overt sexuality paired with surreal and often nightmarish situations. As a consequence, the series contrasted sharply with other cartoons of the era, which, although they may have included fright, violence or threat, inevitably did so in a way that placed them very much more in the 'real' world.

In *Betty Boop: Ha! Ha! Ha!*, Fleischer follows a style developed in the Fleischer brothers' earlier series *Out of the Inkwell*. While Betty is located in an animated world on the page of Fleischer's drawing pad in his (real, live-action) studio, her sidekick, Koko the Clown, jumps from the (real) inkwell into the realm of the (animated) page. This duality – a key device in the earlier series – sees Betty creating a virtual world beyond the page using Fleischer's own pen, left behind at the start of the episode when he leaves his studio for the day. The slippage between the two worlds is exaggerated yet further when Betty and Koko get high on nitrous oxide and allow it to escape beyond the page to infect with hysterical laughter the whole of the (real) city – replete with anthropomorphized (in)animate objects – 'outside'. The scenes of drug-taking and mass mirth proved unpopular with the censor, however, and the episode was reportedly banned in 1934 for its depiction of drug use.

BETTY BOOP. Paramount.

WALT DISNEY/UB IWERKS

Steamboat Willie, 1928

35mm, black and white, sound, 8 min.

© Disney

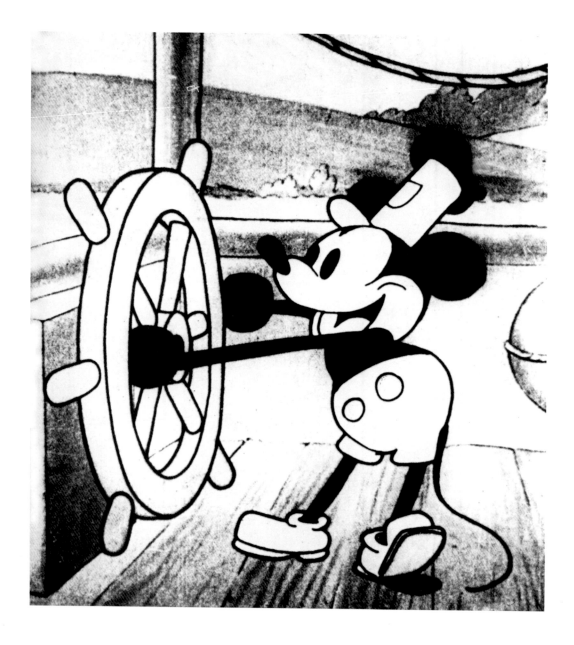

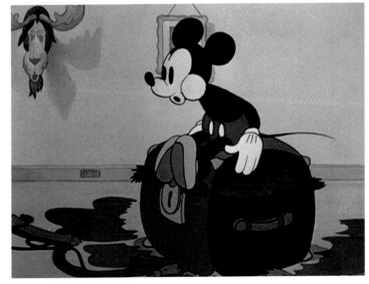

WALT DISNEY

Moving Day, 1936

35mm, colour, sound, 9 min., 25 sec.

© Disney

WILLIAM HANNA AND JOSEPH BARBERA

Tom and Jerry: Mouse Trouble, 1944
35mm, colour, sound, 7 min., 25 sec.

William Hanna and Joseph Barbera met in 1937,
still young men but already with considerable
experience of a variety of animation studios. They
made their first cartoon together, *Puss Gets the
Boot*, in 1940: its lead characters were a cat named
Jasper and a mouse named Jerry. Quickly renamed
Tom and Jerry, the duo became a staple of MGM
Studios, appearing in a total of 114 short films
between 1940 and 1958.

The long-running and perennially popular
Tom and Jerry series focused on the unending
animosity between a cat and a mouse. Despite this
utterly simple premise – each episode was essentially
a variation on the same theme – the series went on
to win seven Academy Awards, and to be screened
on television worldwide. *Mouse Trouble*, like most
episodes, centres on Tom's attempts to catch Jerry,
his huge arsenal of weaponry and traps foiled by his
own all-too-human clumsiness and Jerry's uncanny
cleverness. The series has remained a cultural icon,
even to the extent of being parodied in 'Itchy and
Scratchy' in *The Simpsons*. Its attraction lies both in
the powerful characterization of the lead characters
(all the more compelling for the carefully delimited
stage on which they played) and in the surreally
violent and fast-paced slapstick of their beautifully
choreographed interaction.

Hanna and Barbera worked together on
Tom and Jerry for almost twenty years before the
MGM animation studio was closed down in 1957.
The two men then founded their own company,
Hanna-Barbera Productions, producing such well-
known animated television series as *The Flintstones*,
The Jetsons and *Scooby-Doo*. The *Tom and Jerry*
franchise was subsequently revived twice – first by
MGM, which commissioned Czech animator Gene
Deitch to produce thirteen episodes between 1960
and 1962, and secondly, from 1963 to 1967, by
Chuck Jones – each time with notable changes to
both style and content.

WILLIAM HANNA AND JOSEPH BARBERA

The Yogi Bear Show, 1961–88

Animated television series

The Yogi Bear Show TM and © Hanna-Barbera.

DARRELL VAN CITTERS/WARNER BROS.

Bugs Bunny: Box-Office Bunny, 1990

35mm, colour, sound, 5 min.

Looney Tunes TM and © Warner Bros. Entertainment Inc.

WILLIAM HANNA AND JOSEPH BARBERA

The Flintstones, 1960–66

Animated television series

The Flintstones TM and © Hanna-Barbera. All rights reserved

With their unique brand of clean, family entertainment, Hanna-Barbera's many television series almost single-handedly created a mirror image of Middle America in their depiction of happy nuclear families, tame bears and, in the case of *The Jetsons*, space-age conquistadors.

Together with their neighbours the Rubbles, the Flintstones live in the prehistoric town of Bedrock, where they enjoy the same inventions and commodities as we might, except that, in the absence of electricity, such items are powered by all manner of mechanical contraptions. The series, airing as it did in the technology-hungry, space-obsessed 1960s, is essentially an extended riff on the juxtaposition of prehistoric man with modern tools, the abiding message being that civilization is absolute and inevitable, and that the modern is the ideal to which we have, as a species, been collectively aspiring.

Although by the 1960s television was clearly the dominant outlet for animation, the conditions of production meant that animation made for television was almost entirely different in form compared to animation produced for the cinema. While a seven-minute short for MGM might have a budget of $50,000, Screen Gems, Columbia Pictures' television subsidiary, would offer $2700 for a short of equivalent length. 'Limited animation' was the result, and in such series as *The Flintstones* poses were held for as long as possible to avoid costly animated movement. However, although the animation was not as sophisticated as in the theatrical era, the quality of the programmes was heightened by the introduction of experienced television scriptwriters and the 'appearance' of celebrity guests – Tony Curtis and Ann-Margret Olsson among them – a concept first used on *The Flintstones*.

WILLIAM HANNA AND JOSEPH BARBERA

The Jetsons: The Movie, 1990

35mm, colour, sound, 82 min.

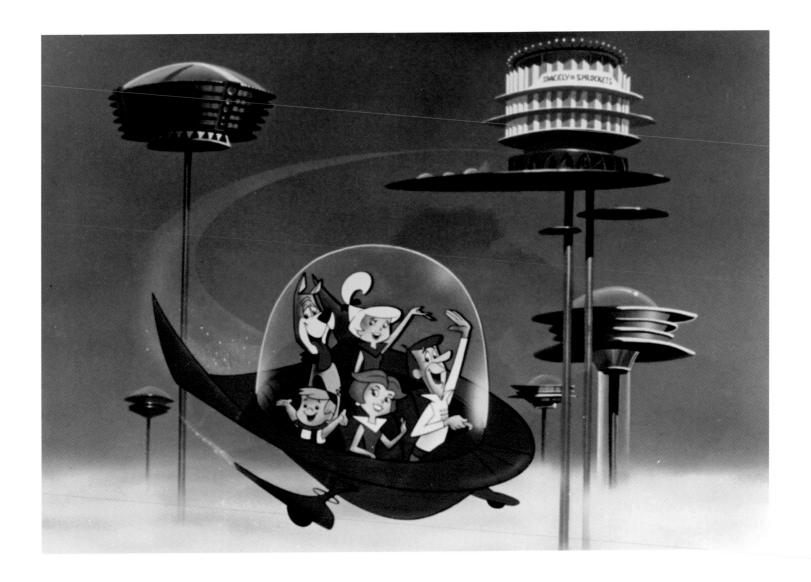

RALPH BAKSHI

Coonskin, 1975

35mm, colour, sound, 100 min.

Courtesy of the artist

MATT GROENING

The Simpsons, 1989–

Animated television series

The Simpsons © 1990 20th Century Fox Television.

The perennially popular television series *The Simpsons* has come to be defined by, and has helped to define, contemporary popular culture. Unusually for an animated series, it has achieved a currency beyond its immediate environment: rather than being relegated to the realm of television entertainment alone, it has seen its wry and well-scripted commentary on life in Anywheresville ignite widespread debate about contemporary US society. While its detractors might argue that its depiction of Middle America is unreservedly unflattering, the outlandish argument proposed by right-wing commentators – that it is contributing to social decay – betrays a nostalgic, deeply conservative philosophy hopelessly out of touch with the US public, neatly summarized by former president George Bush Snr's aspiration 'to keep trying to strengthen the American family. To make them more like the Waltons and less like the Simpsons.' Without doubt, *The Simpsons* offers an entirely more realistic portrayal of Middle America than the wholesome, apolitical version presented by the likes of *The Waltons*. But to read it as a cynical attack on 'American values' fails spectacularly to understand the series, suffused as it is with affection and no small respect for its characters.

The series has enjoyed a prolific and unbroken career on the Fox television network, ironically a notoriously conservative US media conglomerate (and the target of minor but persistent jibes in the show itself). While any number of episodes could be regarded as representative of the series as a whole, *El Viaje Misterioso de Nuestro Jomer* (5 January 1997), which sees Homer take off on a psychedelic trip after eating the world's strongest chilli pepper, certainly crystallizes the series' main themes: the dysfunctional but paradoxically tight-knit family; the anti-hero; and the journey of self-improvement thwarted by the deadly alliance of the vicissitudes of real life and personal, and therefore human, fallibility. The series' astute commentary and referential humour reach beyond its own universe, offering socio-political comment, gently chiding Middle America and questioning the American ideal while remaining firmly American: it is the United States as its own psychotherapist.

CHARACTERS

MATT GROENING/SUSIE DIETTER

Futurama: A Big Piece of Garbage, 1999

35mm, colour, sound, 30 min.

Futurama © 1999 20th Century Fox Television.

TREY PARKER

South Park: Bigger, Longer & Uncut, 1999

35mm, colour, sound, 78 min.

© Warner Bros.

CHARACTERS

LEFT

ROBERT ZEMECKIS/RICHARD WILLIAMS

Who Framed Roger Rabbit, 1988

35mm, colour, sound, 104 min.

© Touchstone Pictures and Amblin Entertainment Inc.

OPPOSITE AND PAGE 88

LEE UNKRICH AND JOHN LASSETER

Toy Story 3, 2010

35mm, colour, sound, 103 min.

© 2010 Disney/Pixar

ABOVE

BUD LUCKEY AND RALPH EGGLESTON

Drawing for Woody from *Toy Story*, 1995

Pencil, ink, silver pen and correction fluid

© Disney/Pixar

ABOVE, RIGHT

JILL CULTON

Drawing for Jessie from *Toy Story 2*, 1999

Pencil

© Disney/Pixar

RIGHT

BUD LUCKEY

Cast for Woody from *Toy Story*, 1995

Urethane resin

© Disney/Pixar

FAR RIGHT

JEROME RANFT AND STEVE MCGRATH

Cast for Jessie from *Toy Story 2*, 1999

Urethane resin

© Disney/Pixar

NICK PARK

Creature Comforts: The Circus, 2003

35mm, colour, sound, 3 min.

Creature Comforts Series 1 © 2003 Aardman Animations

NICK PARK AND STEVE BOX

*Wallace & Gromit in The Curse of
the Were-Rabbit*, 2005

35mm, colour, sound, 85 min.

Wallace & Gromit Curse of the Were-Rabbit © 2005

Aardman Animations Ltd

TIM WEBB

A is for Autism, 1992

16mm, colour, sound, 11 min.

Courtesy of Tim Webb, Dick Arnall and Channel 4 Television

Corporation; © 1992 Channel 4

PETER LORD

Going Equipped, 1989

35mm, colour, sound, 5 min., 8 sec.

Going Equipped © 1989 Aardman Animations Ltd

BOB SABISTON

Snack and Drink, 2000

Rotoshop, colour, sound, 4 min.

Courtesy of Flat Black Films

JULIAN OPIE

Jennifer Walking, 2010

LED screen

© Julian Opie; courtesy Lisson Gallery

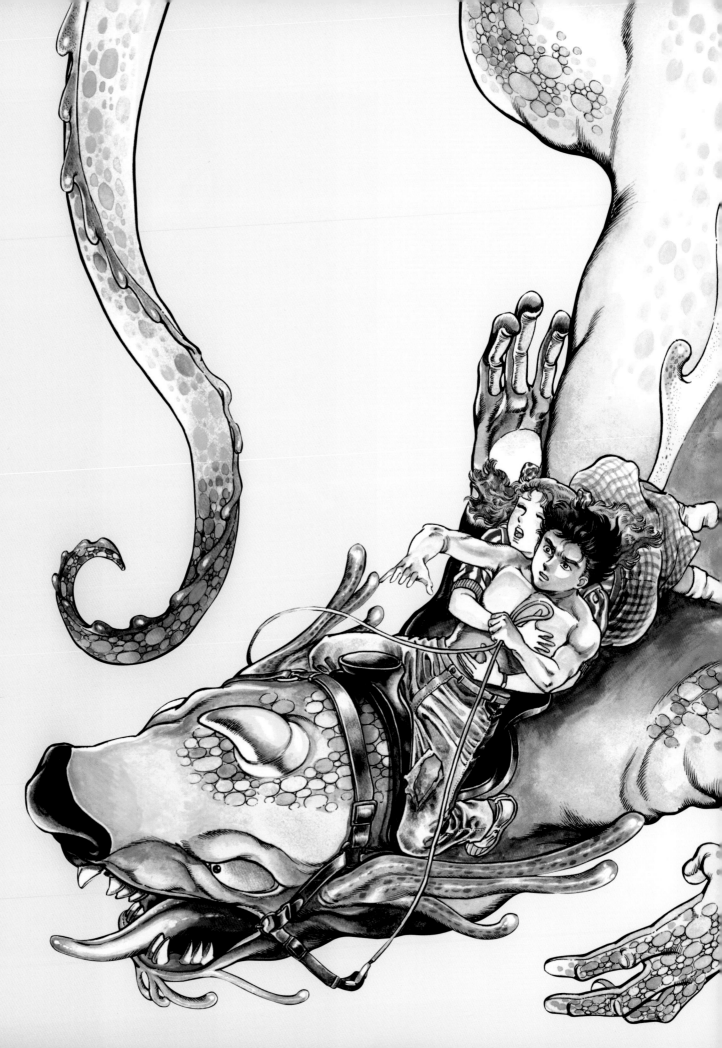

SUPERHUMANS

Characters with extraordinary powers are a staple of post-war animation: Marvel and DC Comics elaborated an initial line-up, while a parallel, more diverse roll-call was generated by the Japanese manga and anime industries. These 'superhumans' have tended to be all-too-ordinary humans who have been possessed or traumatized in some way, and thereby drawn beyond the realm of normal experience. In Ralph Bakshi's ambitious feature *Hey Good Lookin'* (1982; page 114), the character of Crazy hallucinates himself into an orgy of violence and sex that includes a rooftop shooting spree; Popeye eats spinach to become supernaturally strong (page 98); and both Spiderman and the Hulk (pages 118–19) are ordinary young men whose bodies have been chemically altered, giving them remarkable strength coupled with a profound sense of alienation. Jake Sully, the lead character in James Cameron's *Avatar* (2009), is also a victim of external agency, in this case a combination of scientific obsession and corporate greed. Unusually for the genre, Sully physically and psychologically morphs into his avatar form.

For all their iconic brilliance, American superheroes struggle to compete with their Japanese counterparts, in terms of variety, psychological depth and formal imagination. Astro Boy (page 99), created as a manga character in 1952 by the legendary Osamu Tezuka, was one of the first, and he retains his heroic status. His story tells of how the head of the Ministry of Science made a robot boy to replace his son, Tobio, or 'Toby', who had died in a car accident. One remarkable episode from the television series of 1980, 'The Liar Robot', presents an alter ego to Astro Boy who wreaks havoc by perpetually lying. It transpires that he is not evil, as originally supposed, but has been programmed never to tell hurtful truths. Two other series – *Tiger Mask* (1969–71) and *Saint Seiya* (1986–89; pages 102–103) – bear revealing similarities: the protagonists of both shows are orphans, Tiger Mask having been brought up within a criminal wrestling fraternity, and Saint Seiya having been shipped off to Greece from Japan to become one of a group of saints in the service of the goddess Athena. Both characters are outsiders, given status in exchange for their loyalty to a tightly knit community.

The global appeal of such figures is remarkable. Japanese anime has gained enormous popularity right across continental Europe and South America, despite its unwavering cultural specificity. The longevity of the superheroes of the West is also notable. The Hulk, for example, first appeared in comic form in 1962, the product of the paranoid admiration that surrounded scientific research in the dark days of the Cold War. His co-creator, Stan Lee, also associated him with Frankenstein's monster and the golem of Jewish mythology. The character has been powerful enough to appear in comics, several cartoon and live-action television series, and, in 2003 and 2008, two feature films (directed by Ang Lee and Louis Leterrier, respectively).

Hayao Miyazaki's *Princess Mononoke* (1997; pages 110–11) demonstrates adeptly the breadth of motives that characterizes the wider phenomenon of the superhuman in animation. Ashitaka has been possessed by an evil spirit for killing a giant boar, giving him superhuman strength that destines him to death. San, or Princess Mononoke, is a human girl who has been adopted by wolves, and shares many of their qualities. Finally, Lady Eboshi, the ruler of Iron Town, is possessed of such self-assurance and will that she is prepared to bring destruction on the whole world, including her own people.

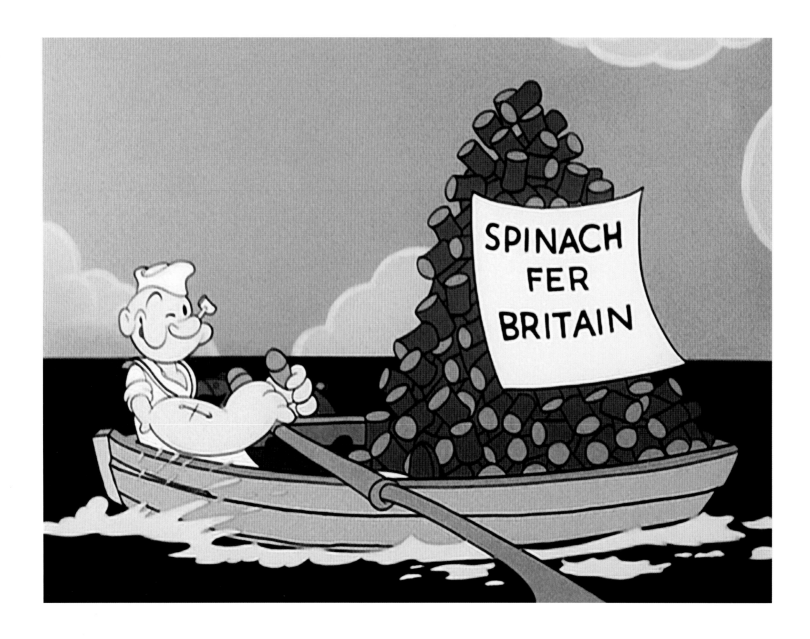

DAVE FLEISCHER

Spinach Fer Britain, 1943

35mm, black and white, sound, 6 min.

OSAMU TEZUKA

Top: *Astro Boy: Big Titan*, 1964; bottom:
Astro Boy: Super Human Beings, 1965
Both 35mm, black and white, sound, 24 min.
© Tezuka Productions, Mushi Production

In 1963, having made his first appearance eleven years earlier in a manga, Osamu Tezuka's Astro Boy (originally Tetsuwan Atomu, or 'Iron Arm Atom') became the star of an animated television series. The first anime to be broadcast outside Japan, and lasting for 193 episodes, it proved its enduring appeal in remakes of the 1980s and early 2000s before being adapted into a full-length CGI feature in 2009.

Astro Boy's status as a 'boy robot' enabled his character, in both manga and animated form, strongly to reflect the key themes of Japan's post-war recovery and its move towards economic stability and growth by the end of the 1960s. Astro Boy embodies progressive technology, increasing industrialization and urbanization, and emergent tensions with the natural environment and ancient orders steeped in spiritual and philosophical meaning. He also toys with such generic influences as Frankenstein's monster, Pinocchio and Superman, successfully combining the pathos of his social and cultural alienation with his inherent moral fortitude in saving the world from seemingly imminent disaster. Indeed, Astro Boy's desire to love and be loved marks him out from the tradition of Japanese 'mecha' that followed, most robots of this tradition being merely veiled metaphors for the legacy of the atomic bomb, militarist agendas and apocalyptic anxiety.

Astro Boy became very popular in the United States, constantly balancing the sentiment and slapstick that resulted from a 'boy' untutored in everyday life with the spectacle resulting from his laser weaponry and rocket flight. His creation – a research scientist's response to the grief caused by the death of his son in a traffic accident – echoes the core theme of much contemporary anime: the seemingly contradictory search for emotional comfort and progress in technology as a substitute for the spiritual loss felt at Hiroshima and Nagasaki.

TOEI ANIMATION

Sailor Moon series, 1992–97

Based on the manga *Sailor Moon* by Naoko Takeuchi

Memories of Bunny and Mamoru, Episode 35, 1992

16mm, colour, sound, 24 min.

© Naoko Takeuchi/PNP, Toei Animation

TOEI ANIMATION

Sailor Moon series, 1992–97

Based on the manga *Sailor Moon* by Naoko Takeuchi

Bunny's Wish Forever: A New Life, Episode 46, 1993

16mm, colour, sound, 24 min.

© Naoko Takeuchi/PNP, Toei Animation

BANDAI, JAPAN

Toys based on animated television series *Saint Seiya: The Hades Chapter – Sanctuary*, Toei Animation, 2002

Left to right: Pegasus Seiya (2005), Phoenix Ikki (2007), Andromeda Shun (2006), Cygnus Hyoga (2006)

Die-cast metal and plastic

Courtesy of Fabrizio Modina

LEFT

POPY, JAPAN

Voltes V toy based on animated television series
Chodenji Machine Voltes V, Nippon Sunrise for
Toei Animation, 1977–78
Die-cast metal and plastic
Courtesy of Fabrizio Modina

OPPOSITE

POPY, JAPAN

Mazinger Z toy based on animated television
series *Mazinger Z*, Toei Animation, 1972–74
Plastic
Courtesy of Grimaldi Forum Monaco

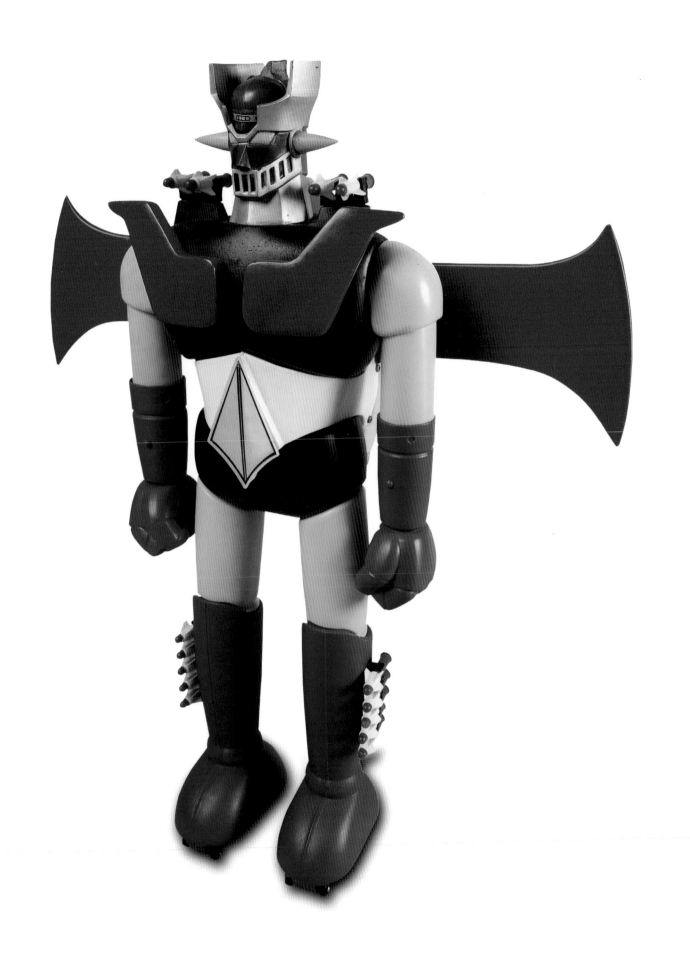

KATSUHIRO OTOMO

Akira, 1988

35mm, colour, sound, 124 min.

MAMORU OSHII

Ghost in the Shell, 1995

35mm, colour, sound, 85 min.

© 1995–2008 Shirow/Masamune/Kodansha, Bandai Visual,

Manga Entertainment. All rights reserved

HAYAO MIYAZAKI/STUDIO GHIBLI

Princess Mononoke (Mononoke Hime), 1997

35mm, colour, sound, 133 min.

© 1997 Nibariki – GND

BRAD BIRD/PIXAR

The Incredibles, 2004

35mm, colour, sound, 115 min.

© 2004 Disney/Pixar

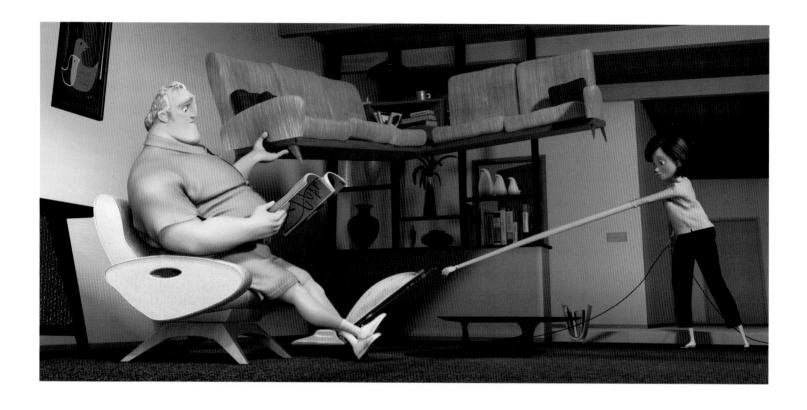

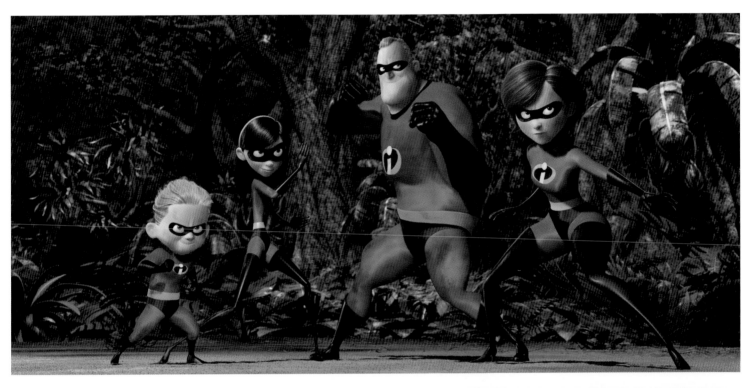

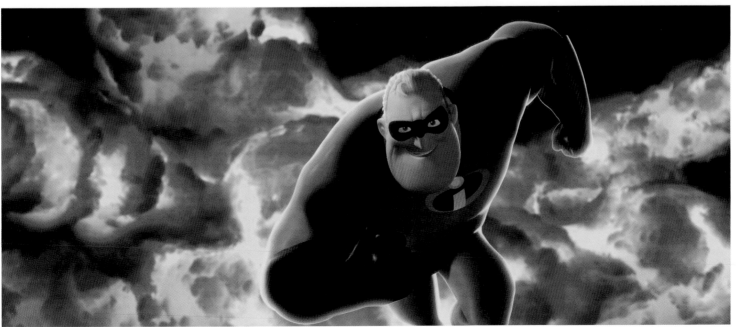

RALPH BAKSHI

Hey Good Lookin', 1982

35mm, colour, sound, 76 min.

Courtesy of the artist

HIDEKI TAKAYAMA/TOSHIO MAEDA

Urotsukidōji: Legend of the Overfiend, 1989

35mm, colour, sound, 146 min. (uncut version)

Courtesy of Manga Entertainment

RALPH BAKSHI

The Lord of the Rings, 1978

35mm, colour, sound, 132 min.

Courtesy of the artist

PETER JACKSON/WETA DIGITAL

The Lord of the Rings: The Return of the King, 2003

35mm, colour, sound, 201 min.

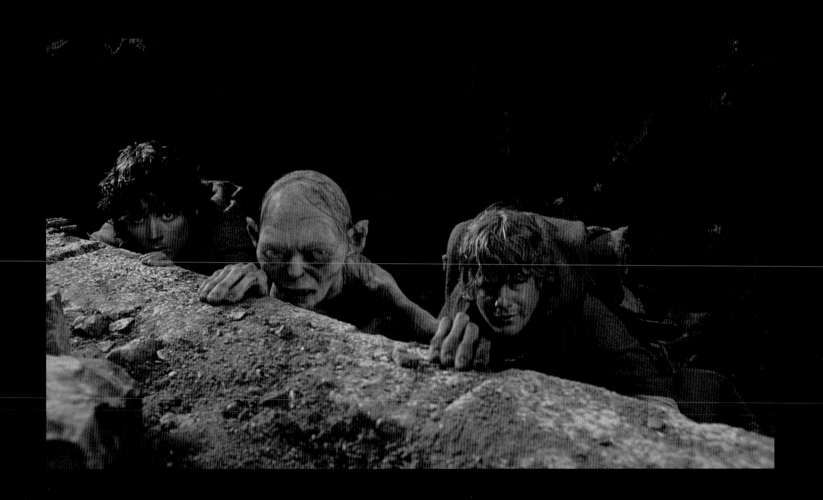

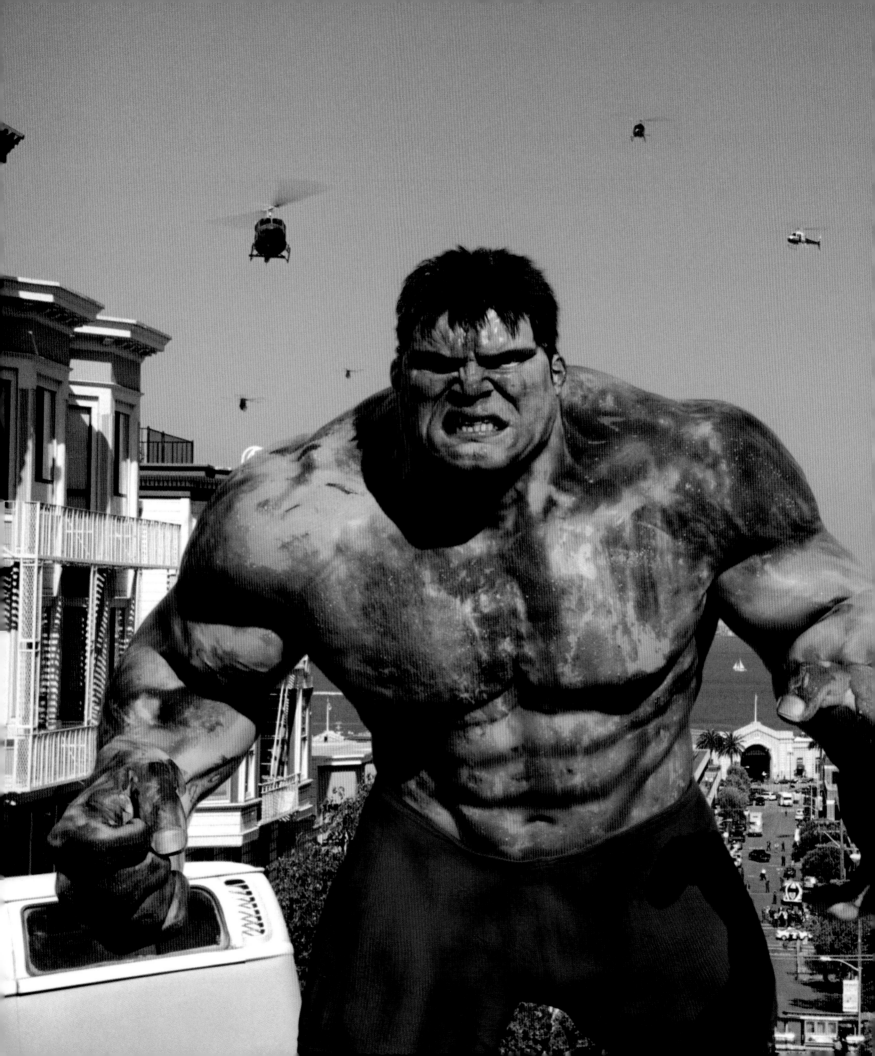

ANG LEE

Hulk, 2003

35mm, colour, sound, 138 min.

Courtesy of Universal City Studios LLC

Created in 1962 by the Marvel-comics team of writer Stan Lee and artist Jack Kirby, the Hulk has become one of the Marvel universe's most enduring figures. Physicist and researcher Bruce Banner, caught in the blast of his own gamma bomb, mutates into a green, marauding behemoth, and ultimately becomes a victim of his own anger, unable to control his transformations. Lee sought to combine Frankenstein's monster and Dr Jekyll and Mr Hyde – characters from his favourite horror narratives – in one figure, looking to create the first sympathetic 'monster' as superhero. The Hulk is an innocent victim, almost pre-human in development. There is something of the pre-socialized child about him; he is inchoate anger writ large, railing against a world he does not understand but by which he is constantly provoked. Crucially, the Hulk thus becomes a ready metaphor for repressed American emotion and deep-rooted anxiety about faith in technological progress.

Ang Lee, previously known for *Crouching Tiger, Hidden Dragon* (2000) and his interest in depicting complex intimate relationships, saw *Hulk* as an opportunity to explore a tension in his own Asian-American identity; namely, the passive-aggressive mindset that comes from pursuing a career in the arts, often in opposition to parents who would prefer a commitment to a more socially respectable and useful profession. At one level, Lee wanted to ground the Hulk's anger in Banner's relationship with his father; at another, he wanted to connect the Hulk's genetic flux to the organic and molecular shifts in the natural world. Lee's approach inevitably extends the idea of the Hulk as both a troubled, unfulfilled soul and an undirected life force. Arguably, however, this idea becomes difficult to represent in either the human guise of Banner or the over-elastic propensities of the Hulk figure, although it is at least legitimized in Lee's use of the framing and composition conventions of the comic book.

FABLES

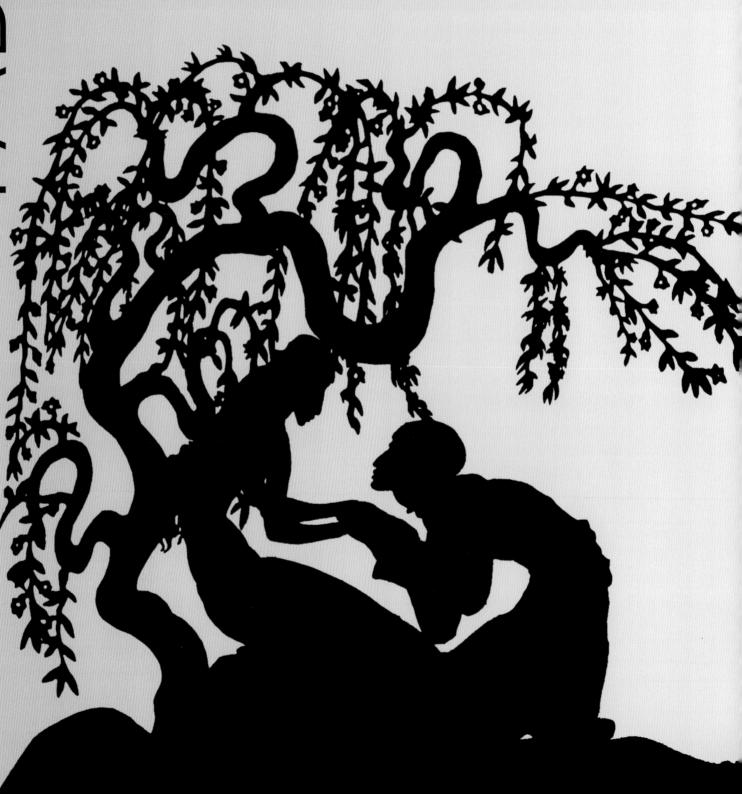

Animation has been a repository of folk memory since its genesis. As an art form it has proven uniquely able to interpret fables, fairy tales and other forms of collective storytelling, while early twentieth-century cinema and the fine arts remained preoccupied with other interests. The phenomenon of animation was global and simultaneous. Paul Terry launched his *Aesop's Film Fables* series in 1921 (page 124), while the Kitayama studio in Japan released *The Tortoise and the Hare* in 1924. *The Frogs Who Demanded a King* (1922), based on another of Aesop's fables, was the first puppet film made by Ladislas Starewitch in Paris; Walt Disney's *The Tortoise and the Hare*, meanwhile, appeared under his *Silly Symphonies* label in 1935. Starewitch released his first animated feature film, *The Tale of the Fox* (1929–30; page 132), in 1937, the same year in which Disney made history with his first feature, *Snow White and the Seven Dwarfs* (page 125), based on the fairy tale by the Brothers Grimm. Chinese animators, having partly embraced the Disney model stylistically, turned to Chinese myths and folk tales for content in order to differentiate their output.

The transference of age-old stories to the new filmic medium was eased by the persistence of traditional storytelling devices – notably puppets and graphic illustrations – which could now be photographed and animated, rather than simply presented in sequence. Lotte Reiniger's *The Adventures of Prince Achmed* (1926; pages 122–23) was the most ambitious of her shadow-puppet animations, and she ranged freely across cultures for her inspiration and content. Such storytelling devices have not diminished in either value or impact: contemporary artists Kara Walker and Nathalie Djurberg (pages 134–35) both use traditional means – shadow puppets and clay animation, respectively – for

their highly personal engagements with collective memory. Sometimes, new technology can give form to stories that would otherwise be unlikely to leave their communities of origin. For the sand animation *The Owl Who Married a Goose: An Eskimo Legend* (1974; page 149), Caroline Leaf adapted a classic and beautiful story that had previously been handed down orally across centuries and thousands of miles of Arctic landscape.

While such figures as Ray Harryhausen have used innovative animation techniques to retell classic stories – from *The Story of 'Rapunzel'* (1952; page 133) to *Jason and the Argonauts* (1963) – both he and his mentor, Willis O'Brien, have also used stop-motion animation combined with live-action footage to create whole new worlds of mythology, which act as foils to our obsession with modern life. O'Brien's *The Lost World* (1925; page 140) was among the first, while his *King Kong* (1933) remains one of the most iconic.

Studio Ghibli, founded in 1985 by Hayao Miyazaki and Isao Takahata, has carved out a unique place in world culture with its hugely imaginative productions. Although occasionally reworking myths, it has largely concentrated on inventing its own. Generally, these fall into one of two categories. The first consists of epic tales of conflict between men, between mankind and nature, or between selfishness and a sense of the common good, of which *Nausicaä of the Valley of the Wind* (1984; pages 127–29) – the success of which led directly to the founding of Studio Ghibli – and *Princess Mononoke* (1997) are outstanding examples. The second is the contemporary fable, usually told from the perspective of a young child coming to terms with the wonder and terrors of the world; *My Neighbour Totoro* (1988) and *Kiki's Delivery Service* (1989) are both classics of this genre.

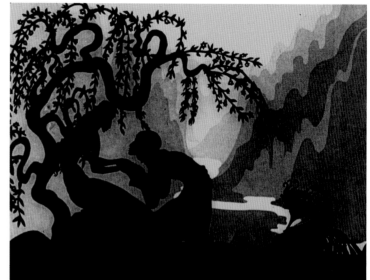

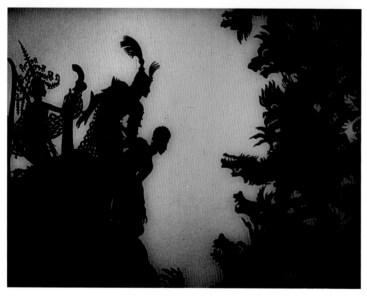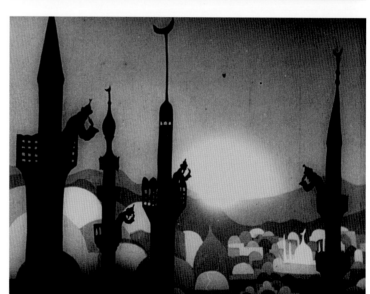

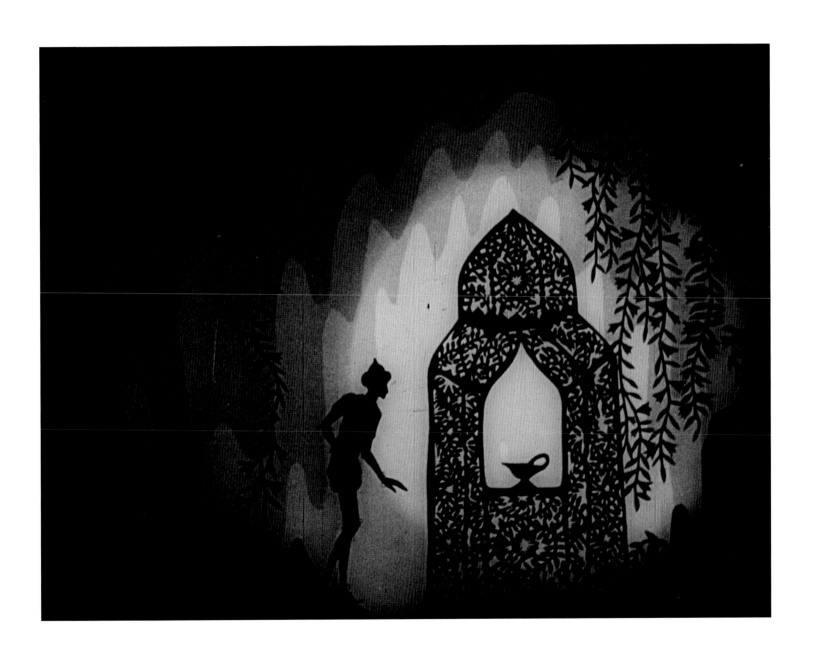

LOTTE REINIGER

The Adventures of Prince Achmed, 1926

35mm, black and white, silent, 65 min.

BFI National Archive

VAN BEUREN STUDIO

Aesop's Fables: The Iron Man, 1930

16mm, black and white, sound, 7 min., 19 sec.

Courtesy of Thunderbean Animation

WALT DISNEY

Snow White and the Seven Dwarfs, 1937
35mm, colour, sound, 83 min.
© Disney

Snow White and the Seven Dwarfs, Disney's loose adaptation of the fairy tale by the Brothers Grimm, premiered at the Carthay Circle Theater in Los Angeles in December 1937. Dubbed 'Disney's Folly', the film nevertheless proved a popular and critical success, combining high sentiment, low clowning and gothic terror to persuasive effect. It was actually based on the stage version by Winthrop Ames; however, in Disney's hands, the story became the tale of a nature-loving young 'mother' caring for seven 'children', who, in turn, attempt to protect her from her evil stepmother, a femme-fatale figure based on Lady Macbeth and the Big Bad Wolf.

Central to the film's evolution were extensive sketch and storyboarding meetings. Such meetings, pioneered at Walt Disney Studios by Webb Smith, were invaluable to the narrative design and art direction, which drew on such European fairy-tale illustrators as Arthur Rackham, Wilhelm Busch and Adrian Ludwig Richter. Snow White was the creation of Grim Natwick, the artist behind Betty Boop, while the film's overall style was determined by Albert Hurter and the inspirational paintings of Gustaf Tenggren and Ferdinand Horvath. More than 2.3 million pieces of art were created to service the 83-minute running time, at a cost of

nearly $1.5 million, four times the budget of the average feature.

Snow White was also notable for its Frank Churchill score – the first commercially available soundtrack recording – which included such popular songs as 'Whistle While You Work' and 'Some Day My Prince Will Come'. Although Disney felt that the rotoscoping of the human figures was only partly successful, he had finessed the animated character into an art form, from Bill Tytla's Stanislavsky-styled character animation of Grumpy to the Chaplin-advised timing of certain comic sequences and the Jekyll and Hyde-like metamorphoses.

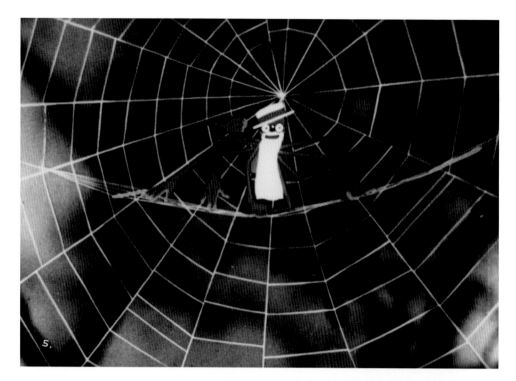

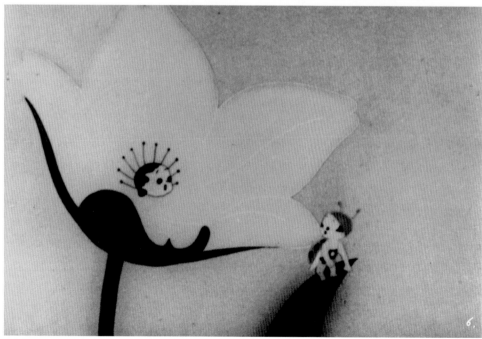

HAYAO MIYAZAKI/STUDIO GHIBLI

Nausicaä of the Valley of the Wind (Kaze no Tani no Nausicaä), 1984
35mm, colour, sound, 116 min.
© 1984 Nibariki – GH

Based on his own manga, which both preceded and later extended the story of the film, Hayao Miyazaki's *Nausicaä of the Valley of the Wind* found its eponymous heroine in the figure of a Phaeacian princess in Homer's *Odyssey* and a character from *Tsutsumi chūnagon monogatari*, a collection of Japanese short stories from the tenth to fourteenth centuries. Nausicaä is the first of Miyazaki's eco-heroines, studying flora and fauna on the periphery of a post-apocalyptic, toxic world, the product of the 'Seven Days of Fire' that occurred a millennium earlier. Her valley tribe endeavour to live a sustainable life, guarding against toxic miasma and deadly spores, and resisting the invasion of Princess Kushana, who wishes to raise from the dead the body of one of the warrior gods who caused the great fire. Nausicaä's discovery of a fertile underground world drives her desire to prevent further conflict and brutality.

Miyazaki refuses to use easy archetypal situations and classical narrative solutions to resolve seemingly irreconcilable ideological conditions in flux. Both Nausicaä and Kushana want to make the world better, but their outlooks are different. Nausicaä's empathy with the natural world marks her out as a sympathetic and intelligent figure, and an early example of Miyazaki's use of empowered female figures as both commentators on and facilitators for intervention in complex environmental scenarios. Such figures include Satsuki and Mei in *My Neighbour Totoro* (1988), San and Lady Eboshi in *Princess Mononoke* (1997) and Chihiro in *Spirited Away* (2001). Miyazaki believes that nature is both generous and ferocious, and seeks to show humankind in direct relationship to the animism informing his environments and their unpredictable vicissitudes. His heroines are used not to expose further differences in human outlook, but to highlight the conditions that must be understood in order to find commonality and resolution.

HAYAO MIYAZAKI/STUDIO GHIBLI

Nausicaä of the Valley of the Wind (*Kaze no Tani no Nausicaä*), 1984

35mm, colour, sound, 116 min.

WAN GU CHAN AND WAN LAI MING

Princess Iron Fan, 1941

35mm, black and white, sound, 73 min.

Special thanks to Chinese Taipei Film Archive

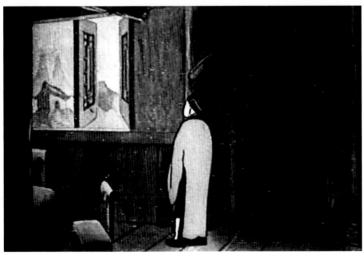

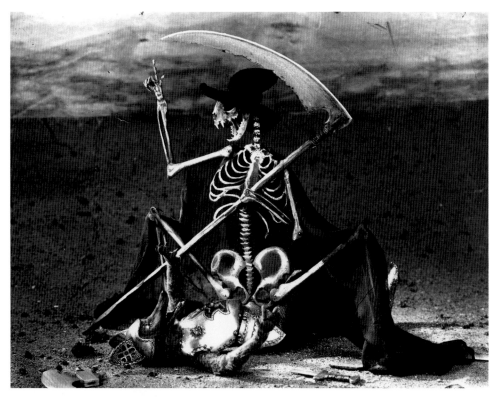

LADISLAS AND IRÈNE STAREWITCH

The Tale of the Fox, 1929–30

35mm, black and white, sound, 65 min.

Collection Martin-Starewitch

RAY HARRYHAUSEN

The Story of 'Rapunzel', 1952

16mm, colour, sound, 10 min., 25 sec.

© The Ray & Diana Harryhausen Foundation

RAY HARRYHAUSEN

Models from *The Story of 'Rapunzel'*, 1952

Latex bodies with internal metal armatures and

plaster replacement heads

© The Ray & Diana Harryhausen Foundation

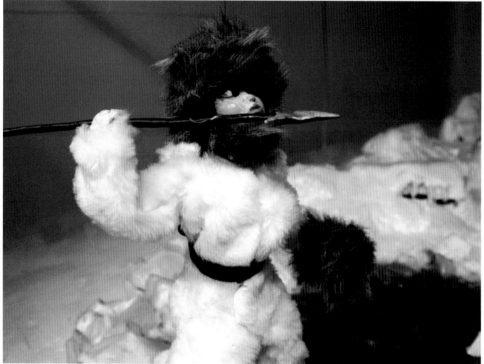

NATHALIE DJURBERG

Putting Down the Prey, 2008

Clay animation, video, music by Hans Berg,

5 min., 40 sec.

Courtesy of Zach Feuer Gallery, New York, and

Gió Marconi, Milan

NATHALIE DJURBERG

The Rhinoceros and the Whale, 2008
Clay animation, video, music by Hans Berg,
4 min., 47 sec.
Courtesy of Zach Feuer Gallery, New York, and
Gió Marconi, Milan

ALEXANDRE ALEXEIEFF

The Nose, 1963

35mm, black-and-white pinscreen animation,

sound, 12 min.

© 2011 Alexeieff – Cinédoc PFC

JIŘÍ TRNKA

The Hand, 1965

35mm, colour, sound, 19 min.

© Krátký Film Praha a.s.

RIGHT

YURI NORSTEIN

Drawings for *Tale of Tales*, 1979

Top to bottom: *The Drunk and the Nag: A Warning to Parents; Drunken Father; Nagging Mother*

© State Cinema Collection of the Russian Federation

OPPOSITE

YURI NORSTEIN

Tale of Tales, 1979

35mm, colour, sound, 29 min.

© State Cinema Collection of the Russian Federation

Out of the reedy, mist-heavy darkness of a damp forest, *Tale of Tales* invokes memory and dream, loss and regret: lives lived, years passed. From fires and ashy embers alike, smoking wearily, and from boarded-up houses, naked trees and sodium street lamps, the film exhumes memory on a personal, intimate level, yet memory inextricably linked to – or a symbol for, perhaps – the twentieth century itself. The spectral light of a hallway floods an autumnal garden, a green apple is lost in the snow, and somehow these motifs, meaningless or mawkish in the wrong hands, are made to weigh heavy with the smoky end of the century, the remains of the day.

Beyond the milk-heavy eyes of an infant at its mother's breast, with the childhood phantasm of a little grey wolf as guide, a (collective) unconscious is awakened. Suffused with the same wistful light and thematic preoccupations as the work of Andrei Tarkovsky, *Tale of Tales* summons, as does Tarkovsky's *Mirror* (1975), not only the images of memory but also its very nature, associatively weaving together seemingly disparate narratives. With the spectre of (the) war crouching always in the shadows, Norstein creates deliberate ruptures in time, the moving images collapsing and failing as the war claims more men, who return in the greatcoats of soldiers to walk as wraiths through once-bright squares. Snow falls silently.

Among the ends of days and the slowly dripping leaves of denuded forests, there appears a halcyon landscape, a mirage bright with sunlight: undulating countryside frames a bucolic scene as a writer, musician and mother sit down together under the shade of summer trees. Yet even this is tinged with regret, with the knowledge that the moment has passed forever. And this is, perhaps, the wisdom that the film imparts beyond all else: what has been, has been. It is a film to watch at the year's end.

With *Tale of Tales* – as well as with certain other key works – the term 'animation' no longer does justice to that which it describes. To limit so complex, so richly textured a work to, essentially, a set of techniques seems baldly unambitious and wholly unsatisfying. Rather, Norstein's film is an example of the radical moving image, and treads the same path as many artists' film and video work: it returns us to the source of what the moving image makes possible, and, indeed, to the source of basic human questions. Unlike mainstream, live-action film, it dispenses with the linearity of time and the geometry of space in order to access a world of experience and emotion where intuition replaces rationalism once more.

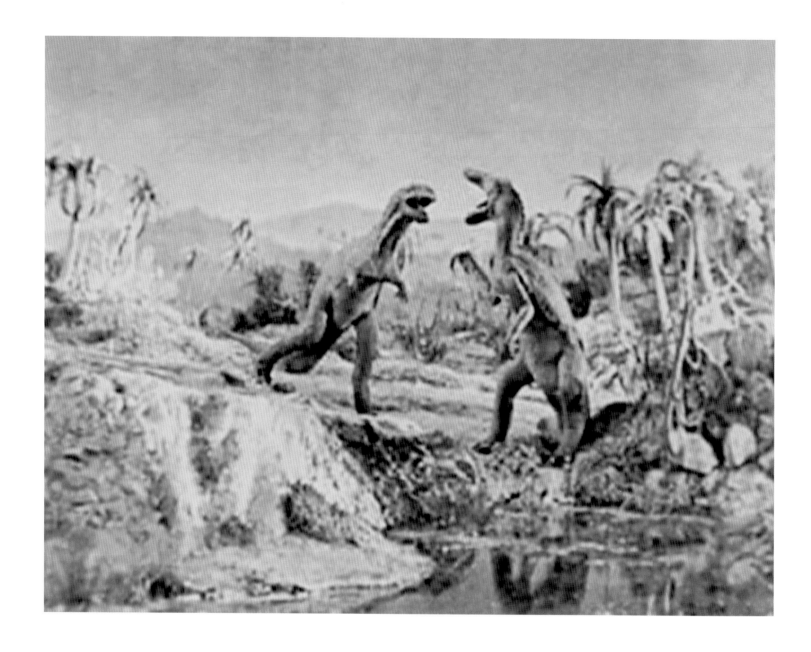

WILLIS O'BRIEN

The Lost World, 1925

16mm, black and white, silent, 92 min.

© Lobster Films Collection

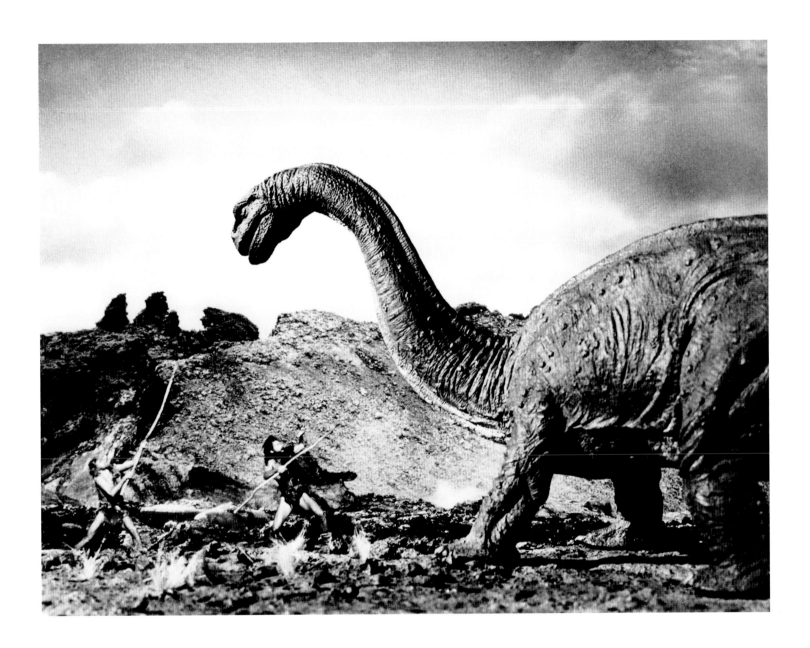

RAY HARRYHAUSEN

One Million Years B.C., 1966

Photographic paste-up of a model combined with
live-action footage. This scene, which would have
shown a brontosaurus attacking the tribe, was
deleted from the final screenplay.

© The Ray & Diana Harryhausen Foundation

LEFT
WINSOR MCCAY
The Sinking of the Lusitania, 1916
16mm/35mm, black and white, silent,
9 min., 45 sec.
Courtesy of Ray Pointer, Inkwell Images Inc.

OPPOSITE, TOP AND BOTTOM RIGHT
HALAS & BATCHELOR
Animal Farm, 1954
35mm, colour, sound, 74 min.
Courtesy of the Halas & Batchelor Collection

OPPOSITE, BOTTOM LEFT
HALAS & BATCHELOR
Blue-pencil drawing for *Animal Farm*, 1954
Courtesy of the Halas & Batchelor Collection

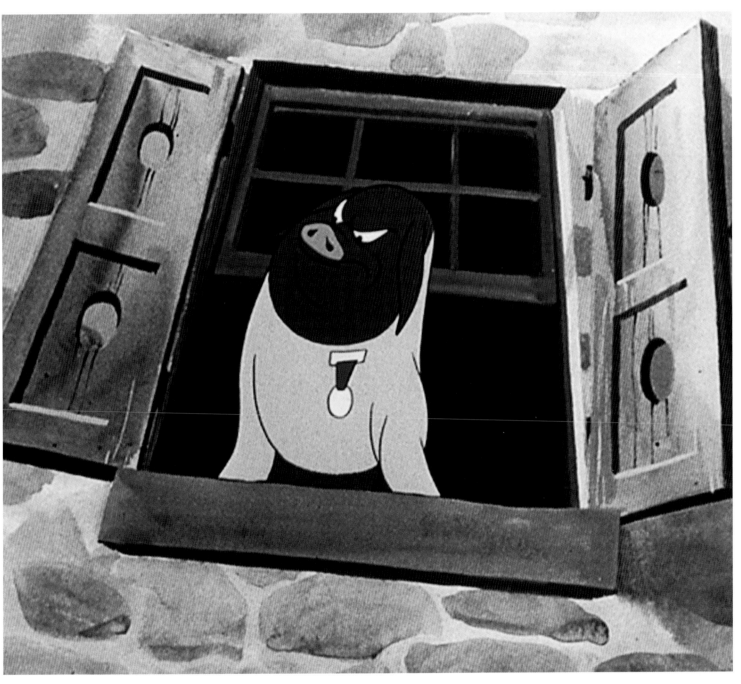

RUTH LINGFORD

Pleasures of War, 1998

Digital format, colour, sound,

11 min., 30 sec.

© Ruth Lingford

RUN WRAKE

Rabbit, 2005

35mm, colour, sound, 5 min.

Courtesy of the artist and LUX, London

Run Wrake's *Rabbit* appropriates 1950s educational picture-book illustrations to spin a gothic, macabre allegory of two children who, on cutting open a rabbit, find an idol that can turn base objects into jewels. Created using elements scanned from images by British illustrator Geoffrey Higham (opposite, bottom), the film's hermetic universe, which depends entirely on material already in existence but itself finite, dictates the aesthetic and narrative parameters of the work. Moreover, the premise of the film acknowledges not only the material artefacts and limitations of the illustrations – the words describing each illustrated object are retained throughout – but also their innocence; and, aware that we are cognizant of the original purpose of the images, Wrake harnesses their neutrality to make them relate an altogether less salubrious tale. As such, this economy of process creates a taut, rigorous artistic framework and a fertile basis on which the artist may weave his story.

Drawing on the history of found-footage and collage film, *Rabbit* uses 'found' material in the purest sense of the word: the artist stumbled upon the illustrations in a junk shop. The retention of the literal descriptions (the word 'girl' accompanies the girl character wherever she goes, the word 'rabbit' wherever the rabbit goes, and so on) serves also, perhaps, to encourage a dialogue about the nature of knowledge and the objectification of things, reminding us that signifiers hover forever above the signified. By such means, too, the dual status of the images with which we are presented – that of original illustration destined for the education of children, and that of constituent element of the newly created fable – is constantly in the foreground; the inclusion of the idol, in particular, asks us to reconsider the illustrations' original context, and questions what place that word had in such a collection.

Commissioned by animate!, the trailblazing Channel 4/Arts Council England animation production scheme, under the stewardship of the late, great producer Dick Arnall, *Rabbit* speaks for and of animation itself, literally 'animating' the inanimate, and giving us access to a world of imagination and invention.

JIM TRAINOR

The Presentation Theme, 2008
16mm, black and white, sound, 14 min.
© Jim Trainor

With an economical style, using a black marker on white paper, Chicago-based Jim Trainor's films are deceptively simple, naïve even, but this belies the depth and perspicacity of their enquiry. The apparent absurdity and fantasy of the prehistoric animal kingdoms and barely documented human civilizations that Trainor presents are dissipated by the realization that such kingdoms and civilizations are based on real prehistory. Moreover, his 'dramatization' or imagining of the lives of their inhabitants is seemingly dominated by a message about the ahistorical nature of our existence: namely, that history itself is a construct, and that in spite of – or perhaps because of – 'progress', we are still brute animals, our behaviour much like that of the prehistoric mammals Trainor exhumes.

The Presentation Theme is based on images made by the Moche (an ancient Peruvian culture), some of which appear to refer to human sacrifice. As in the case of Trainor's previous works, the bestial is never far from the surface, and the humans of *The Presentation Theme* live in a similar way to the animals in his other films, driven by cruel and brutal desires. Yet Trainor seems to be saying that these desires are codified by the society in which the humans live, and that therefore, irrespective of their nature, they are not subject to the same process of suppression and deferral as practised by the 'civilized' West.

The film is relevant here because of its re-imagining of an unknowable yet verifiably real society: less an allegory and more an imagined documentary, it is nevertheless a story that (and this is undoubtedly Trainor's point) is universal and ahistoric despite the specificities of its own environment. It provides an interesting counterpoint not only to work that is recognizably fable-like but also to American film-maker Martha Colburn's take on a contemporary folk tale, *Myth Labs* (2008).

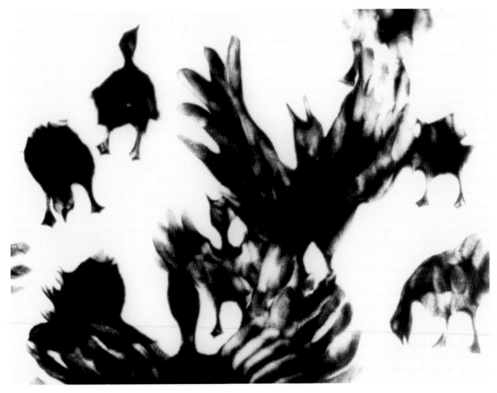

CAROLINE LEAF

The Owl Who Married a Goose:
An Eskimo Legend, 1974
Sand animation filmed on 35mm,
black and white, sound, 7 min., 38 sec.
© 1974 National Film Board of Canada.

FRAGMENTS

While the previous section, 'Fables', considered how animation has been adapted to tell tales drawn from folk memory, 'Fragments' demonstrates the potential of the medium to construct more individual narratives. The distinction is one of degree: the Western cultural canon – certainly from Virgil's *Aeneid* onwards, and no doubt before that through the oral tradition – has always been subject to radical revision by individual storytellers. When the Brothers Grimm began documenting European fairy tales in the early nineteenth century (transcribing interviews conducted in their home), they set living psychodramas in stone. Animation has since allowed for fresh iterations of these shared legends, which are updated in accordance with our shifting sensibilities.

Kara Walker's two films from the series *National Archives Microfilm Publication M999 Roll 34: Bureau of Refugees, Freedmen and Abandoned Lands – Six Miles from Springfield on the Franklin Road* (2009) and *Lucy of Pulaski* (2009; page 162) – offer a compelling link between received and reinterpreted histories. Walker uses shadow puppets to capture the near-mythic past of the Reconstruction era, which followed the American Civil War. The works fuse elements of historical fact with traces of received wisdom. The artist's own intentionality is evident in the shadow-puppet players, who loom visibly behind the story they are articulating (just as Lotte Reiniger showed her snipping scissors in *Cinderella* in 1922). Ari Folman's *Waltz with Bashir* (2008; page 159) also addresses historical trauma, but this time through the lens of personal experience. The nature of the material demanded new animation techniques, so the entire film was shot as live action and then laboriously transferred on to storyboards and illustrated. Folman's film is thus haunted by unseen physical presences, which lend his animation a devastating human touch that would have been impossible to achieve had he worked in a traditional dramatic format.

Jiří Barta's *Golem* (pilot, 1993; page 154) also moves between the flatness of film-recorded time and the depth of animated memory, with the clay-animation technique adding literal weight to the live-action footage. Barta's use of source material further complicates the viewer's engagement with this popular folk tale: drawing on the novel of the same name published in 1915 by Austrian-born author Gustav Meyrink, Barta places this fragment of sixteenth-century Jewish folklore in a nineteenth-century milieu. Animation and film, the real and the imagined, the past and the present – all collide in a melancholy meditation on the soul of a community.

A self-conscious artifice characterizes much of the work in this section. Emerging from a post-war and postmodern genealogy, the films speak to the contingency of knowledge and the validity of multiple forms of expression. The charming simplicity of Francis Alÿs's *The Last Clown* (1995–2000; page 163) evokes a wide range of cultural precedents, from Charlie Chaplin to Samuel Beckett, while also alluding to such key animators as Ryan Larkin. Alÿs uses line and wash to create a character so light of presence as to be almost insubstantial – until a shockingly direct moment when he turns his face to the viewer with a hard, connecting stare. Such devices testify to the animator's freedom to use a panoply of techniques to convey the richness and complexity of his or her subjects.

JAN ŠVANKMAJER

Dimensions of Dialogue, 1983

35mm, colour, sound, 12 min.

Courtesy of Athanor Film Production Company Ltd

(athanor.cz), Jaromír Kallista and Jan Švankmajer

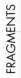

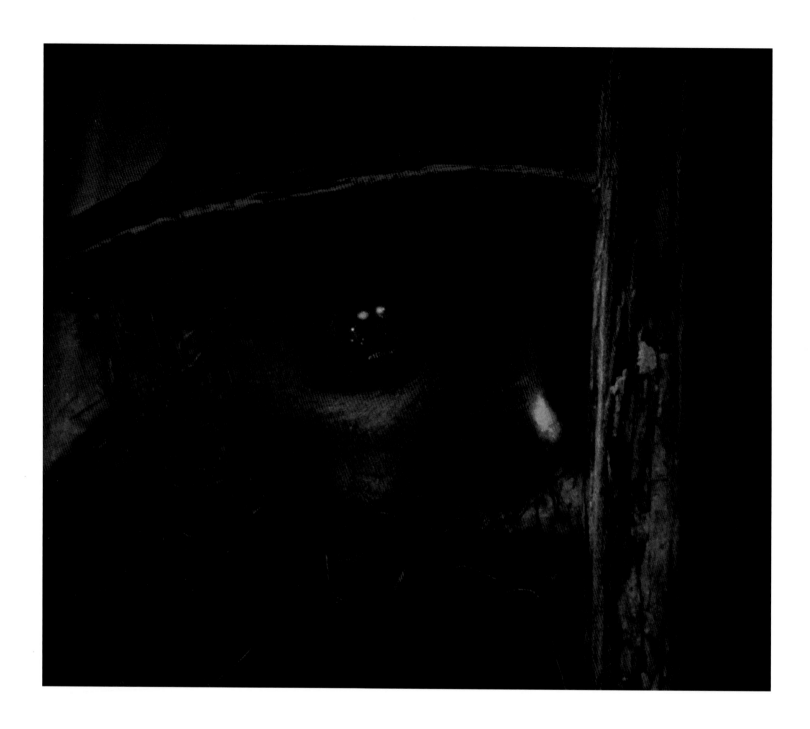

JIŘÍ BARTA

Golem (pilot), 1993

DVD video, colour, sound, 7 min.

© Jiří Barta

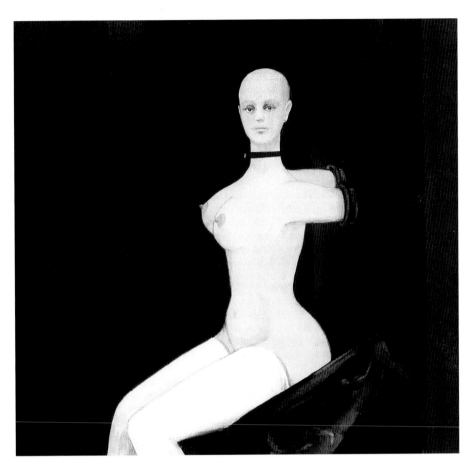

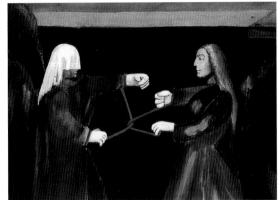

WALERIAN BOROWCZYK

Les Jeux des anges, 1964

35mm, colour, sound, 13 min.

Les Jeux des anges by Borowczyk © 1964

An incandescent masterwork, Walerian Borowczyk's *Les Jeux des anges* is a Lethe-bound voyage across a desecrated landscape into a world of impossible structures, terrible machines and severed wings. Inside a shrouded, labyrinthine no-place – a monstrous aberration of interlocking chambers – we half witness sudden and random acts of cruelty, scenes from within a theatre of sadism.

The film draws, undoubtedly, on Borowczyk's interest in the work of Max Ernst, yet feels at times like a moving Francis Bacon painting, heavy gouache falling through thick air. It is also, however, the judicious use of sound – by acclaimed *musique concrète* composer Bernard Parmegiani – that enables the film to create so hermetic and terrifying a space, from the opening clatter of a railway journey (which is, perhaps, deliberately evocative of the concentration-camp transports) to metallic rasps, transfigured voices and an expanse of organ music. Indeed, the organ itself is important: the film's title, invariably translated into English as 'The Games of Angels', also references the *jeu d'anges* stops on an organ.

Initially, Borowczyk studied painting, turning to poster design before taking up film-making. He worked on animated films early in his career, collaborating with the likes of Jan Lenica and Chris Marker. He then went on to direct several live-action features, including the masterful *Goto, l'île d'amour* (1968), *Blanche* (1971) and *La Bête* (1975), before retreating into relative obscurity as the director of such less-acclaimed titles as *Emmanuelle 5* (1987). Borowczyk deserves to be recognized as a centrally important figure to animation – or rather, to the world of experimental moving images – as opposed to a marginal one, for a praxis that refused to recognize artificial boundaries between disciplines, and for a body of work that remains unique in both its breadth of vision and its mode of realization.

TERRY GILLIAM

The Imaginarium of Doctor Parnassus, 2009

35mm, colour, sound, 123 min.

Courtesy of the artist

TIM BURTON

Vincent, 1982

16mm, black and white, sound, 6 min.

© Disney

HARUN FAROCKI

Serious Games III: Immersion, 2009

2 videos, colour, sound, 20 min. (loop)

© 2009 Harun Farocki

ARI FOLMAN

Waltz with Bashir, 2008

35mm, colour, sound, 90 min.

Courtesy of Bridgit Folman Film Gang, Les Films d'Ici,

Razor Film Produktion, Arte France and Noga

Communications – Channel 8

POUR TROUVER UN SEMBLANT D'ÉQUILIBRE, NOUS FAISIONS LA FÊTE PRESQUE TOUS LES SOIRS...

... MAIS MÊME CHEZ NOUS, ILS NE NOUS LAISSAIENT PAS TRANQUILLES.

J'AI VU UNE PATROUILLE DES GARDIENS DE LA RÉVOLUTION PAR LA FENÊTRE. JE CROIS QU'ILS VIENNENT NOUS ARRÊTER!

VIENS LÀ MON PETIT SALAUD! COMME ÇA, TU ORGANISES DES FÊTES! JE VAIS TE FAIRE PASSER LE GOÛT DE LA JOUISSANCE!!

ILS EMBARQUAIENT TOUT LE MONDE EN PRISON. ÉVIDEMMENT, NOUS EÛMES TRÈS PEUR LA PREMIÈRE FOIS.

... MAIS CELA DEVINT VITE UNE HABITUDE. NOUS ARRIVIONS MÊME À EN RIRE.

LE BARBU, TA BARBE PUE...

ENSUITE VENAIT L'ÉTERNEL BARATIN...

... CONTRE LA MORALE... LE SANG DES MARTYRS..., ... VINGT MILLE TOUMANS ...

... NOS PARENTS PAYAIENT ET ON NOUS LÂCHAIT...

... JUSQU'À LA FOIS SUIVANTE. POUR FAIRE LA FÊTE, IL FALLAIT AVOIR LES MOYENS.

OPPOSITE

MARJANE SATRAPI

Persepolis I, 2000

Graphic novel

Courtesy of Marjane Satrapi

RIGHT

MARJANE SATRAPI

Sketches for *Persepolis I*, 2000

Pen on paper

Courtesy of Marjane Satrapi

KARA WALKER

National Archives Microfilm Publication M999
Roll 34: Bureau of Refugees, Freedmen and
Abandoned Lands: Lucy of Pulaski, 2009
Video, colour, sound, 12 min., 8 sec.
Courtesy of the artist and Sikkema Jenkins & Co.

National Archives Microfilm Publication M999
Roll 34: Bureau of Refugees, Freedmen and
Abandoned Lands: Lucy of Pulaski re-historicizes the
struggle of African Americans in the slavery system
and in the immediate aftermath of the abolition of
slavery, using a documented event as the source for
a commentary on racial conflict and racism that uses
the mantle of history to impart truths still relevant
today. The disjuncture between the obviously, self-
consciously 'period' technique and *mise en scène* of
shadow puppetry and the realization that such
conflict still exists serves to highlight even more
prominently the very length of the struggle – and to
remind the viewer that the abolition of slavery did
not end racial inequality.

 Kara Walker's film relates an alternative
history to that codified by the (inevitably) white,
European historians and custodians of social history:
an account by the powerless of the mechanisms of
power. While the use of shadow puppetry and early
silent-film conventions (a 'live' piano soundtrack,
intertitles and subtitles indicating action) is

manifestly designed to date the story, Walker's real
interest in doing so, presumably, is to effect and
investigate the slippage between the sanctioned and
the subordinate histories. That is, the subject-matter
– sexuality, perversion, murder – seems very much
at odds with the propriety and innocence suggested
by the particular historicity of the techniques used
to make the film; yet the racial stereotypes, in
appearance and behaviour, are entirely transposable
to contemporary society, in which a black underclass
is routinely characterized in terms of sexual
licentiousness and violent crime. In this way, the
eponymous protagonist of *Lucy of Pulaski*, a
'colored strumpet', is as much an ahistoric caricature
as any historic character.

 The only conclusion at which the viewer
can arrive, therefore, is that the mechanics of power
produced ugly disparities that, far from coming to
an end, cleanly, with the abolition of slavery – as
we are encouraged to believe – continue to be
produced to this day.

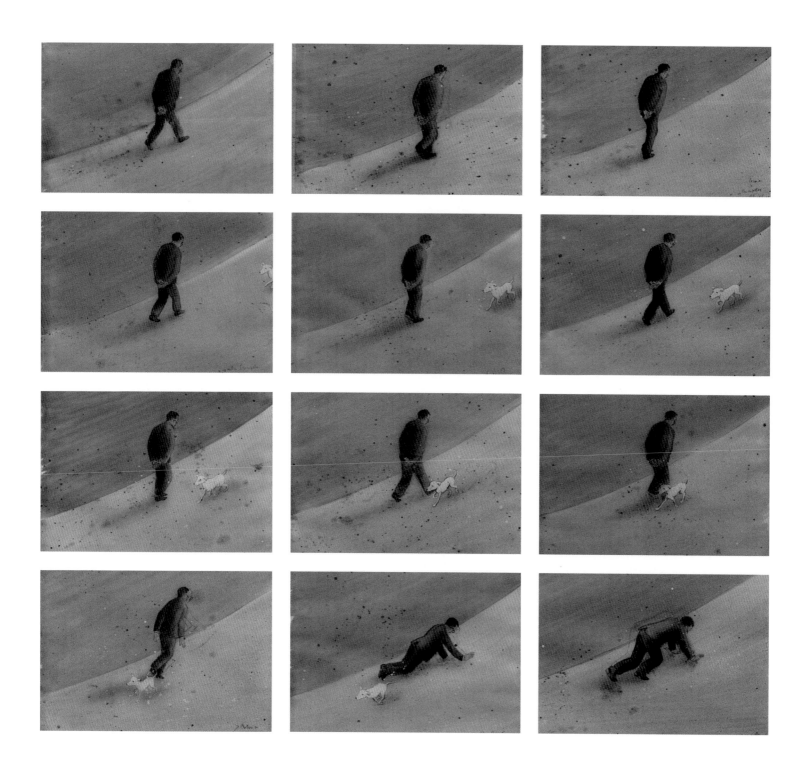

FRANCIS ALŸS

Study for *The Last Clown*, 1995–2000

Watercolour, enamel and pencil

Courtesy of the artist and Lisson Gallery

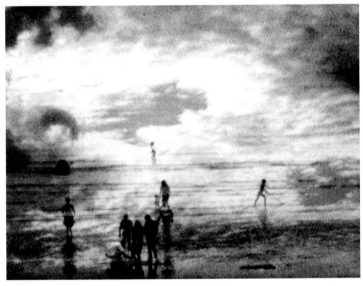

PATRICK BOKANOWSKI

La Plage, 1992

35mm, colour, sound, 14 min.

© Patrick Bokanowski and Light Cone

The French artist and film-maker Patrick Bokanowski makes use of aberrant and specially adapted optics – 'imperfect' lenses – to create 'real' (as opposed to manipulated in post-production) but carefully controlled distortions of the image. His is a dichotomous practice, at once surgically precise and joyfully chaotic, in that its incubation needs to be clinical, yet the fruit it yields is mercurial, at the mercy of chance.

La Plage makes extensive use of Bokanowski's modified optics to present a dream-like, fluid landscape: a beach transfigured, spilling over with light and water. Distorted and occluded figures traverse the scene, but somehow move above and within the image at the same time, on the beach yet within it, of it, as though they were made of the same stuff as the landscape itself – seawater bones and ultramarine shadows. The scene is at once the representation of a beach and, somehow, the essence of it, the obscure, refracted, fluent images suggesting an image of memory, or of the imagination itself, in a way that provides an interesting complement to the work of Jerzy Kucia and the Brothers Quay.

Bokanowski's optical distortions help to intervene in the film's motion and sense of time, conspiring with the strange, immersive soundscape (composed by Bokanowski's wife, Michèle, an established electro-acoustic musician) to create an experience that is quite unique. Indeed, although a practice defined to so great a degree by (an esoteric) process is likely to be seen as somewhat arcane, Bokanowski's reliance on the materiality of the lens, on the serendipitous optical 'accidents' it produces and on the very notion of imperfection lends his work an increasing ideological bias, a refusal or refutation of sorts as the triumph of the digital demands ever-greater perfection, synthesis and predictability.

ROBERT BREER

Fuji, 1974
16mm, colour, sound, 6 min.
Courtesy of the artist and LUX, London

Although Robert Breer is perhaps best known for
his free-form, abstract animated films, his long
career has encompassed painting and kinetic
sculpture, notably his 'floats', which, like his
moving-image practice, bring an anarchic sensibility
to the gallery. His playful sense of humour and
maverick, intuitive sense of movement, duration,
form and line have meant that his work has always
followed its own trajectory, influencing many other
artists along the way.

 Fuji makes use of rotoscoping – a technique
often associated with Breer – to present us with live-
action footage of a train passing Mount Fuji only
to cover, abstract and distort it, playing with form
and plane until mountains, birds and people alike
become mere right angles. Sprayed colour fields and
half-drawn lines reduce the landscape outside to its
constituent parts, the shifting light conveyed by
sprays of blue and red across the snow-capped peak
of the mountain, the train's own rhythmic advance
affecting both the soundtrack and the cadence of
the images.

 As Breer no doubt intended, the film is
most interesting where the rotoscope fails – or
rather, where the two worlds are not flawlessly
composited – and we get to see, via holes in the
artist's traced layer, some of both of them at the
same time. If the photographic image is 'reality', or
at least a proxy for it, then the effect of the traced
image breaking down creates an annotated reality,
revealing that the 'real' world is but a single leaf
of a richly layered meta-universe in which signs and
symbols collide and collude to present multiple
possible meanings.

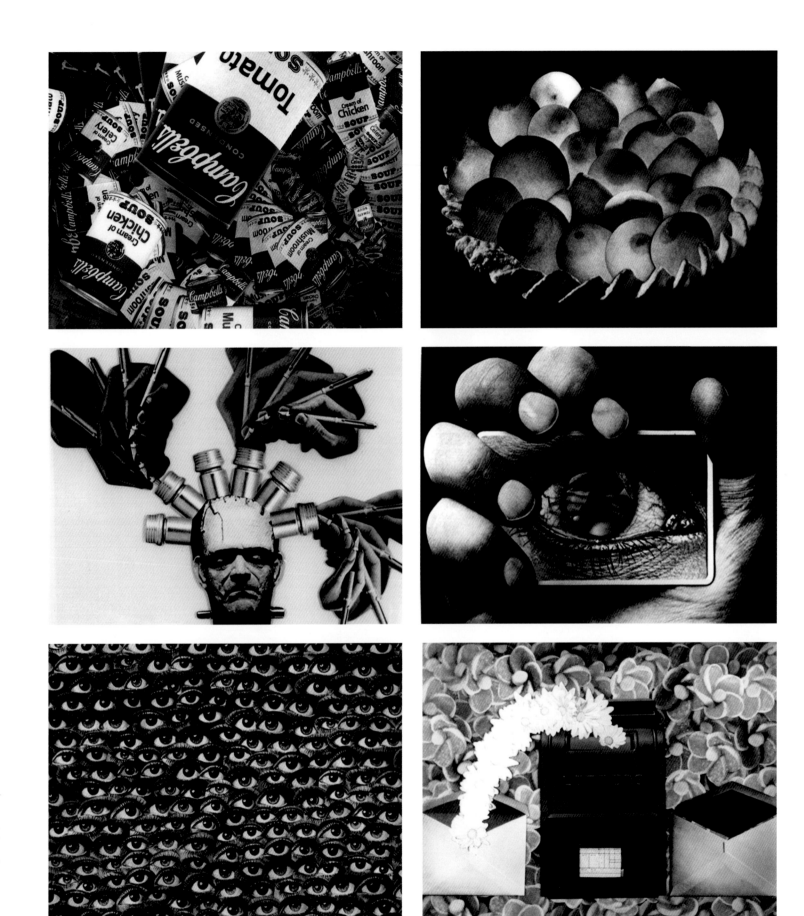

OPPOSITE

FRANK AND CAROLINE MOURIS

Frank Film, 1973

16mm, colour, sound, 9 min.

© Frank and Caroline Mouris

RIGHT

STAN VANDERBEEK

Science Friction, 1959

16mm, colour, sound, 10 min.

Courtesy of Electronic Arts Intermix (EAI), New York

STRUCTURES

The magic of animation lies in its ability to transform inert physical material into the illusion of life. Since its early days, animators have felt compelled to challenge the narrative and imaginative capabilities of the medium; their successes have been intimately tied to innovations in its formal possibilities. All too often, these animators were experimenting with the building blocks – the DNA – of their art form for the sheer pleasure of witnessing the results.

Such experiments have tended to focus on the 'integrity' of the animated film: the ease with which it could conjure up a complete world of its own, even while drawing on external frames of reference. A key factor here is duration, since the exact length of a work can have significant consequences for its meaning and impact. These material concerns bring animation into dialogue with the early modernist movement, reminding us that, together with performance, photography and film, animation played a notable role in the development of the historic avant garde. Thus, in the first half of the twentieth century, such artists as Viking Eggeling (page 171), Oskar Fischinger (pages 176–77), Fernand Léger (pages 178–79) and Stefan and Franciszka Themerson (page 180) pursued parallel experiments in the formal possibilities of film. The fragmentation of cultural disciplines has meant that such a figure as experimentalist Stan Brakhage (whose dynamic engagement with technique produced a visionary opus; page 175) remains respected but unduly isolated within the visual-arts world.

Other forms of practice are equally revealing of the unique structural determinants of animation. In *Alone. Life Wastes Andy Hardy* (1998; page 183), Martin Arnold uses short clips from classic black-and-white feature films as his raw material, editing and repeating fragments to create a wholly new compositional paradigm. Zbigniew Rybczyński's *Tango* of 1980 (page 184) is ostensibly figurative: people enter a claustrophobic room individually, repeatedly, until it is full of atomic individuals, each seemingly unaware of his or her neighbour. The existential challenge of this work is mirrored by its technical ingenuity.

Norman McLaren is well known for his abstract, musical animations, but is represented here by his remarkable film *Neighbours* (1952; page 182), an Academy Award-winning work described by McLaren as 'a really strong film about anti-militarism'. Today, it also documents the animator's art: using stop-motion filming with live characters and real-life props (the 'pixilation' technique), McLaren weaves a dizzying visual tapestry in which the left and right half of the frame seem to mirror each other in the ebb and flow of a parable about escalating destruction. Form is similarly inseparable from content in Chuck Jones's *Duck Amuck* (1953; page 185), which offers an improbable masterclass in structural film-making by seamlessly merging popular cartooning with conceptual game playing.

169

JULES ENGEL

Train Landscape, 1974

16mm, colour, sound, 4 min.

© iotaCenter

VIKING EGGELING

Symphonie Diagonale, 1924

35mm, black and white, silent, 8 min., 26 sec.

Courtesy of Filmform – The Art Film & Video Archive

LEN LYE

A Colour Box, 1935
35mm, colour, sound, 4 min.
BFI National Archive

Len Lye's first experiment with painting directly on to celluloid, *A Colour Box* is a riot of light and motion, revelling in the ability of the moving image to conjure worlds unfathomable save in the recesses of the mind itself. Geometric patterns pulse and shift over backgrounds of bold colour, dancing to the soundtrack; yet in contrast to the somewhat hard-edged geometry of the early 'visual music' films, they are always organic in form and relaxed in realization. More than anything else, perhaps, *A Colour Box* manages to convey a sheer excitement about the moving image *as* moving images. It is a paean to the alchemical energy of the still-novel technology itself, exhilarated by the possibilities that the moving image presents at its most fundamental level, frame by frame.

Originally planned and executed as a film in its own right, *A Colour Box* was later restructured by Lye so that it could be used as an advertisement by the General Post Office. While somewhat incongruous as an advertisement, it nevertheless signifies the growing interest at the time in finding new means by which to sell products; Austrian film-maker Peter Kubelka's commission to produce a beer commercial, *Schwechater* (1958), represents another such novel partnership. Lye's film also points to the then-superior status of the animated moving image as compared to live-action film, due no doubt to its ability to conjure light and colour at a time when 'regular' film still laboured in chiaroscuro black and white.

HARRY SMITH

Early Abstractions 1–5, 7 and 10, 1941–57

16mm, colour, sound, 23 min.

Courtesy of Harry Smith Archives

STAN BRAKHAGE

The Dante Quartet, 1987

35mm/70mm, colour, silent, 7 min.

Courtesy of the estate of Stan Brakhage and fredcamper.com

Stan Brakhage's luminous, elemental response to Dante's *The Divine Comedy* harnesses the moving image at its root, claims light itself, and invokes a moving image of experience and emotion.

The Dante Quartet is divided into four parts, which refer to Dante's depictions of hell, purgatory and heaven. 'Hell Itself' begins with a lucid, fluid yet heavy mass of colour, mulch-green merging with sulphurous ochres in striated lines, smears, scrapes and cracks until obsidian envelops all. 'Hell Spit Flexion', Brakhage's mainspring, a source of and from hell, opens suddenly on smaller-gauge film, a bejewelled window within the frame. Splintered and cracked lines of light appear and are gone, like a wintry sun seen through moving branches. 'Purgation' brings hope, a depth now visible, layers of light and colour offering fragile glimpses of photographic images and a way through to a close yet obscured doorway. In a very complex sequence of images, there is a sense of the heightening of the contrast between and within forms, the motion now slowing to a halt, now accelerating rapidly, now finding its way – like a gesture of light – between still images. And then comes the final section, 'Existence is Song', which, it seems, contains all that has passed before. But it is not the clear message of hope or happiness that we might have expected; rather, it is the altogether more substantial, sustaining thought that all exists within all else, that just to exist is enough.

A peerless masterwork, *The Dante Quartet* remains – as perhaps does Brakhage's career itself – a call to arms to resist easy representation, the slight and shallow description of surfaces alone, and to realize an internal world; to summon a radical, essential moving image that draws from, and helps unravel, human experience.

OSKAR FISCHINGER

Radio Dynamics, 1942

35mm, colour, silent, 4 min.

© Fischinger Trust; courtesy of Center for Visual Music

FERNAND LÉGER

Ballet mécanique, 1924

35mm, black and white, sound, 16 min.

Courtesy of Anthology Film Archives

ABOVE

LUMIÈRE BROTHERS

Démolition d'un mur II, 1896

Camerawork attributed to Louis Lumière

35mm, nitrate negative, black and white,

silent, 47 sec.

© Association Frères Lumière (Lumière Film No. 40)

OPPOSITE

STEFAN AND FRANCISZKA THEMERSON

The Eye and the Ear, 1944–45

35mm, black and white, sound, 10 min.

Courtesy of Themerson Archive and LUX, London

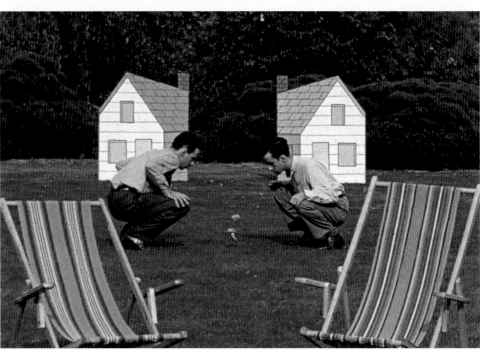

NORMAN MCLAREN

Neighbours, 1952

35mm, colour, sound, 8 min., 6 sec.

© 1952 National Film Board of Canada.

MARTIN ARNOLD

Alone. Life Wastes Andy Hardy, 1998
16mm, black and white, sound, 15 min.
Courtesy of Galerie Martin Janda, Vienna

Vienna-born film-maker Martin Arnold occupies
a prominent position in the history of Austrian
experimental moving images, alongside such figures
as Mara Mattuschka, Kurt Kren and Valie Export.
His technique, whereby he deconstructs the moving
image frame by frame, is in radical contrast to the
'additive' techniques of most animators; his work,
which includes both installation pieces (*Deanimated*,
2002) and single-screen films, elaborates on and
investigates the possibilities of this process further.

For *Alone. Life Wastes Andy Hardy*, Arnold
takes apart a selection of short passages from three
of the 'Andy Hardy' films (1937–58), a series of
sentimental Hollywood feature films starring Mickey
Rooney as Hardy. Arnold interrogates the image at
an atomic level, re-editing the passages in single
frames, drastically slowing down, stopping, cutting
and repeating the action until an entirely new,
Oedipal story emerges from the characters' simple
interchange. As in his other works, it feels as
though Arnold is refuting the apparent fluidity of
movement – the illusion of reality – that the live-
action footage (at twenty-four frames per second)
achieves, claiming it as animation and, by viewing
it as nothing but a succession of single frames,
subjecting it to the same rigours as animation.

While the effect of shuttling between
frames might have parallels with the work of a
video jockey, any such comparison pales beyond a
technical discussion: Arnold's film is no hollow MTV
filler but a radical exhumation of the contradictions
inherent not only in the moving image but also in
society itself. It is a *mise en abyme*, wherein a latent
narrative emerges from the saccharin of the original
action: a mirror-story already fixed on celluloid,
only encoded in the atomic structure of the moving
image and invisible until deciphered by the artist.
By extension, therefore, other worlds must also exist
within the first, limited, in some Borgesian algebra,
only by the number of frames themselves and the
skill of the artist to decode them.

ZBIGNIEW RYBCZYŃSKI

Tango, 1980

35mm, colour, sound, 8 min., 9 sec.

Filmoteka Narodowa (Polish National Film Archive)

In addition to being a taut, superbly restrained study of the ways in which animation can be used to alter the flow of time, Zbigniew Rybczyński's *Tango* is a visible record of the dimensionality of time itself; a musical score for movement made manifest.

A boy climbs through the open window of a room in a house to fetch his ball, and climbs out – but then does so again in exactly the same way. The course of time is evidently disrupted. However, in a fundamental shift, what we have presumed to be unique moments in time become moments at once: not only time but also space–time is ruptured as more characters arrive and carry out an increasingly bewildering array of tasks, simultaneously, each locked into his or her own course of action and oblivious to the others.

Playful, comic and undoubtedly intended for the wide audience it has garnered since it was made, *Tango* nevertheless acts as a springboard for a popular yet serious conceptual question, one best – perhaps only – illustrated by animation, able as it is to augment, reverse or arrest the flow of time. It is a question of dimensionality, of the notion of the existence of moments at once: if it is possible to imagine (and depict) this transgression of dimensions, does it call them into existence? Are we endlessly moving in cycles, displaced from other concentric cycles only by space, our actions subject to an eternal return at a cosmological level? It is the task of the manipulated moving image to summon such situations, to make manifest the imagination and to challenge the assumption of linearity in favour of a universe of curves and knots, parallels and divides.

CHUCK JONES

Duck Amuck, 1953

35mm, colour, sound, 7 min.

© Warner Bros.

VISIONS

Where 'Apparitions' showed how new moving-image technologies gave rise to the animated subject, previously literally unseeable, 'Visions' provides evidence of animation's extension since the late twentieth century into entire virtual worlds. So pervasive has the animated image become, and so compelling its technological capabilities – not only in terms of CGI realism (as breathtaking as this can be) but also in the emotional persuasiveness of a whole variety of techniques and styles – that the real and the imaginary have come close to fusion.

Just as the tropes and formats seen in 'Apparitions' were derived in part from the music hall and other forms of popular entertainment, so the new immersive fictions explored in this section draw on existing entertainment worlds. Steven Lisberger's pioneering film *Tron* (1982; pages 194–95) took the aesthetics and systems of the nascent video-game industry and expanded them into a whole world vision. Almost thirty years later, *Avatar* (2009; pages 192–93) made use of technologies that were effectively hugely developed game engines, now so sophisticated that they could allow virtual characters (derived from motion-capture renderings of real actors) to move as if through real space; the film also utilized a specially designed cloud computing system, which enabled the generation of a compellingly realistic artificial world, witnessed most memorably in the hallucinatory jungles of Pandora. With *SwanQuake: House* (2007; page 188), London-based moving-image artists igloo allow their viewers to navigate a virtual East End underworld with the use of gaming technologies, effectively framing the world as a game.

In *(Tommy-Chat Just E-mailed Me)* (2006; page 190), Ryan Trecartin builds a disconcerting reality television-style community portrait based on the conventions and semantics of e-mail dialogue, which has apparently replaced the temporal, linguistic and other behavioural codes of the analogue world. Semiconductor's *Matter in Motion* (2008; page 189) presents a series of vignettes that started life as photo-documentary snapshots of the Italian city of Milan, but which are transformed as buildings and roads begin to disintegrate and re-form, as if their very molecular structures were being reconfigured.

IGLOO

SwanQuake: House, 2007
Computer installation with sound
Courtesy of the artists

Devised by British artist-duo igloo (Bruno Martelli and Ruth Gibson), *SwanQuake: House* is an immersive, interactive installation that repurposes video-game technology and aesthetics to create a singular universe that is at once hermetic and free.

Video games are purposeful by nature: there is a goal to be reached, points to be won, opponents to be slain. *SwanQuake: House*, however, subverts such expectations at their most fundamental level: the point of Martelli and Gibson's 'game' is that there is no point – or, perhaps, that experience alone is the only goal. As such, the work presents a meticulously rendered, fully navigable world in which the usual 'protagonists' of a traditional video game – rooms, stairs, doors, windows, an outside and an inside – may at some other time have provided fertile and meaning-laden ground for battles, victories and losses, but now stand silent.

Something has happened, undoubtedly: deep beneath the building around which the installation is based, a burnt-out tube train rests on twisted tracks. But whatever it is that has happened, it happens no more. It is a virtual set, re-animated. Where figures appear – in the form of dancers – their presence elicits a certain calm. There is life yet in this universe; moreover, there is no mandate to kill or maim.

As much as it interrogates the experience of gaming and video games, *SwanQuake: House* is about space itself. It uses the devices of video games – in particular, the powerful first-person perspective, whereby the world of the game can be navigated 'naturally' – to engage with spaces both homely and un-homely, the security of an understood domestic geometry suddenly jarring with spatial aberrations akin to those in Borges's *Tlön, Uqbar, Orbis Tertius* or Mark Danielewski's *House of Leaves*. And it is this exploration of space, as though a question or challenge that might be posed on a larger scale in other 'virtual worlds', that most effectively deconstructs the mechanics of the video game, demanding a shift from acting to looking, and from goal-centred behaviour to something altogether more contemplative.

SEMICONDUCTOR

Matter in Motion, 2008

HD installation, colour, sound, 5 min., 36 sec.

Courtesy of Semiconductor

(Tommy-Chat Just E-mailed Me), 2006
Digital video, colour, sound, 7 min., 15 sec.
Courtesy of the artist and Elizabeth Dee, New York

Although valid on its own terms, as an attention-deficient and superbly entertaining critique of popular culture, Ryan Trecartin's *(Tommy-Chat Just E-mailed Me)* also functions as a treatise on mediated experience and the effect of the technology of mass culture on human interaction. With his protagonists reduced to hyperactive yet somnambulant drones, lurching from e-mail to text message in a high-colour dumb-show, Trecartin makes visible the grip that communications technology has on its users, ridiculing its vacuity via deliberately clichéd, ready-made video effects and rudimentary computer animation.

Disorientating and without a frame of reference, the 'real' and the 'virtual' are enmeshed, with human and ethereal conversations indistinguishable from one another as voices become increasingly distorted; the written word, when it appears, is dislocated from meaning. The physical world collides with the animated world, prompting the realization that there is perhaps no basis for supposing that even the former was ever physical, that the literal was ever truthful, or that the human was ever distinguishable from the machine.

As in the case of Trecartin's other works, *(Tommy-Chat Just E-mailed Me)* sports a cast of several of his friends and family. Indeed, it is this spirit of (aware) amateurism and bricolage, together with the artist's purposeful appropriation (and wilful misuse) of high-end, 'serious' video compositing effects, that distinguishes his work and prevents it from becoming two-dimensional, as either a semiotic thesis or an ironic, faux-naïve video mash-up.

CAO FEI/CHINA TRACY

Live in RMB City, 2009

Video, colour, sound, 25 min.

Courtesy of the artist and Vitamin Creative Space

JAMES CAMERON

Avatar, 2009

35mm, colour, sound, 163 min. (extended edition
170 min.)

© 20th Century Fox

James Cameron's *Avatar* was a genuine box-office phenomenon, attracting audiences who would not otherwise have attended a predominantly animated science-fiction film. This success can be attributed to two factors: first, the long-standing viral campaign that promoted the film as the future of cinema in its deployment of real-time motion-capture animation and its attention to immersive 3D space; and secondly, the broad mythic church of Cameron's narrative, which led to claims that he had plagiarized from any number of sources, including the 'World of Noon' novels by Arkady and Boris Strugatsky; Poul Anderson's film *Call Me Joe* (1957); Ursula Le Guin's novel *The Word for World is Forest* (1976); Hayao Miyazaki's animated feature *Laputa:*

Castle in the Sky (1986); Kevin Costner's *Dances with Wolves* (1990); John Boorman's *The Emerald Forest* (1985); and the fantasy designs of Roger Dean. Cameron's use of archetypes, some might say 'stereotypes', inevitably prompted such claims, but it is clear that the film's fundamental messages – the profound cost, damage and waste of American military intervention, and the deep-rooted failure of foreign policy – offer a radical perspective in conservative guise.

The giant, blue-skinned Na'vi of the planet Pandora are the focus of Cameron's eco-concerns, referencing origin myths and a pantheistic outlook to draw attention to the ways in which the natural world might be better understood. Moreover, the

plight of the Na'vi has distinct parallels with the fate of Native Americans, once more prompting public debate about the marginalization of certain peoples and cultures in pursuit of ideological and financial gain for White political elites. While Cameron might be criticized for one-dimensional storytelling, for the triumph of technology over theme, or for the depiction of George W. Bush-style 'shock and awe' in pursuit of Barack Obama-like pragmatism and diplomacy, it is telling that his use of the mainstream blockbuster format has generated more public discourse about significant issues than many high-minded art films.

STEVEN LISBERGER/WALT DISNEY

Tron, 1982

35mm, colour, sound, 96 min.

© Disney

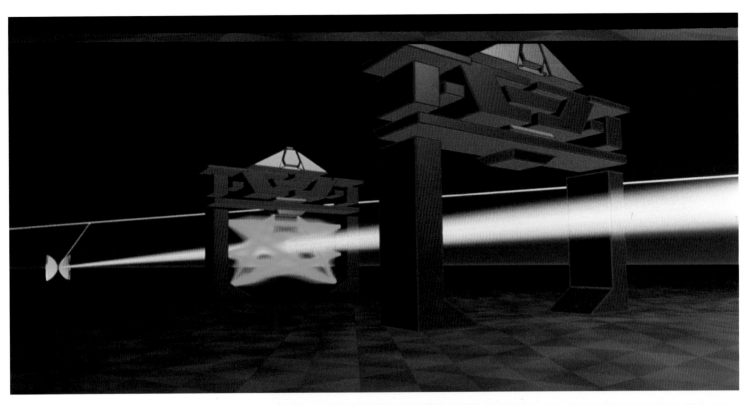

BIOGRAPHIES

A

AARDMAN ANIMATIONS was founded in Bristol in 1976 by school friends Peter Lord and David Sproxton. The pair began by creating the clay-model character of Morph for the BBC children's television programme *Take Hart*. They were also keen to develop an adult audience for model animation through such work as *Conversation Pieces*, commissioned by Channel 4 in 1982. In 1985 the studio hired animator Nick Park, whose *Creature Comforts* (1989) – originally aired as part of Channel 4's *Lip Synch* series – went on to win the Academy Award for Best Animated Short Film in 1990. Park also developed the clay-model adventures of Wallace and Gromit, the naïve English inventor and his canine best friend. With such films as *A Grand Day Out* (1989), *The Wrong Trousers* (1993) and *A Close Shave* (1995), the comic pair became beloved household names. In 2000 the studio made its first full-length feature film, *Chicken Run*; directed by Peter Lord and Nick Park, and produced by DreamWorks, the film grossed $220 million worldwide.

ALEXANDRE ALEXEIEFF (1901–1982) was a Russian-born artist, film-maker and illustrator. Following the revolution of 1917, he studied painting in St Petersburg before moving to Paris, where he designed sets and costumes for the Ballets Russes at the Chauve-Souris Theatre. A pioneer of early animation, Alexeieff invented the pinscreen method of animation with Claire Parker (1910–1981), his collaborator and second wife. The technique uses a screen perforated with headless pins, which are impressed at varying depths and lit obliquely. The resulting animations were considered revolutionary in their ability to escape the flat aesthetic of cel animation through the chiaroscuro of shadow-play. Alexeieff and Parker produced a number of films using the pinscreen, beginning with *Night on Bald Mountain* (1933), an adaptation of the symphony by Modest Mussorgsky. The impracticalities of the method, which was time-consuming and costly, meant that it was adopted by only one major studio, the National Film Board of Canada, which helped to produce the couple's second film, *En passant* (1944). In between making advertising films, Alexeieff and Parker continued to use the pinscreen, creating their first narrative film, *The Nose*, an animation of Nikolai Gogol's satirical short story, in 1963.

FRANCIS ALŸS (b. 1959) is a Belgian-born artist based in Mexico City, whose practice encompasses a range of different media, from photography and installations to painting and performances. A trained architect, he frequently works in drawing and animation, creating humorous, politically poignant films that look to the absurdities of everyday life. *The Last Clown* (1995–2000), for example, is an animation inspired by an incident that occurred when Alÿs was walking through a park: the curator he was with succeeded in tripping over a passing dog. The circus music and canned laughter that accompany the film underline the interplay between comedy and critique, while also satirizing the vulnerability of contemporary artists, who continue to be placed under an expectation to entertain. Alÿs's own performances have included *The Green Line* (2004), considered to be one of his most significant works, in which he walked

the length of the armistice border created between Palestine and Israel in 1948, trailing a line of green paint.

MARTIN ARNOLD (b. 1959) is an experimental Austrian film-maker, and a founding member of the distributor Sixpack Film. Since studying psychology and art history at the University of Vienna, he has taught at a host of film-making schools, including the San Francisco Art Institute; the Academy of Fine Arts, Frankfurt; Bard College, New York; and Binghamton University, New York. His body of work is characterized by an obsessive reworking of found footage, with seconds stretched out into intensely edited sequences. Arnold has described his intention to expose the latent narratives of the familiar films that he samples; *Passage à l'acte* (1993), for example, is modelled around a sequence from *To Kill a Mockingbird*. In 1998 Arnold made his first digitally cut project, *Alone. Life Wastes Andy Hardy*, which appropriated footage of the popular film character Andy Hardy, as famously played by Mickey Rooney.

B

RALPH BAKSHI (b. 1938) is an Israeli-born director of animated and live-action films who grew up in Brooklyn, New York. He graduated in 1957 from the School of Industrial Art (now the High School of Art and Design) in New York with an award in cartooning, and went to work as a cel polisher for Terrytoons Animation Studio in New Rochelle. At the age of twenty-eight he created and directed *The Mighty Heroes*, and was made creative director of the studio. In 1967 he moved to the animation division of Paramount Pictures, where he was responsible for *Marvin Digs*, *The Mini-Squirts*, *Super Basher and Bop* and *The Fiendish Five*. At Al Guest Studios he

produced and directed *Spiderman*, reincarnating the hero away from his comic-book life. With producer Steve Krantz he released his debut feature film, *Fritz the Cat* (1972), which was the first animated film to receive an X rating. He is known for his fantasy films, such as *The Lord of the Rings* (1978), which was shot entirely in live action before being rotoscoped; and for his television work, such as *Mighty Mouse: The New Adventures*. In 2003 he founded the Bakshi School of Animation and Cartooning.

JOSEPH BARBERA *see* HANNA-BARBERA PRODUCTIONS

JIŘÍ BARTA (b. 1948) is an acclaimed Czech animator who trained at the Prague School of Arts and Crafts. His early work made use of paper cut-out techniques; in *The Design* (1981), the equipment of scissors, set square and tweezers become additional characters in a film that revels in the meticulous artistry of the animator. He earned an international reputation with *The Pied Piper of Hamelin* (1985), in which carved wooden puppets populate a gothic cubist town. This dark animation of the classic German fairy tale (aesthetically reminiscent of Ingmar Bergman's epics) is today considered a landmark in puppet animation. In 1987 he made *The Last Theft*, his first live-action film. Created in the studio founded by Czech animator Jiří Trnka, Barta's films have often been overlooked by Western audiences. In 1993 he was appointed head tutor at the Academy of Fine Arts in Prague, and in 2001 was made a professor there.

JOY BATCHELOR *see* HALAS & BATCHELOR

J. (JAMES) STUART BLACKTON (1875–1941) was an Anglo-American film-maker and producer, and one of the first animators to experiment with stop-motion and drawn animation techniques. He began his career as a vaudeville performer specializing in 'lightning sketches', where he would rapidly modify drawings on an easel pad in front of a live audience. He joined the *New York Evening World* as a reporter and artist, and, in 1896, was assigned to interview Thomas Edison, who introduced him to his Vitascope projector. Blackton founded his own film studio in New York the following year – the Vitagraph Company of America – together with friend and colleague Albert E. Smith. The studio's productions included both live-action narrative films and stop-motion animated shorts. Notable among these were *The Enchanted Drawing* (1900) and *Humorous Phases of Funny Faces* (1906), which Blackton wrote and directed himself. The Vitagraph studio was sold to Warner Bros. in 1925.

PATRICK BOKANOWSKI (b. 1943) is an avant-garde French film-maker. In 1962 he went to study photography, optics and chemistry under the scholar Henry Dimier, who shared his interest in optical phenomena and perspective. Bokanowski began experimenting with filming through shards of hammered or blown glass in order to create more expressive, fluid forms. Soon, he began to incorporate reflective surfaces and mercury baths, with *At the Edge of the Lake* (1994) making use of fifteen specially manufactured mirrors. Bokanowski has described his artistic debt to the animations of Jean Mutschler, who originally inspired his cinematic interests. All his films are accompanied by soundtracks composed by his wife, Michèle. His challenging combination of media, as well as his disruption of traditional filmic genres, has led industry insiders to dub him the 'artist-alchemist of celluloid'.

CHRISTIAN BOLTANSKI (b. 1944) is one of France's foremost artists. With no formal art training, he began painting as an adolescent in 1958. His personal history became increasingly prominent as his practice diversified into letter writing and compiling compendia of family albums. Amending these personal relics, Boltanski explored an ambivalent past of 'truth' and 'untruth', while also parodying the mythology that surrounds the artist's biography. As he wrote for his Musée National d'Art Moderne retrospective in 1984: '1958. He paints. He wants to make art. 1968 … has a shock, gets into photography, black and white, tragic, human.' In this year of 'shock' he produced his first solo exhibition, *La vie impossible de Christian Boltanski*, in the Cinéma le Ranelagh in Paris, in which his first film was screened amid life-sized puppets. A string of fantasy shorts followed in 1969, including *L'Homme qui tousse*, a three-minute film in which a collapsed man coughs a lungful of blood over himself. In 1974 he 'stopped talking about his childhood and started playing with it', producing comic vignettes of himself farcically re-enacting milestones from his family history.

WALERIAN BOROWCZYK (1923–2006) was a Polish film director who worked largely in France. At the Academy of Fine Arts in Kraków, he specialized in painting and lithography, producing prize-winning posters for the cinema. After settling in Paris, he transferred his cinematic skills to film-making, experimenting with such animations as *Dom* (1958), which is only a few seconds long. *Les Jeux des anges* (1964), which portrays the metaphysical terror of the concentration camps through an aesthetic reminiscent of the work of Giorgio de Chirico, was selected by Terry Gilliam as one of the ten best animated films of all time. Borowczyk's first animated feature film, *Théâtre de Monsieur & Madame*

Kabal: un film dessiné pour les adultes, was directed in 1967. That same year, he was awarded the Max Ernst Prize for his achievements in animated film. His wife, Lygia Branice, featured in several of the live-action feature films that he began to make, beginning with *Goto, l'île d'amour* (1968). The pornographic content of his later works meant that many of them were met with a mixed critical reception. *Scherzo infernal* (1984) was Borowczyk's last animation, a depiction of hell as a sexual inferno populated by big-breasted demonesses with phallus tails, strutting amid the flames.

JAMES STANLEY 'STAN' BRAKHAGE (1933–2003) was an American film-maker and pioneer of experimental cinema. Born in Kansas City, he attended the California School of Fine Arts (now the San Francisco Art Institute) before dropping out to move to New York. There he was introduced to some of the acclaimed artists of the age, leading to collaborations with Joseph Cornell – on *Gnir Rednow* and *Centuries of June* (both 1955–56) – and John Cage, who agreed to the use of one of his compositions as the soundtrack for Brakhage's first colour film, *In Between* (1955). Although initially derided, his films earned critical recognition in the early 1960s, with Jonas Mekas writing in *Film Culture* that Brakhage's dynamic camera movement had initiated a 'stylistic revolution', making his *Desistfilm* (1954) 'one of the most influential of all modern American films'. Brakhage had completed more than fifty films by 1974, when P. Adams Sitney positioned him at the heart of *Visionary Film*, a seminal work on the history of American avant-garde cinema. In 1986 he was the first recipient of the Maya Deren Award, given by the American Film Institute to independent film artists. He taught at the School of the Art Institute of Chicago,

and later at the University of Colorado, continuing to be a productive film-maker right up until the end of his life.

ROBERT BREER (b. 1926) is an American artist and film-maker, whose work challenges the aesthetic conventions of animation. Breer delights in the poetry inscribed in the seemingly inconsequential, creating rhythmic collages out of drawings, cartoons, photographs and ephemera. His early films – simple stop-motion studies shot on a Bolex camera – reflect his training as an abstract painter in Paris from 1949. There, he became associated with the Denise René Gallery, where he saw screenings of abstract films by Hans Richter, Viking Eggeling and Walter Ruttmann. His fascination with mechanical forms continued after his return to the United States, finding prominence in his documentary *Homage to Tinguely* (1961), which was screened at the Museum of Modern Art in New York. After settling in New York, Breer became involved in the contemporary art scene there, befriending both Pop artists and performance artists involved in Fluxus happenings. Between 1952 and 1993 he made more than forty films exploring innovative combinations of animation techniques, including hand drawing and rotoscoping, as well as photocollage, live action and sound. From 1973 to 2001 Breer taught at the Cooper Union School of Art in New York.

TIM BURTON (b. 1958) is an American director, producer and screenwriter known for his macabre filmic visions. After studying character animation at the California Institute of the Arts, he was hired by the animation studio at Walt Disney Productions, where his personal tastes jarred with the house style as he worked as a concept artist on such films as *The Fox and the Hound* (1981). At this point

he created his first short, *Vincent* (1982), a black-and-white stop-motion film produced by Rick Heinrichs. His first live-action film was *Hansel and Gretel*, a Japanese-themed adaptation of the Brothers Grimm fairy tale produced for the Disney Channel in 1983. After being hired by Paul Reubens to direct *Pee-wee's Big Adventure* (1985), he went on to direct such acclaimed films as *Beetlejuice* (1988), *Batman* (1989), *Edward Scissorhands* (1990) and *Sweeney Todd: The Demon Barber of Fleet Street* (2007). His computer-animated version of *Alice in Wonderland* (2010) grossed more than $1 billion worldwide. Burton is known for his recurrent collaborations with such actors as Johnny Depp and Helena Bonham Carter, his partner, as well as with musician Danny Elfman, who has composed for all but five of his films.

C

JAMES CAMERON (b. 1954) is a Canadian film director, producer, screenwriter, editor and inventor. After his family moved to California in 1971, he began to teach himself the rudiments of special effects, later deciding to enter the film industry after watching the original *Star Wars* film. Working initially as a maker of miniature models at New World Pictures, he was subsequently appointed as the art director for *Battle Beyond the Stars* (1980); the following year, he was hired as the special-effects director for *Piranha II: The Spawning*. Cameron sold his screenplay for *The Terminator* (1984) to Hemdale Pictures for $1 on the condition that he could make his directorial debut. Following the film's unexpected box-office success, he went on to script and direct the two highest-grossing films to date, *Titanic* (1997) and *Avatar* (2009), which made $1.8 billion and $2.7 billion, respectively. An avid scientist, Cameron is the co-founder of Digital Domain, an Academy

Award-winning digital production studio. Since 2000 he has made a series of documentary films, and has co-developed the digital Fusion 3D camera system.

CAO FEI (b. 1978) is a Chinese artist who lives and works in Beijing. She received her BFA (Batchelor of Fine Arts) from the Guangzhou Academy of Fine Arts in 2001, and has since earned recognition for her video installations and new-media works, which reflect on the rapid pace of development in Chinese life. She uses sampling, role play and documentary film-making to capture the role of fantasy in contemporary patterns of social interaction. Fascinated by Second Life, the online platform that has amassed more than 14 million registered users, Cao often appears in her work as her Second Life avatar, China Tracy. Working within a fluid world of hyperlinks, she explores the reduction of cultural traditions to a global melting pot of references. In her virtual utopia RMB City, allusions to ancient Chinese painting abound in an urban amalgam of Chinese icons – old and new – from the panda to the Beijing National Stadium built for the 2008 Olympics.

SEGUNDO DE CHOMÓN (1871–1929) was a Spanish film director of French descent. A trained engineer, he is considered one of cinema's first great masters of optical effects. In 1895 he travelled to Paris, where he met and wed the performer Julienne Mathieu, who introduced him to the laboratory facilities of Georges Méliès and Pathé Frères. In 1901 he moved to Barcelona, where he worked as a concessionary for Pathé, organizing the distribution of its films to Spanish-speaking countries, and opening a workshop for tinting the films with colour. In 1905 he returned to Paris, where he assumed control of Pathé's special-effects department, working on such films as *Les Cent trucs* (1906) and *Les Kiriki,*

acrobates japonais (1907). He was responsible for developing a number of new camera tricks, including single-frame techniques, optical dissolves and travelling shots, becoming a master in animation. Chomón made thirty-seven films with Chomón y Fuster, the company he founded in 1910, before working for the Barcelona-based Pathé subsidiary Ibérico. In 1912 he patented the film-colouring system 'Cinemacoloris', and was made director of photography for Itala Film in Turin, where he would create the animated puppet scenes for *Momi's War and Dream* (1916).

ÉMILE COHL (1857–1938) was a French pioneer of animation. His interest in caricature led him to André Gill, who gave him a job as a background artist in 1878. Following Gill's death in 1885, Cohl moved to London to work for the magazine *Pick Me Up*. In 1908, having returned to Paris, he joined the Gaumont film company, first as a writer, and then as a director. Fascinated by animation, he used line drawings, cut-outs, puppets and other techniques to pioneer the use of character in the new medium. His first animated work (often credited as the first fully animated film) was *Fantasmagorie* (1908), which used more than 700 chalk line-style drawings on sheets of paper. Other films for Gaumont include *Clair de lune espagnol* (1909) and *Le Tout Petit Faust* (1910). In the year of the latter film's completion Cohl joined Pathé, making just two animations before being forced to direct live-action burlesques. He briefly joined the Eclipse studio in 1911 before moving to Fort Lee, New Jersey, where he created newsreel inserts and animated advertisements. He returned to Paris in 1914.

D

WALT DISNEY *see* THE WALT DISNEY COMPANY

NATHALIE DJURBERG (b. 1978) is a Swedish video artist who lives and works in Berlin. Her stop-motion short films typically operate in a faux-naïve aesthetic, with characters modelled in a child-like, gestural fashion from clay or plasticine. Each of her films offers up a twisted fairy tale disrupted by scenes of violence and graphic sexuality. As Roberta Smith has written, they present 'various kinds of vileness: from mild deception, friendly torture and oddly benign bestiality to murder and mayhem' (*New York Times*, 19 May 2006). Accompanied by musical compositions by Hans Berg, the films are often screened as part of an installation designed to accentuate their surreal quality. Djurberg transports the visitor into the tabooed recesses of the popular imagination. *Tiger Licking Girl's Butt* (2004), for example, features a tiger reminiscent of the icon of Kellogg's Frosties, who licks a girl's buttocks behind the recurrent subtitle, 'Why do I have this urge to do these things over and over again?'

E

VIKING EGGELING (1880–1925) was a Swedish-born German artist. Having studied painting and art history in Milan, he moved to Zurich at the outbreak of the First World War, befriending such protagonists of the Dada movement as Hans Richter, Jean Arp and Tristan Tzara. In 1922 he bought a motion-picture camera, which enabled him to experiment with a cinematic style completely at odds with the prevailing naturalism. The following year he screened a ten-minute film based on an earlier scroll; titled *Horizontal-Vertical Orchestra*, the film has since been lost. In 1924 he completed work on *Symphonie Diagonale*, for which he had individually photographed frames of paper cut-outs and tin-foil figures. In the film, movement is objectively analyzed; as Standish Lawder has written, 'a sober quality of rhythm articulation remains the most pronounced quality'. Eggeling died sixteen days after the film was publicly screened in Germany on 3 May 1925.

JULES ENGEL (1909–2003) was an American artist, film-maker and director of both live-action and animated films. After training at the Chouinard Art Institute in Los Angeles, he worked first for Charles Mintz Studios, and then for Walt Disney Productions. There, he was responsible for storyboarding the dance sequences of the Nutcracker Suite segment in *Fantasia* (1940) before doing colour work and movement analysis for *Bambi* (1942). Engel left Disney after a labour strike by the animators, moving to work for the First Motion Picture Unit. He became a founding member of United Productions of America (UPA), where he worked as a background artist on such cartoons as *Mr. Magoo* (1949) and *Madeline* (1952). With colleagues from UPA he helped to establish Format Films, which produced one-off animated shorts, including the Academy Award-nominated *Icarus Montgolfier Wright* (1962), as well as such popular American television series as *The Lone Ranger* (1966–67). In 1970 Engel founded the Program in Experimental Animation at the California Institute of the Arts, which became a centre for aspiring animation talent.

F

HARUN FAROCKI (b. 1944) is a German film-maker of Czech descent. From 1966 to 1968 he trained at the German Film and Television Academy in West Berlin. He has since made more than one hundred productions for television and cinema – working in a range of media and for different audiences – including documentary films, film essays and children's television. He has also collaborated with other film-makers as a screenwriter, actor and producer. Acclaimed early films include *The Words of the Chairman* (1967), *The Inextinguishable Fire* (1969) and *As You See* (1986). He had his first major retrospective in 1990 following the success of festival screenings of *Images of the World and the Inscription of War* (1988). This subversive meditation on the philosophy of Paul Virilio has since become a landmark in thinking on the ethics of representation in the wake of Auschwitz. Between 1993 and 1999 he was a visiting professor at the University of California, Berkeley, and in 2006 he became a professor at the Academy of Fine Arts Vienna.

OSKAR FISCHINGER (1900–1967) was a German-American artist and film-maker. Around 1920 he met Dr Bernhard Diebold at a literary club in Frankfurt; seeing Fischinger's abstract scroll sketches, Diebold urged him to take up abstract film-making. At what was the first public screening of an abstract film, Fischinger was greatly impressed by Walter Ruttmann's *Opus I* (1921). Not long afterwards, he resigned his engineer's job and moved to Munich to become a full-time film-maker. In June 1927 financial difficulties forced him to leave Munich, so he walked to Berlin, where he began to re-establish himself. In 1928 he was hired to create rockets and other special effects for Fritz Lang's *Frau im Mond* (1929). The following year he took the decision to devote himself entirely to abstract film-making. This led to a remarkable series of black-and-white studies tightly synchronized to music, which screened widely in Europe, Japan and the United States. Fischinger pursued his experiments with drawn synthetic

sound and collaborated on the development of a three-colour film process, Gasparcolor, which allowed him to complete his first colour film, *Kreise* (1933). His subsequent colour films, *Muratti Marches On* (1934) and *Composition in Blue* (1935), gained so much critical and popular acclaim that Paramount offered him a contract, and in February 1936 he set sail for Hollywood. However, he found it extremely difficult to work in studio situations, enduring episodes at Paramount (1936), MGM (1937) and Disney (1938–39), where he worked on *Fantasia* (1940). His frustration at not being able to produce independent films led him to take up oil painting, and he came under the patronage of Hilla Rebay, curator of the Solomon Guggenheim Foundation, who extended several grants to him during the difficult war years. Unfortunately, they quarrelled over the artistic merits of his film *Motion Painting No. 1* (1947), and he never again received adequate financial support to complete a film. For the last twenty years of his life, Fischinger had to content himself with unfinished projects, his paintings and the Lumigraph, his colour organ.

DAVID 'DAVE' FLEISCHER (1894–1979) was an American animator. After working as a film cutter for the US division of Pathé, he assisted his brother Max in developing and patenting the rotoscope. This device allowed an animator to create cartoon forms by tracing over live-action figures, such as when Max used footage of Fleischer to animate his first major cartoon character, Koko the Clown. In 1921 the brothers founded Inkwell Studios (renamed Fleischer Studios in 1929), where Fleischer would direct and later produce a number of the company's acclaimed animations, including those starring Betty Boop and Popeye the Sailor. Popeye proved to be an instant success, enabling Paramount, which distributed the Fleischer cartoons, to

contend with Disney's increasing dominance of the market. In 1942, following financial strains and a feud with his brother, Fleischer left Fleischer Studios and went on to become president of Screen Gems at Columbia Pictures. Towards the end of the decade he moved to Universal, where he became a special-effects expert, working on such films as *The Birds* (1963) and *Thoroughly Modern Millie* (1967).

MAX FLEISCHER (1883–1972) was an American animator. He received commercial art training at Cooper Union School of Art in New York before becoming a cartoonist for the *Brooklyn Daily Eagle*. In 1915 he was granted a patent for his rotoscope, which vastly simplified the process of animating movement. Six years later he founded Inkwell Studios with his brother Dave. Fleischer's *Song Car-Tunes* series (1924–27) pioneered the use of a 'bouncing ball' device to guide audiences in sing-along sequences, and were the first cartoons in which sound was synchronized with animation. Following bankruptcy in 1929, Inkwell Studios was reorganized as Fleischer Studios, and the new company went on to gain success with its *Talkartoons* series (1929–32) and Betty Boop, who was quickly dubbed the 'Queen of the Animated Screen'. Now supported by Paramount, Fleischer Studios became a major New York operation, renowned for its saucy, urban aesthetic. The decline began when Fleischer lost out to Disney on the newly available three-colour Technicolor process, and when the 'Hays Code' of 1934 forced the racier aspects of Betty Boop to be toned down, causing her popularity to wane. The intricate Art Deco designs of the *Superman* series (1941–42) made it a final triumph for the innovative studio, which closed in 1942. Fleischer went on to become head of animation at the Jam Handy Organization, leaving in 1954 for Bray Productions in New York.

ARI FOLMAN (b. 1962) is an Israeli screenwriter, director and film-score composer who lives and works in Tel Aviv. He is the child of Holocaust survivors, and his work documents an intimate investment in the politicization of memory. In 2008 Folman was brought to global attention with the release of *Waltz with Bashir*, an animated documentary film that follows his attempt to recollect the Sabra and Shatila massacre of 1982, which took place when he was a nineteen-year-old soldier in the Israel Defence Forces. Made into a graphic novel in 2009, the film betrays its visual roots in this medium, with art director David Polonsky citing the work of the comic artist Joe Sacco as a prominent influence. Together with Tatia Rosenthal's *$9.99* (2008), Folman's film was the first Israeli animated feature-length film to be released in cinemas since Alina and Yoram Gross's *Ba'al Hahalamot* (1962). *Waltz with Bashir* has won numerous awards, including a Golden Globe for Best Foreign Language Film and a National Society of Film Critics Award for Best Picture.

JOE GERHARDT *see* SEMICONDUCTOR

RUTH GIBSON *see* IGLOO

TERRY GILLIAM (b. 1940) is a British screenwriter, film director, animator and actor who came to prominence through his work with the Monty Python comedy troupe. Born in Minnesota, he moved to California in 1952, and studied political science at Occidental College, Los Angeles. He joined Harvey Kurtzman as an assistant on *Help!*, and when the magazine folded he joked that he was being 'transferred to the European branch'. Having moved to England, he

animated the children's television series *Do Not Adjust Your Set* (1967–69), which featured future Pythons Eric Idle, Terry Jones and Michael Palin. Gilliam's surreal animations linked the sketches in *Monty Python's Flying Circus* (1969–74), while he often appeared in individual scenes. As the Pythons gradually disbanded between the making of *The Life of Brian* (1979) and *The Meaning of Life* (1983), Gilliam began to work on other projects as a screenwriter and director. His 'trilogy of imagination' began with *Time Bandits* (1981), and was followed by *Brazil* (1985) and *The Adventures of Baron Munchausen* (1988). Belonging to the fantasy genre, his films are known for their *mise en scène*, and for their use of unusual camera angles to create a hallucinatory aesthetic. His recent projects have included *The Imaginarium of Doctor Parnassus* (2009), which was co-written with his long-time collaborator, Charles McKeown. Gilliam made his opera debut in May 2011, directing *The Damnation of Faust* for the English National Opera.

MATTHEW 'MATT' GROENING (b. 1954) is an American screenwriter, cartoonist and producer. The son of film-maker and cartoonist Homer Groening, he moved to Los Angeles in 1977 to pursue a career in writing. He depicted his life there in a self-published comic book called *Life in Hell*, which became an instant underground success and is still carried by 250 weekly newspapers. Groening is perhaps better known as the creator of *The Simpsons*, an animated television series about a loveable, dysfunctional family named after his own. Initially created for the Fox variety programme *The Tracey Ullman Show*, it first aired in 1987. A spin-off series followed two years later, through a collaboration with what is now the Klasky Csupo animation house. In 1997 Groening teamed up with writer and producer David X. Cohen to develop an animated series set in the year 3000.

Futurama premiered in 1999 and aired for four years; new episodes commissioned by Comedy Central were screened in June 2010. Groening is the recipient of innumerable awards, including eleven Emmys.

H

JOHN HALAS *see* HALAS & BATCHELOR

HALAS & BATCHELOR was an English animation studio formed in 1940 by husband-and-wife team John Halas (1912–1995) and Joy Batchelor (1914–1991). Starting life as a small animation unit creating commercials for theatrical distribution, it grew to be the country's largest producer of animated films. During the Second World War it made more than seventy short propaganda films, including *Dustbin Parade* (1941), in which a brave bone encourages his friends – a collection of other items of rubbish – to help with the war effort. In 1945 the studio made *Handling Ships*, the first-ever British animated feature, which was followed by an adaptation of George Orwell's *Animal Farm*, released to critical acclaim in 1954. Although the studio operated in a variety of genres, from documentaries to experimental art movies, it became popularly known for its animated series, including *Foo Foo* (1959–60), *DoDo, The Kid from Outer Space* (1965–70) and *The Lone Ranger* (1966–69). After the death of Joy Batchelor in 1991, John Halas continued to produce films until his death in 1995.

WILLIAM HANNA *see* HANNA-BARBERA PRODUCTIONS

HANNA-BARBERA PRODUCTIONS was an American animation studio formed in 1957 by

William Hanna (1910–2001) and Joseph Barbera (1911–2006), in partnership with Columbia Pictures' Screen Gems. Having previously worked for the animation team of Harman and Ising and Van Beuren Studios, respectively, the pair first collaborated at Metro-Goldwyn-Mayer. In 1940 they directed *Puss Gets the Boot*, a one-reel cartoon starring Jasper the cat and Jinx the mouse that would eventually lead to their long-running, Academy Award-winning series *Tom and Jerry*. After the closure of the MGM animation studio, Hanna and Barbera founded H-B Enterprises (later renamed Hanna-Barbera Productions), employing several of their former colleagues. The new company's first creation was *The Ruff and Reddy Show* (1957–60), featuring a smart-alec cat (Ruff) and a slow-thinking dog (Reddy). Despite being produced with a limited budget, Ruff and Reddy proved popular enough for the studio to receive a commission for a brand-new, half-hour series. Starring Huckleberry Hound, Pixie and Dixie and Mr Jinks, and Yogi Bear in their own short cartoons, *The Huckleberry Hound Show* premiered on 2 October 1958, and was a runaway success, garnering an Emmy for outstanding achievement in children's programming. An avalanche of new characters followed, including Quick Draw McGraw, Wally Gator, Snagglepuss, Secret Squirrel, Atom Ant and the hapless contestants of *Wacky Races*. In 1960 *The Flintstones* – an affectionate tribute to the hugely popular 'The Honeymooners' segment on *The Jackie Gleason Show* – premiered on prime-time television, eventually running for six seasons. Over the next three decades Hanna-Barbera produced prime-time, weekday-afternoon and Saturday-morning cartoons for all three major US television networks, becoming famed for such series as *Scooby-Doo, Where Are You!*, *The Jetsons* and *The Smurfs*. In 1967 Hanna and Barbera sold the studio to Taft Broadcasting, remaining

as co-chairmen until it was acquired by Turner Broadcasting in 1991, after which it was absorbed by Time Warner.

RAY HARRYHAUSEN (b. 1920) is an American film producer and special-effects expert, best known as the creator of Dynamation, a type of stop-motion model animation. Following an influential meeting in 1938 with his idol, Willis O'Brien, the animator for *King Kong* (1933), Harryhausen was encouraged to develop his modelling skills by enrolling in art and anatomy classes at the Los Angeles City College. His education continued in night classes at the University of Southern California, where he studied art direction, editing and photography. His first animation job followed in 1940, working with George Pal on the small-scale *Puppetoons* series. During the Second World War, Harryhausen helped to produce propaganda films for the Army Motion Picture Unit. He later compiled a demo reel of recent projects to present to O'Brien, who hired him as an assistant on what would be Harryhausen's first major film, *Mighty Joe Young* (1949). He went on to work as an animation specialist on a number of science-fiction and action-adventure films for Columbia Pictures and, later, Metro-Goldwyn-Mayer, bringing stop-motion animation into live-action films with his Dynamation technique. In 1992 he received the Gordon Sawyer Award for his technological contributions to the motion-picture industry.

CECIL M. HEPWORTH (1874–1953) was an early pioneer of film, and a driving force in the development of British cinema. The son of Thomas Cradock Hepworth, a popular magic-lantern entertainer, he began touring with his own slide and film show in 1896. Having attended lectures on the technical art of photography as a child, he was well positioned to publish a handbook on the

medium, *Animated Photography*, in 1897. The following year he began working for Charles Urban, the manager of what would become known as the Warwick Trading Company. Hepworth established his own laboratory, and by the turn of the century was releasing a hundred films a year with associates Percy Slow and Lewin Fitzhamon. Although occasionally writing, directing, editing, photographing and even starring in the films credited to him, Hepworth was primarily a producer on such celebrated films as *Rescued by Rover* (1905), *The Other Side of the Hedge* (1905) and *That Fatal Sneeze* (1907). He returned to directing in 1914; however, he was unable to keep up with trends in filmic technique, and in 1924 filed for bankruptcy. The original film negatives in Hepworth's possession were melted down by the receiver in order to sell the silver they contained.

I

IGLOO is the creation of London-based artists Bruno Martelli (b. 1967) and Ruth Gibson (b. 1964). Martelli trained in graphic art at Central Saint Martins, London, before establishing a multimedia platform for interactive design. As well as curating such exhibitions as *Wired Worlds* at the National Media Museum in Bradford (1994–2004), he has worked with artist John Latham and muf architects. As the recipient of a Wingate Scholarship, he continues to research 'technologies to abstract the human body, its movement and its senses'. Gibson graduated with a BA in Performing Arts from the University of Kent, Canterbury. While on a scholarship at the University of Michigan she studied with the Marcel Marceau Group, later moving to Amsterdam to study at the School for New Dance Development. In 2000 she was nominated for a Paul Hamlyn Award for Visual Art, and has since worked with such artists as

Sandra Fisher, Gary Rowe and Gaby Agis. As igloo, Martelli and Gibson work in a wide range of media, from installation and intervention to film and performance.

UB IWERKS (1901–1971) was an American animator, inventor and special-effects technician famed for his work at the Walt Disney studios. Born Ubbe Ert Iwwerks, he began his career at the Pesmen-Rubin Commercial Art Studio, where he befriended a young Walt Disney. The pair formed the short-lived Iwerks-Disney Commercial Artists in 1920 before Disney left to work for the Kansas City Film Ad Company, soon to be followed by Iwerks. In 1924 Iwerks moved to California, once more to join forces with Disney, who had formed the Disney Brothers Cartoon Studio with his brother Roy. Here Iwerks worked on the cartoon series *Oswald the Lucky Rabbit* before developing Disney's new character, Mickey Mouse. His relationship with Disney was severed after he accepted a contract with rival Pat Powers in order to establish himself independently. The Iwerks Studio opened in 1930, and produced a range of Cinecolor shorts, including the racially stereotyped *Little Black Sambo* (1935), which was subsequently banned. Financial support was withdrawn the following year, causing the studio to fold soon afterwards. Iwerks took on contract work for Leon Schlesinger Productions and Screen Gems before returning to Disney in 1940, where he focused on special effects.

J

PETER JACKSON *see* WETA DIGITAL

RUTH JARMAN *see* SEMICONDUCTOR

CHARLES MARTIN 'CHUCK' JONES (1912–2002) was an American artist, animator, producer and director, notably of the *Looney Tunes* and *Merrie Melodies* cartoon series. He made more than 300 animated films over a sixty-year career, winning three Academy Awards as director and, in 1996, receiving an honorary Oscar for Lifetime Achievement. Raised in Hollywood, Jones trained at the Chouinard Art Institute before being hired as a cel washer for Ub Iwerks in 1932. The following year he moved to Leon Schlesinger Productions – later bought by Warner Bros. – where he was assigned to Tex Avery's animation unit in 1935. He remained at Warner Bros. until the studio closed, co-creating some of the great characters of the golden age of animation, including Bugs Bunny, Daffy Duck, Elmer Fudd and Porky Pig. In 1962 he established his own production company and began producing cartoons for MGM. He later started his own studio, Chuck Jones Productions, with which he produced a number of animated series, including *Rikki-Tikki-Tavi* and *The White Seal*.

K

WILLIAM KENTRIDGE (b. 1954) is a South African artist widely acclaimed for his animated films, many of which draw on the past and present injustices of South Africa. He originally studied politics and African studies at the University of Witwatersrand before turning first to fine art at the Johannesburg Art Foundation, and then to mime and theatre at L'École Internationale de Théâtre Jacques Lecoq in Paris. Kentridge's work has been described as 'drawing for projection', since charcoal or pastel marks are erased after each step. This process is filmed using a 16mm or 35mm camera, a frame or two at a time. The drawings themselves are then exhibited alongside the films as components of the work. His most famous films, such as *Felix in Exile* (1994) and *History of the Main Complaint* (1996), follow the lives of two characters, Soho Eckstein and Felix Teitelbaum. Often interpreted as representing Kentridge himself, Teitelbaum is a Jewish entrepreneur who lives through, and is somewhat complicit in, apartheid and its tragic aftermath. More recently, Kentridge has also directed and designed operas, including *The Magic Flute* and *The Nose*.

MASAMI KURUMADA (b. 1953) is a Japanese manga artist and writer. In 1974 his first work, *Otoko Raku*, won him an award for aspiring *mangaka* (manga authors). He made his professional debut in the same year, with *Sukeban Arashi*, and earned acclaim three years later with *Ring ni Kakero*, which featured a young boxer named Ryuunji Takane and his coaching sister, Kiku. Translated as *Put It All in the Ring*, the manga was published between 1977 and 1981 in twenty-five volumes. Kurumada is a noted follower of Osamu Tezuka's 'star system', whereby a stable of characters is drawn on for each new manga, and many of his characters resemble Ryuunji Takane in personality and physique. Later acclaimed works include *Saint Seiya* (also known as *Knights of the Zodiac*), which was serialized in the magazine *Weekly Shonen Jump* from 1986 to 1991 before being adapted into a television series by Toei Animation between 1986 and 1989.

L

JOHN LASSETER (b. 1957) is the chief creative officer (CCO) at the Pixar and Walt Disney animation studios. Born in Hollywood, he became the second student to enrol in the new animation course at the California Institute of the Arts, where his classmates included Brad Bird and Tim Burton. During his time there he won student Academy Awards for his shorts *Lady and the Lamp* (1979) and *Nitemare* (1980). He joined the Walt Disney Company shortly after graduating, and was soon promoted to work for Walt Disney Feature Animation. He realized the potential of computer animation after seeing the first light-cycle sequences for *Tron* (1982). Frustrated by his more conservative superiors, Lasseter left Disney in 1984 to join the computer-animation division of Lucasfilm's Industrial Light and Magic. Shortly afterwards the company was purchased by Steve Jobs, who renamed it Pixar. In 1988 Lasseter won an Oscar for the first entirely computer-animated short, *Tin Story*, which paved the way for *Toy Story* (1995), the first feature-length computer-animated film. A string of blockbusters followed, including *A Bug's Life* (1998), *Toy Story 2* (1999) and *Cars* (2006), which won the first-ever Golden Globe for Best Animated Feature. In 2006 Disney officially acquired Pixar, awarding Lasseter with the post of CCO.

CAROLINE LEAF (b. 1946) is a Canadian-American film-maker known for her innovative use of handcrafted, under-the-camera animation techniques. While studying at Harvard University she made her debut film, *Sand, or Peter and the Wolf* (1969), by manipulating individual frames of images drawn in sand spread across the surface of a light box. She continued to explore technique with her second film, *Orfeo* (1972), for which she painted directly on to glass under the camera, while *The Street* (1976) saw her use a mixture of paint and glycerine. Adapted from Mordecai Richler's short story, the latter film was nominated for an Academy Award for Best Animated Short Film. In 1972 Leaf moved to Montreal at the invitation of the National Film Board of Canada, where she worked as a staff animator and director until

1991. Between 1981 and 1986 she dedicated herself to live-action documentaries, a genre to which she has intermittently returned. *Two Sisters* (1990) won the Best Short Film award at the Annecy International Animated Film Festival in 1991, and in 1996 Leaf received a Lifetime Achievement Award from Animafest in Zagreb.

ANG LEE (b. 1954) is a Taiwanese-American film director. After graduating with a degree in theatre studies from the University of Illinois in 1980, he completed an MFA (Master of Fine Arts) at the Tisch School of the Arts in New York; his thesis film, *Fine Line* (1984), won the Wasserman Award for Outstanding Direction, and was later shown on the Public Broadcasting Service (PBS). In 1990, following a period in which he struggled to launch his career, he gained the attention of producer Li-Kong Hsu with two screenplays, *Pushing Hands* and *The Wedding Banquet*, which were entered into a competition sponsored by the Government Information Office of the Republic of China. The former was realized in 1992, and was a resounding success in Taiwan, receiving eight nominations in the Golden Horse Film Festival; the latter was made in 1993, and won the Golden Bear at the Berlin Film Festival. In 1995 Lee directed Columbia TriStar's *Sense and Sensibility*, which was followed by two Hollywood features: *The Ice Storm* (1997) and *Ride with the Devil* (1999). With poor box-office receipts, both films were in direct contrast to the storming success of *Crouching Tiger, Hidden Dragon* (2000), a sprawling martial-arts epic that demonstrated the global appeal of Lee's artistry. In 2003 he directed *Hulk*, a film based on the Marvel character of the same name. Two years later he returned to independent cinema, directing an adaptation of E. Annie Proulx's short story *Brokeback Mountain* to international acclaim.

FERNAND LÉGER (1881–1955) was a French painter, sculptor and film-maker. In 1900, after working in an architect's office in Caen, he moved to Paris, where he attended the École Nationale Supérieure des Beaux-Arts (although he was never formally enrolled as a student) and the Académie Julian. Working initially as a painter, he developed a great enthusiasm for the cinema. In 1923 he designed the set for the laboratory scene in Marcel L'Herbier's *L'Inhumaine*. The following year he collaborated with Dudley Murphey (co-director), Man Ray (cinematographer) and George Antheil (composer) on the iconic film *Ballet mécanique*. A score of loud percussive noises (heavily influenced by the Futurists) was written to accompany the film, which consists of close-up shots of a woman's lipsticked smile interspersed with images of ordinary objects and abstract mechanical forms. Today, this sixteen-minute black-and-white film is considered a landmark in the development of montage as a cinematic tool. The jarring structure of shattered fragments reflects Léger's enduring interest in machinery, which potently symbolized his experience on the front line during the First World War. Antheil's original score ran for nearly thirty minutes, and a print of the film in which music and images were synchronized was achieved only in 2000, by sound engineer and composer Paul Lehrman.

RUTH LINGFORD (b. 1953) is a British animator. After working as an occupational therapist with the mentally ill, she retrained in fine art and art history at Middlesex Polytechnic, beginning her studies in 1987. Three years later she undertook an MA in animation at the Royal College of Art, where she would later teach. A Channel 4/Arts Council England 'animate!' grant enabled her to make *What She Wants* (1993), which was produced entirely on an Amiga 1500 personal computer. The film marked her entry into the

'feel-bad' genre, drawing on the seductive medium of animation to entice an audience towards uncomfortable content. Accompanied by a solo saxophone performance by Lol Coxhill, it tenderly explored the anxieties surrounding contemporary models of femininity. In 1998 Lingford completed *Pleasures of War* for Channel 4, a short film that retells the biblical tale of Judith and Holofernes, unravelling a network of connections between femininity, war and sexual desire. Devised in collaboration with the novelist Sara Maitland, it was selected as one of the 150 best films ever made in Geoff Andrew's *Film: The Critics' Choice* (2001). Lingford has won numerous awards, and in 2008 was the recipient of a Harvard Film Study Center Fellowship.

PETER LORD *see* AARDMAN ANIMATIONS

AUGUSTE MARIE LOUIS NICOLAS LUMIÈRE *see* THE LUMIÈRE BROTHERS

LOUIS JEAN LUMIÈRE *see* THE LUMIÈRE BROTHERS

THE LUMIÈRE BROTHERS, Auguste Marie Louis Nicolas (1862–1954) and Louis Jean (1864–1948), were pioneers of early cinema and colour photography. Their first encounter with the camera occurred while working at their father's photography firm, where they developed an enhanced version of the dry photographic plate. In 1895, taking their cue from Thomas Edison's kinetoscope, they created the cinematograph, a combination of a movie camera and a projector. That year they also created their first film, *La Sortie des usines Lumière à Lyon* (Workers Leaving the Lumière Factory in Lyon). Screened publicly at the Salon Indien du Grand Café in Paris

with a selection of their other films, it is widely credited as the first live-action motion picture in history. The Lumière brothers went on to create hundreds of films, focusing on everyday life. Beyond their technological interest, these films offer a unique historical insight into nineteenth-century French society.

LEN LYE (1901–1980) was a New Zealand-born American experimental film-maker. He explored the possibilities of kinetic art as a student before travelling extensively around the South Pacific, drawing on indigenous communities for ideas. He moved to London in 1926, joined the artistic collective known as the Seven and Five Society (which, following the admission of such abstract artists as Ben Nicholson, had recently taken a modernist turn), and exhibited in the International Surrealist Exhibition of 1936. Lye's first animated film, *Tusalava* (1929), which required 4000 separate drawings, was followed by films sponsored by the General Post Office Film Unit. His film for 'cheaper parcel post', *A Colour Box* (1935), became the first 'direct animation' film to be screened to a general audience. He went on to work for the Crown Film Unit, providing such wartime animations as *Musical Poster Number One* (1940). Today, Lye is heralded as one of the most important innovators of direct film-making, having pioneered the technique of painting directly on to celluloid, while also experimenting with a range of dyes, stencils, felt-tip pens, stamps, combs and surgical instruments.

M

WINSOR MCCAY (*c*. 1867–1934) was an American animator. Although his exact place and date of birth are uncertain, it is known that he attended Cleary's Business College in Ypsilanti, Michigan. In search of a reprieve from his studies, he began performing at a dime museum in Detroit, where he caught the attention of John Goodison, a professor at Michigan State Normal School and a master of perspective. Goodison gave McCay his only formal art training, which had an enduring influence on his subsequent comic strips (perspective played a prominent role in the aesthetics of *Dream of the Rarebit Fiend*; 1904–13). He moved to Chicago in 1889 and worked for the National Printing and Engraving Company. Later moving to Cincinnati, he worked at the Vine Street Dime Museum, where, from 1906, he presented his 'Seven Ages of Man' vaudeville 'chalk talk' act. His first cartoon strip, *Tales of the Jungle Imps by Felix Fiddle*, was published in the *Cincinnati Enquirer* from January to November 1903 in such instalments as 'How the Elephant Got His Trunk'. McCay also created animated short films from hand-drawn cartoons, including *Little Nemo Moving Comics* (1911) and *Gertie the Dinosaur* (1914), which he took on vaudeville tours.

NORMAN MCLAREN (1914–1987) was an acclaimed abstract film-maker born in Stirling, Scotland. In 1932 he enrolled at the Glasgow School of Fine Arts (intending to study set design), where he made his earliest extant film, *Seven Till Five* (1933), a record of 'a day in the life of an art school'. Influenced by the works of Sergei Eisenstein and Oskar Fischinger, he began to experiment with painting directly on to film stock. In 1934 he was awarded prizes at the Scottish Amateur Film Festival, prompting jury member John Grierson to offer him a job at the General Post Office Film Unit. McLaren worked as a cameraman during the Spanish Civil War, and in 1939 emigrated to North America, where he joined the National Film Board of Canada (NFB). In addition to making films for the war effort, such as *V for Victory* (1941) and *Dollar Dance* (1943), McClaren founded an animation department at the NFB. Over the course of his career he made fifty-nine films, including two 3D films in 1951 and various experiments with optical printing processes. His best-known work, *Neighbours* (1952), received an Academy Award, while *Blinkity Blank* (1955) was awarded the Short Film Palme d'Or at the Cannes Film Festival.

TOSHIO MAEDA (b. 1953) is a Japanese erotic-manga artist. He began his career at the age of sixteen, when he left his hometown of Osaka to work as an assistant to a professional cartoonist in Tokyo. Several of his works have been used as the basis for anime films, including *Urotsukidōji* (1986), *Adventure Kid* (1988) and *La Blue Girl* (1989). In 1989 the first of these was adapted into a series of anime films directed by Hideki Takayama. *Urotsukidōji* remains Maeda's most famous and controversial work, mixing extreme violence, fantasy and eroticism. It is considered a pioneering work in the *hentai*, or pornographic, manga and anime genre. In 2001 Maeda was a guest of honour and keynote speaker at the Big Apple Anime Fest (BAAF), where he was celebrated as 'the most influential erotic manga artist in Japan' ('BAAF: New Guests of Honour', animenewsnetwork.co.uk; accessed March 2011). A severe motorbike accident later that year left him with limited drawing abilities, but he continues to work with the aid of a computer, writing scripts and developing characters.

ÉTIENNE-JULES MAREY (1830–1904) was a French scientist and chronophotographer. Having studied medicine at the Faculty of Medicine in Paris, he established the first private laboratory for experimental physiology. Here, he developed several instruments for research, such as the sphygmograph for

measuring blood pressure. After 1868, when he was appointed as a professor at the Collège de France, Marey began to use the recently invented medium of film to study animal locomotion. In 1881 he attended a photographic demonstration by Eadweard Muybridge, and was prompted to dedicate himself to the mechanics of animal photography, using a single camera rather than many to produce a series of images in rapid succession. Using his 'photographic gun', Marey was able to take twelve pictures per second, which was still too few for the purposes of analysis. In 1885 George Eastman marketed a photographic film that used silver-bromide emulsion on a gelatin base. The increased exposure speed enabled Marey to create a *chambre chronophotographique*, in which a ribbon of film drawn behind a shutter could be exposed to sixty images per second. Marey used his new apparatus to film a variety of human and animal activity, publishing his observations in scientific journals.

BRUNO MARTELLI *see* IGLOO

KENZO MASAOKA (1898–1988) was an early creator of anime. Born in Osaka, Japan, he worked as an assistant director for Makino Shouzou (often described as 'the father of Japanese film'), and as a set-maker for the film *Nichirin* (1925), directed by Teinosuke Kinugasa. After taking on such jobs as independent director and cameraman, he completed and released the animated film *The Monkey Island* (1930). In 1933 he directed the first 'talkie' anime, *Within the World of Power and Women*, which was followed by a string of successful films. While working for the Shochiku film company, he directed one of his most famous works, *The Spider and the Tulip* (1943). In 1946, after the end of the war, Masaoka directed *Cherry Blossoms – Fantasy in Spring*, which the production

company, Toho, prevented from being screened on the basis that it was considered too artistic for a public audience. Masaoka then formed the Japanese Animation Company with Sanae (Zenjirou) Yamamoto, and made *The Abandoned Cat* (1947). He was forced to retire early in 1949 owing to failing eyesight, but recovered sufficiently to teach in later life.

GEORGES MÉLIÈS (1861–1938) was a French pioneer of early cinema. Born in Paris, he originally worked as a stage magician at the Théâtre Robert-Houdin. Inspired by a presentation of the Lumière brothers' camera in 1895, he began to explore the moving image, establishing a studio in Montreuil, Paris. At first screening other people's films designed for the kinetoscope, he soon moved to making his own one-reel, one-shot films, each lasting for about a minute. The 531 films that he went on to record on cellulose between 1896 and 1914 are mostly silent, plot-free experiments with special effects; in *L'Homme orchestre* (1900), for example, he plays seven characters simultaneously. These early works document his experimentation with such techniques as a split screen, double exposures and dissolves, while others, such as *Le Voyage à travers l'impossible* (1904), with its longer running time of twenty-four minutes, evidence the birth of narrative cinema. In 1913, unable to compete with the American studios, Méliès's company was forced into receivership, and was later bought by Pathé Frères. Much of Méliès's film stock was seized by the French Army during the First World War in order to be made into boot heels; as a consequence, little of his oeuvre survives today. Forced back to his pre-film career as a showman, Méliès descended into obscurity. In 1931, however, he was presented with the Croix de la Légion d'Honneur by Louis Lumière.

OTTO MESSMER (1892–1983) was an American animator. Born in New Jersey, he attended the Thomas School of Art, New York, before participating in a work-study programme at Acme Agency. Citing Winsor McCay as an early influence, Messmer began creating his own cartoon strips, which featured in such local newspapers as *New York World*. He made his first animated film, *Motor Mat*, in 1915, laboriously photographing it on hired equipment at Universal Studios in Los Angeles. Although never released, the film attracted the interest of such animators as Pat Sullivan and Henry 'Hy' Mayer. It was while working for the latter on *The Travels of Teddy*, a cartoon series based on Teddy Roosevelt, that Messmer began to learn production techniques. In 1919, after serving in the First World War, he returned to Sullivan's studio, where he began work on *Feline Follies*, which featured Master Tom, the prototype for Felix the Cat. Although Messmer went on to be the director of and lead animator for the Felix cartoons, Sullivan took the on-screen credit. Messmer dedicated the rest of his working life to Felix, in newsprint, in comic books produced for such companies as Dell Comics, and, from the 1960s, on television, by which point he was finally credited as creator.

HAYAO MIYAZAKI (b. 1941) is a prominent Japanese film director and the co-founder, with Isao Takahata, of Studio Ghibli. He was inspired to venture into animation as an adolescent after watching *Hakujaden* (The Tale of the White Serpent; 1958), considered to be the first colour Japanese animated feature film. In 1963 he was hired by Toei Animation, where he gained attention for his work on *Gulliver's Space Travels* (1965). He later worked as chief animator on the landmark film *Hols: Prince of the Sun* (1968), directed by Takahata, with whom he would continue to collaborate. In 1979 Miyazaki directed his

first animated feature film, *The Castle of Cagliostro*. This was followed by the better-known adventure film *Nausicaä of the Valley of the Wind* (1984), based on his manga series of the same title. After this success Miyazaki was able to co-found Studio Ghibli, which has produced all his subsequent works, including *My Neighbour Totoro* (1988) and *Kiki's Delivery Service* (1989). *Princess Mononoke* (1997) was a huge box-office success, winning Picture of the Year at the Japanese Academy Awards. Miyazaki has continued to direct critically acclaimed films, such as *Spirited Away* (2001), *Howl's Moving Castle* (2004) and *Ponyo on the Cliff by the Sea* (2008). In 2005 he was awarded the Golden Lion for Lifetime Achievement at the Venice International Film Festival.

CAROLINE MOURIS *see* FRANK MOURIS

FRANK MOURIS (b. 1944) is an American animator. Born in Florida, he showed an early interest in architecture before studying graphic design at graduate school. An interest in photography prompted him to experiment with film. He is best known for his Academy Award-winning stop-motion animation *Frank Film* (1973), created with his wife, Caroline Mouris. Released to immediate critical acclaim, the film features 11,592 fragmented images sequenced into a kaleidoscopic visual biography of the film-maker's life, accompanied by a soundtrack created by Tony Schwartz. In 1996 the film was chosen for preservation by the US National Film Preservation Board. Mouris has described the work as 'that one personal film that you do to get the artistic inclinations out of your system before going commercial'. In collaboration with his wife, Mouris has continued to make independent shorts – including *Franky Caroline* (1999), which

features the couple's unique collage aesthetic – as well as commercial work for such companies as Levi's and Nickelodeon Toys.

EADWEARD MUYBRIDGE (1830–1904) was a photographer known for his investigations into animal locomotion. Born in Kingston-upon-Thames as Edward James Muggeridge, he emigrated to the United States in 1852, where he worked first in New York and then in San Francisco. He learned the wet collodion photographic process while convalescing in England after suffering head injuries in a stagecoach accident, and developed a successful career in photography on his return to San Francisco in 1866. His reputation was based on landscape shots of the Yosemite Valley and the San Francisco Bay Area, although he also offered his services for portraiture. Today, he is renowned for having resolved the long-running debate over whether all four of a horse's hooves leave the ground while it is galloping. Hired by Leland Stanford, a former governor of California, Muybridge used a battery of cameras and a special shutter with a speed of 2/1000 of a second to capture Stanford's racehorse Occident airborne mid-gallop. His findings were widely published, and Muybridge gave lectures throughout the United States and Europe answering the questions of disbelievers. In 1882 he returned to England to lecture at the Royal Institution in London, where he described the motion picture using his zoopraxiscope. Muybridge made his most important studies under the auspices of the University of Pennsylvania, producing a total of 100,000 images between 1883 and 1886, which were published as 781 plates in the portfolio *Animal Locomotion: An Electro-Photographic Investigation of Consecutive Phases of Animal Movements*.

N

YURI NORSTEIN (b. 1941) is a Russian animator known for such acclaimed films as *Hedgehog in the Fog* (1975) and *Tale of Tales* (1979). Raised in Moscow, he was hired by Soyuzmultfilm in 1961, where he met his future wife and sometime collaborator, Francesca Yarbusova. After working as an animator on more than fifty films, including *Who Said 'Meow'?* (1962), he made his directorial debut in 1968 with *25th October, the First Day*. His animation techniques became increasingly sophisticated over the course of the following decades, incorporating a series of moveable glass planes that allowed for a three-dimensional look. In 1985, after being fired from Soyuzmultfilm, Norstein joined forces with three other leading animators – Fyodor Khitruk, Andrey Khrzhanovsky and Edward Nazarov – to found the Animation School and Studio. He has been working on a feature-length adaptation of Nikolai Gogol's *The Overcoat* for more than twenty years, clips of which have been released to the public in low-resolution formats. In 2005 he published *Snow on the Grass, Fragments of a Book: Lectures About the Art of Animation*, which has since been released in an extended edition featuring 1700 colour illustrations.

O

WILLIS O'BRIEN (1886–1962) was an American special-effects artist. Having worked as a cartoonist for the *San Francisco Daily News*, he was hired by the Edison Manufacturing Company, the first commercial film studio in the United States. He produced a series of short stop-motion films based on prehistoric themes, including *The Ghost of Slumber Mountain* (1918), for which he modelled figurines out of clay. He worked

on his first Hollywood feature in 1925, *The Lost World*, which led to his most famous creations, the giant apes in *King Kong* (1933) and its sequel, *The Son of Kong* (1933). In 1949 O'Brien worked with his protégé, Ray Harryhausen, on *Mighty Joe Young*, which won an Academy Award for Best Visual Effects. Later films included *The Animal World* (1956), *The Black Scorpion* (1957) and *Behemoth, the Sea Monster* (1959). A pioneer of stop-motion techniques, O'Brien laboured largely in obscurity. Recognition came posthumously, however, when he was given the Winsor McCay Award in honour of his lifetime contributions to the art of animation.

JULIAN OPIE (b. 1958) is a British contemporary sculptor, printmaker and installation artist. In 1979 he enrolled at Goldsmiths in London, where he studied under conceptual artist Michael Craig-Martin. His first solo show came in 1983, at London's Lisson Gallery. Opie was originally celebrated as the youngest of the 'New British Sculptors'; however, towards the end of the 1980s he began to move away from creating painted metal sculptures, working increasingly in other media. *Imagine You Are Walking* (1998), for example, consists of eighteen painted images of the interior of a computer-generated maze. He has also used computers to generate portraits, such as those on the cover of the album *Blur: The Best Of* (2000). Such portraits are characterized by black outlines filled with bright block colours, with detail reduced to a minimum. A former trustee of the Tate, Opie has exhibited widely in Europe, Japan and the United States.

MAMORU OSHII (b. 1951) is a Japanese director and writer. After graduating from Tokyo Gakugei University in 1976, he found employment with Tatsunoko Productions,

working on the television series *Time Bokan* (1975–76). In 1980 he moved to Studio Pierrot, where his work as director on the animated television series *Urusei Yatsura* (1981–86) met with success. This was followed by the films *Urusei Yatsura: Only You* (1983) and *Urusei Yatsura 2: Beautiful Dreamer* (1984). Having moved to Studio Deen, he wrote and directed *Angel's Egg* (1985) – a surreal film rich with biblical symbolism, and featuring character designs by Yoshitaka Amano – which is often described as his masterpiece. In the late 1980s he directed the television series and film versions of *Patlabor*, a sophisticated 'mecha' drama set in the near future. The year 1995 saw the release of *Ghost in the Shell*, his landmark cyberpunk thriller about a female cyborg trying to find meaning in her existence. In 2008 he directed *Sky Crawlers*, a film based on a series of novels by Hiroshi Mori.

KATSUHIRO OTOMO (b. 1954) is a Japanese manga artist, film director and screenwriter. His first work, *A Gun Report* (1973), was a manga adaptation of Prosper Mérimée's short story *Mateo Falcone* (1829). He later became known as the creator of *Akira*, a manga set in post-apocalyptic Neo-Tokyo. The series ran from 20 December 1982 until 25 June 1990, and totalled more than 2000 pages. His anime film version, released in 1988, has achieved cult status, and is widely considered a landmark in Japanese anime. Otomo is also the writer behind the manga series *Domu: A Child's Dream* (1980) and *The Legend of Mother Sarah* (1990), while his other directing credits include the anime *Steamboy* (2004) and the live-action film *Mushishi* (2006).

NICK PARK (b. 1958) is a British animator and film-maker, best known as the creator of Wallace and Gromit. He studied communication arts at Sheffield Polytechnic (now Sheffield Hallam University) before going on to the National Film and Television School in Beaconsfield, Buckinghamshire, where he began work on *A Grand Day Out*, the first Wallace and Gromit film. He was hired by Aardman Animations in 1985, initially working on such commercial projects as advertisements and music videos. In 1989, while completing post-production work on *A Grand Day Out*, he made *Creature Comforts* for Channel 4's *Lip Synch* series. Both films were nominated for a host of awards, with the former taking a BAFTA, and the latter winning an Academy Award. Two further Wallace and Gromit shorts followed – *The Wrong Trousers* (1993) and *A Close Shave* (1995) – before Park embarked on his first feature-length film, *Chicken Run* (2000), co-directed by Aardman co-founder Peter Lord. The first feature-length Wallace and Gromit film, *The Curse of the Were-Rabbit* (2005), won the Academy Award for Best Animated Feature Film in 2006.

TREY PARKER (b. 1969) **AND MATT STONE** (b. 1971) are creative partners, best known for their award-winning television series, *South Park*. Parker met Stone at the University of Colorado film school, where they studied under Stan Brakhage and Jerry Aronson. While there, they collaborated on *The Spirit of Christmas* (1992 and 1995), two short films animated using construction paper, glue and an old 8mm camera. The films featured four children called Stan, Kyle, Kenny and Eric – clear precursors to the South Park boys. They also worked on *Cannibal! The Musical* (1993), a black comedy based on the apocryphal tales of Alferd Packer, which caught the attention of Fox executive

Brian Graden. *South Park* debuted in August 1997 on Comedy Central, and is the network's highest-rated and longest-running programme to date. Originally made using cut-out animation, the series is now entirely computer-generated, although Parker and Stone continue to write, direct and provide voices for most episodes. In 1999 Parker directed the satirical film *South Park: Bigger, Longer & Uncut*, which parodies the controversy stirred by their work, and in 2004 they released *Team America: World Police*. The pair hit the headlines again in April 2010 when they depicted the Prophet Muhammad in a bear costume.

PIXAR ANIMATION STUDIOS is an American computer-animation studio best known for its groundbreaking CGI feature films. The company was formed in 1986 when Apple co-founder Steve Jobs purchased the computer-graphics division of Lucasfilm, naming it 'Pixar'. Initially a computer-hardware company, Pixar began making computer-animated commercials for such companies as Listerine and Tropicana in a bid to drive sales of its Pixar Image Computer. In 1991 a deal worth $26 million was brokered with Walt Disney Feature Animation to produce three computer-animated feature films. The first of these, *Toy Story*, directed and co-written by John Lasseter, premiered on 19 November 1995, and has since taken more than $350 million at the international box office. Following the production of *Toy Story 2* (1999), disagreements with Disney began to grow, particularly between Steve Jobs and Disney's chairman, Michael Eisner. Negotiations over a new deal resumed after Eisner resigned his position, and in 2006 Disney bought Pixar for $7.4 billion. The year 2011 marks the studio's twenty-fifth anniversary, having produced eleven films

to date, including *A Bug's Life* (1998), *Monsters, Inc.* (2001), *Finding Nemo* (2003), *The Incredibles* (2004) and *Ratatouille* (2007).

Q

THE BROTHERS QUAY (Stephen and Timothy; b. 1947) are influential director-animators. Identical twins from Pennsylvania, they studied illustration and graphics in Philadelphia before relocating to London in 1969 to attend the Royal College of Art. In 1979 they began collaborating with British producer Keith Griffiths at Koninck Studios, which has since produced all their films. Masters of the miniaturized world, they often base their work around repressed childhood dreamscapes, using puppets assembled from doll parts. Their stop-motion animation *Street of Crocodiles* (1986), based on the novella by Bruno Schulz, was named as one of the ten best films of all time in the *Sight and Sound* critics' poll of 2002. Influenced by the tradition of Eastern European animation, their practice also incorporates commercials and set designs for opera, theatre and ballet; in 1998, their design for the Broadway play *The Chairs* won the Drama Desk Award for Outstanding Set Design. In 2002 they contributed an animated sequence to Julie Taymor's film *Frida*, and in 2003 they collaborated with composer Steve Martland to produce four short films as part of a live event at Tate Modern in London.

R

LOTTE REINIGER (1899–1981) was a German pioneer of silhouette animation, adapting the ancient art of shadow theatre to cinematic ends. Born in Berlin, she trained as an actress with Max Reinhardt before her work caught the attention of noted film

director Paul Wegener, who invited her to make silhouettes for the intertitles on *Rübezahls Hochzeit* (1916) and *Rattenfänger von Hameln* (1918). She made her first film, *Das Ornament des verliebten Herzens* (The Ornament of a Loving Heart), in 1919 for the experimental animation studio the Berliner Institut für Kulturforschung. In 1921 she married the film historian Carl Koch, who worked for her animation studio as producer and camera operator until his death in 1963. Her films, which drew on operatic themes, and often harked back to a more innocent age, were described by Jean Renoir as a 'visual expression of Mozart's music'. From 1923 to 1926 she worked on her most renowned work, *The Adventures of Prince Achmed*, sometimes credited as the first full-length animated film. For the rest of her career she focused on one- or two-reel shorts, often creating sequences to feature in others' films. After the Second World War she took British citizenship and settled in the Abbey Arts Centre in north London, setting up Primrose Productions with Louis Hagen Jr.

CHARLES-ÉMILE REYNAUD (1844–1918) was a French physicist and inventor who earned his place in cinematic history after inventing the praxinoscope (which translates from the Greek as 'action viewer'). Originally a teacher, he unveiled his optical device in Paris in 1877. Similar in appearance to William George Horner's zoetrope, Reynaud's instrument produced an illusion of movement that was viewed on mirrors in the centre of the drum rather than through slits on the outside. In 1888 he patented the Théâtre Optique, a device based on the praxinoscope that could project a continuous series of moving images on to a screen, enabling him to show hand-drawn cartoons to a larger audience. On 28 October 1892, at the Musée Grévin in Paris, he gave the first public performance of a moving-picture show.

Billed as *Pantomimes lumineuses*, the show featured three cartoons, including *Pauvre Pierrot*. However, interest in Reynaud waned after 1895 in the wake of the appearance of the Lumière brothers' more popular device for screening moving images, the cinematograph.

ZBIGNIEW RYBCZYŃSKI (b. 1949) is a Polish film-maker who lives and works in Los Angeles. Having studied cinematography at the Łódź Film School, he began making animated shorts, including *Kwadrat* and *Take Five* (both 1972), before becoming a member of the experimental film group Warsztat Formy Filmowej (The Workshop of Film Form). Between 1973 and 1980 he worked with the Polish animation studio Se-ma-for, where he directed such films as the Academy Award-winning *Tango* (1980). He established a visual-effects studio for Austrian national television in 1977, and in 1985 he founded his own research and visual-arts production company, Zbig Vision. He emigrated to the United States in 1983, where his Manhattan and Hoboken studios pioneered the use of high-definition technology. Throughout the 1980s he also directed music videos for such artists as John Lennon and Mick Jagger. Between 1994 and 2001 he lived in Germany, first in Berlin, working at CBF Studios, and later in Cologne, where he was a professor of experimental film at the Academy of Media Arts. Rybczyński is the recipient of numerous industry and film-festival awards.

S

BOB SABISTON (b. 1967) is an American film director and computer programmer. He began developing software while he was a graduate researcher at the MIT Media Lab, from 1986 to 1991. His early films included *Grinning Evil Death* (1990) and *God's Little*

Monkey (1994), which, in 1995, won the Prix Ars Electronica Golden Nica award in the computer-animation category. In 1997 Sabiston developed Rotoshop, the proprietary rotoscoping software for which his company, Flat Black Films, has become known. It was initially used to create a series of interstitial programmes for MTV, *Project Incognito*, and was later employed in the making of the feature film *Waking Life* (2001). In 2004 Sabiston was hired as Head of Animation for Richard Linklater's *A Scanner Darkly* (2006), for which he created an enhanced version of Rotoshop. He is also the creator of *Inchworm*, a paint/animation title for the Nintendo DSi.

MARJANE SATRAPI (b. 1969) is an Iranian novelist, illustrator and director of animated films who lives and works in Paris. She is the author of *Persepolis*, a graphic novel that traces her path to adulthood, from her early years in Tehran and the overthrow of the Shah to the terrorizing Khomeini rule, war with Iraq and her escape to Europe. Originally published in French between 2000 and 2003 in four parts, it was later translated into English and released in two parts, in 2003 and 2004. Satrapi adapted the novel into an animated film of the same title, which was co-directed by Vincent Paronnaud, and premiered at the Cannes Film Festival in 2007. As stark as the original drawings, the animated film employs an expressionist aesthetic reminiscent of the work of Fritz Lang. Her other novels include *Embroideries* (2005) and *Chicken with Plums* (2006), which is currently being adapted into a live-action film.

SEMICONDUCTOR, founded in 1997, comprises artists Ruth Jarman (b. 1973) and Joe Gerhardt (b. 1972), who live and work in Brighton, England. They started producing work as Semiconductor with their project *Retropolis* (1999). Their pieces – which use

computer animation, single- and multi-channel video, sound, documentary, and multi-media installations – are created as part of a practice that they describe as exploring 'science and the material nature of the world, questioning our place in the physical universe'. Their unique approach has earned them a place in several public collections. They have also exhibited globally, including at the Venice Biennale; the Royal Academy, London; the Hirshhorn Museum and Sculpture Garden, Washington, D.C.; the Institute of Contemporary Arts, London; and the Exploratorium, San Francisco. Their best-known work, *Magnetic Movie* (2007), was purchased by the Hirshhorn Museum for its permanent collection in 2008. Other notable short films include *Brilliant Noise* (2006), produced with the help of a NASA Space Sciences Fellowship; *Matter in Motion* (2008), commissioned by Careof Gallery, Milan; and *Indefatigable* (2010), made during a Gulbenkian Galapagos Artists' Residency.

HARRY SMITH (1923–1991) was an American artist, archivist, film-maker, record collector and ethnomusicologist. Raised in Portland, Oregon, by theosophist parents, he was exposed to a variety of pantheistic ideas, which led to a lifelong interest in the occult. He studied anthropology at the University of Washington from 1943 before dropping out to join the bohemian community of artists in San Francisco, where he established himself as an experimental film-maker. Developing his own blend of stop-motion collage and hand-painting directly on to film, he would spend years labouring over a single film. Drawing on such artistic influences as Wassily Kandinsky, Smith sought a filmic synaesthesia, and was described by Kenneth Anger as 'the greatest living magician'. A Solomon Guggenheim grant took him to New York, where, in 1952, Folkways Records issued his multi-volume

Anthology of American Folk Music, credited as prompting the genre's revival in the following decades.

PERCY SMITH (1880–1945) was an English film-maker. He began his career at the Board of Education before his close-up photograph of a bluebottle's tongue caught the attention of film entrepreneur Charles Urban, whom he joined in 1910 as a film-maker. Before the advent of the First World War, he made more than fifty nature films for the *Urban Sciences* series, including the acclaimed *The Birth of a Flower* (1910). In 1922 he created the *Secrets of Nature* series for British Instructional Films, which (under the new title of *Secrets of Life*) thrived until his death in 1945. He pioneered new methods of time-lapse and micro-cinematography, and was known to invent bizarre, home-made devices, such as alarms that woke him in the middle of the night so that he could change the film in a camera. A passionate enthusiast for the educational possibilities of film, he understood his task as feeding public audiences 'the powder of instruction in the jam of entertainment'. Towards the end of his career, Mary Field and H.R. Hewer took over the direction of his films, while he focused on the meticulous photography.

STEVEN SPIELBERG (b. 1946) is an American film director, screenwriter, producer and studio executive, widely regarded as one of the most influential film-makers in the history of cinema. He was just sixteen years old when he created his first feature-length film, *Firelight*. After being rejected from the University of Southern California film school, he became a student at California State University, Long Beach. He made his first short film, *Amblin* (1968), as an intern at Universal Studios, after which he began his professional directorial career on the television programme *Night Gallery*. He later signed a contract with Universal for four television films, beginning with *Duel* (1971), and made his theatrical feature-film debut with *The Sugarland Express* (1974). Spielberg went on to win the Academy Award for Best Director for *Schindler's List* (1993) and *Saving Private Ryan* (1998). Three of his films, *Jaws* (1975), *E.T.: The Extra-Terrestrial* (1982) and *Jurassic Park* (1993) – renowned for the way in which they combined live-action drama with animatronics and/or CGI – made box-office history, each smashing the previous record for the highest-grossing film of all time.

DAVID SPROXTON *see* AARDMAN ANIMATIONS

LADISLAS STAREWITCH (born Władysław Starewicz; 1882–1965) was a Polish-Lithuanian stop-motion animator. A graduate of the Russian Academy of Arts in St Petersburg, he began his career in about 1909 at the Kovno Ethnography Museum, Lithuania; there, he created documentaries for the museum, including *Lucanus Cervus* (1910), a short film about insect life featuring his first animated puppets. After moving to Moscow in 1912 to work for Aleksandr Khanzhonkov's film company, he created one of his best-known works, *The Cameraman's Revenge* (1912). Some of the films he made at this time combine live action with puppet animation, including, from 1913, *The Night Before Christmas* and *Terrible Vengeance*, which won him the Gold Medal at an international festival in Milan in 1914. After the First World War (and under a new name) he moved to Fontenay-sous-Bois in France; from that time onward, his daughter Irène became instrumental in the making of his films. Between 1929 and 1930 production took place for another of his well-known works, *The Tale of the Fox*, released in Berlin in 1937.

MATT STONE *see* TREY PARKER AND MATT STONE

STUDIO GHIBLI is a Japanese animated-film studio. It was founded in 1985 by film-makers Isao Takahata and Hayao Miyazaki following the success of *Nausicaä of the Valley of the Wind* (1984), which was written and directed by Miyazaki and produced by Takahata. Successful collaborations have since been struck with such directors as Yoshifumi Kondo, Goro Miyazaki and Hiromasa Yonebayashi. To date, Studio Ghibli has made seventeen feature-length films, several of which – including *Laputa: Castle in the Sky* (1986) and *Kiki's Delivery Service* (1989) – have won the Animage Anime Grand Prix. In 2002 *Spirited Away* (2001) was awarded the Golden Bear for best feature film at the Berlin International Film Festival; the following year, it won the Oscar for Best Animated Feature Film, making it the first Japanese animation to win an Academy Award. In 2004 *Howl's Moving Castle* received the Osella Award for outstanding technical achievement at the Venice International Film Festival, in recognition of the high quality of the work and the continuing achievements of Hayao Miyazaki and Studio Ghibli.

PAT SULLIVAN *see* OTTO MESSMER

JAN ŠVANKMAJER (b. 1934) is a Czech film-maker. Raised and educated in Prague, where he continues to live and work, he studied first at the Institute of Applied Arts (1950–54), and then in the Department of Puppetry at the Academy of Performing Arts. He first encountered film at the Laterna Magika theatre, the performances at which are often a combination of moving images, mime and dance. In 1970 he joined the Czech surrealist movement, where he met

two of the group's key protagonists: the theorist Vratislav Effenberger, and the painter Eva Švankmajerová, who later became his wife. He made his first film in 1964, and has since become one of the world's most renowned animators, with key works including the clay-animation film *Dimensions of Dialogue* (1983) and his first feature film, *Alice* (1987), a dark and uncanny rendering of Lewis Carroll's classic story.

T

HIDEKI TAKAYAMA *see* TOSHIO MAEDA

PAUL TERRY (1887–1971) was an American cartoonist and producer. As a newspaper photographer working in New York, Terry attended an early screening of Winsor McCay's *Gertie the Dinosaur* (1914). McCay's film inspired Terry to create his own short animated film, *Little Hermann*, which he sold to the Thanhouser film company in 1915. The following year he began working for John R. Bray, creating the character of Farmer Al Falfa, who remained popular for many decades. An early advocate of cel animation, Terry opened his own studio, Paul Terry Productions, in 1917, where he produced nine animated films. In 1920 Terry formed a short-lived partnership with Amedee J. Van Beuren, opening Fables Studios, which, in *Dinner Time* (1928), experimented with sound processes two months before Disney released *Steamboat Willie* (1928). Terry later carried much of his staff over into Terrytoons, the animation studio that operated between 1929 and 1968, producing such popular characters as Mighty Mouse, Gandy Goose, Sourpuss and Deputy Dawg. Ever keen to keep costs down, Terry did not aspire to the same technical finesse as the Disney or Fleischer studios, although his

prolific output was hard to match. He retired in 1955, having sold Terrytoons to the television network CBS.

OSAMU TEZUKA (1928–1989) was a Japanese manga artist, animator and producer, sometimes dubbed 'the father of manga'. He began drawing cartoons as a child, creating his first works, *Diary of Ma-chan* and *Shin Takarajima*, in the wake of the Second World War. Despite graduating from Osaka University in medicine, he remained committed to a career in manga, writing and illustrating such popular titles as *Astro Boy*, *Black Jack*, *Princess Knight*, *Kimba the White Lion* and *Buddha*. He was extraordinarily prolific, with the Japanese anthology of his work (which is not even comprehensive) consisting of 400 volumes and 80,000 pages. Tezuka founded the animation studio Mushi Production, which pioneered television animation in Japan. He stepped down as director in 1970 to form a new studio, Tezuka Productions, which was responsible for such series as *Marvelous Melmo* and *Unico*. The Osamu Tezuka Manga Museum was inaugurated in April 1994.

STEFAN AND FRANCISZKA THEMERSON were avant-garde Polish film-makers. Franciszka (née Weinles; 1907–1988) was born in Warsaw, and trained as a painter at the city's Academy of Fine Arts; Stefan (1910–1988) was born in Płock, and studied physics and then architecture while pursuing his real interests in photography and film-making. They met in 1930, married the following year, and became lifelong artistic collaborators. In Warsaw, where they made five short films together, they became key figures in the film-makers' co-operative SAF (founded in 1935); they also created its journal, *f.a.*, in which Stefan published 'The Urge to Create Visions', his seminal article on film-making. Their

improvised practice made use of photograms, with *Pharmacy* (1930) setting them 'in motion', and *Europa* (1931–32) – an adaptation of Anatol Stern's Futurist poem – collaging them against fragments of real-time action. The couple moved to Paris in 1938; a few years later, however, the events of the Second World War forced them to move to London, where they worked for the film unit of the Polish Ministry of Information and Documentation. In 1948 they founded the Gaberbocchus Press, which they ran until 1979.

TOEI ANIMATION was founded in 1948 as Japan Animated Films. Six years later it was bought by Toei, which renamed it Toei Doga. The company's current title was settled on in 1998. Toei Animation completed its first animated short, *Little Kitty's Graffiti*, in 1957, while its debut feature-length film, *The White Snake*, followed in 1958; *Ken the Wild Boy* (1963) was the first of Toei's animated television series. Several of Japan's acclaimed film-makers gained experience at the studio, including Hayao Miyazaki, who worked as an 'in-betweener' on the film *Gulliver's Space Travels* (1965). Other names in Toei Animation's history include Isao Takahata (a co-founder of Studio Ghibli) and Leiji Matsumoto and Yoichi Kotabe (respectively, a designer and an illustrator at Nintendo). Both Miyazaki and Kotabe worked on Takahata's *Hols: Prince of the Sun*, released by Toei in 1968. The studio's most famous television series, *Dragon Ball*, was first broadcast in Japan in February 1986, becoming a worldwide hit following a Hollywood adaptation (*Dragon Ball Evolution*; 2009). Other successes include the film *Galaxy Express 999* (1978) and the television series *Saint Seiya* (1986–89) and *Sailor Moon* (1992–97). In April 1995 the Toei Animation Institute was opened in Tokyo to enable

students to study animation at a professional level, and to fast-track artists into anime production.

JIM TRAINOR (b. 1961) is an American film-maker and animator. He lives and works in Chicago, where he has been a professor of animation at the School of the Art Institute of Chicago since 2000. Raised in Washington, D.C., he made his first film at the age of thirteen, and continues to work in his preferred medium of black marker on white typing paper, sketching shaky line-drawn characters that are both playful and prurient. Trainor spent eleven years working on his filmic portrait of a serial killer, *The Fetishist* (1997), before starting on a series of films – *The Bats* (1998), *The Moschops* (2000), *The Magic Kingdom* (2002) and *Harmony* (2004) – known collectively as *The Animals and Their Limitations* (in 2004, *The Magic Kingdom* was featured in the Whitney Biennial in New York). Recent work includes *The Presentation Theme* (2008), based on the rituals of an ancient Peruvian culture; *The Little Garden of Herbert S. Zim* (forthcoming), in which the science section of a school library is brought unnervingly to life; and *The Pink Egg* (also forthcoming), a live-action 'documentary horror movie' about parasitic wasps.

RYAN TRECARTIN (b. 1981) is an American film-maker and artist. He gained his BFA from the Rhode Island School of Design in 2004, and has since exhibited internationally, with his work held in several major collections. Trecartin's practice exists at the intersection between film, sculpture and installation, typically featuring a cast of family and friends in fantastical narratives rendered through manipulated live-action footage interspersed with animation and material found on the Internet. With stylized sets and feverish performances, his videos read like surreal dreamscapes. As artist Kevin McGarry has observed, 'The combination of assaultive, nearly impenetrable avant-garde logics and equally outlandish virtuoso uses of color, form, drama, and montage produces a sublime, stream-of-consciousness effect that feels bewilderingly true to life' ('Ryan Trecartin', eai.org; accessed March 2011). In 2009 Trecartin won the inaugural Jack Wolgin Fine Arts Prize, and was the recipient of the Calvin Klein Collection New Artist of the Year award at the first Art Awards at the Solomon R. Guggenheim Museum, New York. The same year, he also received a Pew Fellowship in the Arts.

JIŘÍ TRNKA (1912–1969) was a Czech painter, illustrator, puppeteer and film-maker. From 1928 he attended the Prague School of Arts and Crafts, where he studied under the renowned Czech puppeteer Josef Skupa. In 1936 he founded his own puppet theatre, the Dřevěné Divadlo. After the theatre disbanded at the end of its first season, Trnka turned to illustrating children's books. Between 1941 and 1944 he set up the animation unit Studio Bratři v Triku at the Prague Film Studio, specializing in puppet animation. Over the next two decades he made more than forty animated films, ranging from short and feature-length puppet films to cut-out and drawn animations. While his early works – many of which were based on Bohemian folklore – were subsidized by the Czech communist government, his later, award-winning film *The Hand* (1965) was banned by the authorities for its veiled critique of totalitarianism.

V

AMEDEE J. VAN BEUREN *see* PAUL TERRY

STAN VANDERBEEK (1927–1984) was an American film-maker and pioneer of live-action animation. After studying at Cooper Union in New York, he continued his education at Black Mountain College in North Carolina. He was a frequent collaborator with such avant-garde artists as Claes Oldenburg, Allan Kaprow, Merce Cunningham and Yvonne Rainer, and his activities contributed to what theorist Gene Youngblood has termed 'expanded cinema'. Following the completion of his first film in 1955, his experimental practice was increasingly driven by a radical political agenda, aimed at a utopian fusion of art and technology. In his manifesto of 1966, he wrote that 'It is imperative that we (the world's artists) invent a new world language.' Throughout this decade he produced theatrical, multimedia pieces and computer animation, often working with Bell Telephone Laboratories. Vanderbeek also experimented with viewing spaces, creating the Movie-Drome in Stony Brook, New York, a dome-shaped theatre featuring multiple projectors for the screening of such events as 'Vortex-Concerts', which consisted of sequences of random images. His work has since been the subject of retrospectives at the Museum of Modern Art and the Whitney Museum of American Art, both in New York.

W

KARA WALKER (b. 1969) is an American artist based in New York, where she is a professor of visual arts on the MFA programme at Columbia University. She is best known for examining the underbelly of America's racial tensions through large-scale tableaux of cut-paper silhouettes. Born in California, she moved to the South as an adolescent after her father accepted a post at Georgia State University. She specialized in printmaking at the Atlanta College of Art in

1991 before going on to gain an MFA at the Rhode Island School of Design. In 1997 she featured in the Whitney Biennial in New York, and, at the age of twenty-eight, became the youngest artist to receive the John D. and Catherine T. MacArthur Foundation's 'Genius Award'. Although her sexualized plantation scenes caused controversy in the late 1990s, they also attracted many admirers. In the wake of Hurricane Katrina, Walker produced a new body of work titled *After the Deluge*, which, in the artist's own words, looked to the 're-inscription of all the stereotypes about the black body'. In 2007 the Walker Art Center in Minneapolis organized the first full-scale museum survey of her work, *Kara Walker: My Complement, My Enemy, My Oppressor, My Love*.

THE WALT DISNEY COMPANY is

the largest media and entertainment conglomerate in the world, named after the American producer, director and cartoonist who co-founded the Disney Brothers Cartoon Studio in 1923 with his brother Roy O. Disney. In 1919 Walter Elias Disney (1901–1966) started work at the Pesmen-Rubin Commercial Art Studio, later moving to the Kansas City Film Ad Company, for which he made cut-out animations with cartoonist Ub Iwerks. After reading Edwin G. Lutz's book *Animated Cartoons: How They Are Made, Their Origin and Development* (1920), Disney was inspired to experiment with cel animation, producing a series of films titled *Laugh-O-Grams*, which he screened in a local theatre. Having pooled resources to establish their own cartoon studio in Hollywood, Disney and Roy, together with Iwerks, developed the character of Mickey Mouse, whose voice was provided by Disney himself until 1947. Mickey made his screen debut in *Steamboat Willie* (1928), the first fully synchronized sound cartoon. During the production of an early *Silly Symphonies* cartoon, the world of animation witnessed

the introduction of Technicolor. Disney's first experiment with it (at the behest of Herbert Kalmus, co-founder of the Technicolor Corporation), *Flowers and Trees* (1932), won him the inaugural Academy Award for Best Animated Short Film, his first personal Oscar. Mickey's success meant that, by 1938, the characters of Donald Duck, Goofy and Pluto had been given their own spin-off series, while the studio had also released America's first full-length animated musical feature, *Snow White and the Seven Dwarfs* (1937). A special Academy Award followed (in the shape of one full-sized Oscar and seven miniature versions), ushering in a period dubbed 'the golden age of Disney animation', which produced such films as *Pinocchio* (1940), *Fantasia* (1940) and *Bambi* (1942). During the Second World War the studio was contracted to produce instructional films for the military, as well as such morale-boosting films as *Victory Through Air Power* (1943). In the aftermath of the war it diversified into other media, from its first fully live-action feature, *Treasure Island* (1950), to the opening of Disneyland, California, in 1955 and, in the same year, the debut of its first daily television show, *The Mickey Mouse Club*. After Disney's death in 1966, Roy delayed his planned retirement to head what was by now an empire of family entertainment, and to realize his brother's dream of developing what is today known as Walt Disney World, Florida. Taking its current name in 1986, the Walt Disney Company now consists of a large number of subsidiaries and affiliates, including the Walt Disney Motion Pictures Group, the ABC television network, the Disney Channel, ESPN and Marvel Entertainment. The poor box-office reception of traditionally animated features at the turn of the millennium led to the closure of the company's animation studios in Orlando and Paris, while its animation facilities in Burbank, California, began to focus on computer animation. However, a watershed followed in

2006 after the acquisition of Pixar, with Disney returning to traditional hand-drawn animation for *The Princess and the Frog* (2009).

THE WAN BROTHERS (Wan Lai Ming,

Wan Gu Chan, Wan Chao Chen and Wan Di Huan), born in Nanjing in the early years of the twentieth century, were pioneers of the Chinese animation industry. As children, using cut-paper silhouettes, they created puppet shows inspired by the sixteenth-century Chinese epic *Journey to the West*. In 1916 the family relocated to Shanghai, where, from 1919, Wan Lai-Ming worked for the Department of Activities' film service. His brothers joined him at the Shanghai Commercial Press after graduating from art school, and together they collaborated on the advertising short *Shuzhendong Chinese Typewriter* (1922). They went on to make *Uproar in the Studio* (1926), their first silent cartoon, before producing *The Camel's Dance* (1935), their first cartoon with sound. In 1941, during the Japanese occupation of Shanghai, the brothers released *Princess Iron Fan*, China's first full-length animated film. Aesthetically closer to the Fleischer Studios than to Disney, it made extensive use of rotoscoping. In 1961 the brothers released the first part of *Havoc in Heaven*, with the second instalment following in 1964. The film met with both domestic and international acclaim, going on to win the prize for best film at the London International Film Festival in 1978.

TIM WEBB (b. 1960) is an English film-maker

and Senior Tutor in Animation at the Royal College of Art, London. After graduating in 1986 from West Surrey College of Art and Design with a BA in animation, he was commissioned by Channel 4 to create *A is for Autism* (1992), an award-winning film that brought him considerable critical acclaim. Accompanied by assembled voiceovers, this

'animated documentary' combines live-action sequences with drawings in order to offer a poignant glimpse into the condition of autism. Webb later directed the Channel 4/Arts Council England 'animate!' film *15th February*, winner of the ICA Dick Award in 1995 as 'the most provocative, innovative and subversive short film of the year'. In 2000 he wrote, directed and animated the BAFTA-nominated *Six of One* for Channel 4, while his first foray into digital film, *Mr Price* (2004), was another 'animate!' project.

WETA DIGITAL is a visual-effects company based in Wellington, New Zealand. Founded in 1993 by a group of New Zealand film-makers, including Peter Jackson, Richard Taylor and Jamie Selkirk, it forms part of a network of special-effects and film-production companies located in the Wellington suburb of Miramar. One of its first commissions was to provide visual effects for Peter Jackson's *Heavenly Creatures* (1994); since then, the company has won awards for its work on two of Jackson's other projects, *The Lord of the Rings* trilogy (2001–03) and *King Kong* (2005). It has also collaborated with a host of other Hollywood directors, providing digital effects for such box-office hits as *X-Men: The Last Stand* (2006). Weta Digital recently worked on James Cameron's *Avatar* (2009), using a new camera system, shooting on a virtual stage, and developing new technologies for groundbreaking visual effects. The film received the Academy Award for Best Visual Effects in 2009, thanks in part to the work of the company's director, the acclaimed visual-effects artist Joe Letteri.

RICHARD WILLIAMS (b. 1933) is a Canadian animator, best known for his work on *Who Framed Roger Rabbit* (1988). He made his first film, *The Little Island*, in 1958, and its success enabled him to establish his own studio. Throughout the 1960s he balanced his commercial work, which included a series of advertisements for Truman Bitter, with such personal films as *A Lecture on Man* (1962). In 1968 he produced an animated sequence based on the graphic style of *Punch* magazine for Tony Richardson's *The Charge of the Light Brigade*. He also designed title sequences for *Casino Royale* (1967) and *The Return of the Pink Panther* (1974). Williams won an Academy Award for his direction of *A Christmas Carol* (1971), and an Emmy for Outstanding Animated Program for *Ziggy's Gift* (1982). Released in the United States, these acclaimed made-for-television productions attracted the attention of Steven Spielberg and Robert Zemeckis, who commissioned Williams to work on their adaptation of Gary K. Wolf's mystery novel *Who Censored Roger Rabbit?* (1981). Williams's intended masterpiece, *The Thief and the Cobbler*, suffered a series of false starts and was never released, although it has exerted untold influence through the generation of animators who worked on it.

RUN WRAKE (b. 1963) is a London-based animator. After studying graphic design at Chelsea College of Art and Design, he embarked on a Master's in animation at the Royal College of Art, graduating in 1990. Since then his work has encompassed visuals for U2 concerts, music videos for Howie B, commercials for Coca-Cola and NatWest, and illustrations for *NME* magazine. Following the success of his first Channel 4/Arts Council England 'animate!' commission, *Jukebox* (1994), he gained widespread attention for *Rabbit*, his BAFTA-nominated short film of 2005. Based on a collection of vintage educational illustrations by Enid Blyton-illustrator Geoffrey Higham, the film tells a dark, dream-like story of false innocence, invoking images from a lost collective childhood. For his early work, Wrake used traditional animation techniques, drawing, painting and assembling images on punched acetate; since 1998, however, he has worked primarily in Photoshop, animating in After Effects. His more recent work includes *The Control Master* (2007).

Z

ZHOU XIAOHU (b. 1960) is a Chinese artist who works in performance, photography, installation, sculpture, video and animation. He studied sculpture for three years at the Suzhou Art Institute before graduating in 1989 from Sichuan Academy of Fine Arts with a degree in oil painting. In 1997 he began to experiment with analogue technology, embedding it in sculptural installations. His practice today uses digital technologies to maximize the possibilities of stop-motion techniques, with miniature clay and porcelain sculptures being transformed into satirical animations. Questioning the role of the media in a digital age, Zhou's complex processes relate to the fabrication of history. As he explains, 'art can never be made by machine alone'. In 2002 he was invited to participate in the Long March Project, a contemporary-art initiative based in Beijing, and he has since exhibited the works produced for the project at home and abroad. He continues to live and work in Changzhou, China.

The biographies were compiled by Sunny Cheung, Juliette Desorgues, Eleanor Nairne and Zofia Trafas, with the exception of the entry on Oskar Fischinger, which was written by William Moritz.

FURTHER READING

Animated Painting, exhib. cat. by Betti-Sue Hertz *et al.*, San Diego, Tijuana and Grinnell, Ia., 2007–09

Michael Barrier, *Hollywood Cartoons: American Animation in Its Golden Age*, New York and Oxford (Oxford University Press) 1999

Howard Beckerman, *Animation: The Whole Story*, New York (Allworth) 2003

Giannalberto Bendazzi, *Cartoons: One Hundred Years of Cinema Animation*, tr. Anna Taraboletti-Segre, London (John Libbey) 1994

Suzanne Buchan, ed., *Animated 'Worlds'*, Eastleigh (John Libbey) 2006

Jonathan Clements and Helen McCarthy, *The Anime Encyclopedia: A Guide to Japanese Animation Since 1917*, Berkeley, Calif. (Stone Bridge Press) 2001

Benjamin Cook and Gary Thomas, *The Animate! Book: Rethinking Animation*, London (LUX) 2006 (includes DVD)

Donald Crafton, *Before Mickey: The Animated Film, 1898–1928*, Cambridge, Mass., and London (MIT Press) 1984

Jonathan Crary, *Techniques of the Observer: On Vision and Modernity in the Nineteenth Century*, Cambridge, Mass. (MIT Press) 1990

Sean Cubitt, *Digital Aesthetics*, London (Sage) 1998

Liz Faber and Helen Walters, *Animation Unlimited: Innovative Short Films Since 1940*, London (Laurence King) 2004 (includes DVD)

Maureen Furniss, *Art in Motion: Animation Aesthetics*, London (John Libbey) 1998

———, *The Animation Bible: A Guide to Everything – From Flipbooks to Flash*, London (Laurence King) 2008

Chris Gehman and Steve Reinke, *The Sharpest Point: Animation at the End of Cinema*, Toronto (YYZ Books) 2005

Vivien Halas and Paul Wells, *Halas & Batchelor Cartoons: An Animated History*, London (Southbank Publishing) 2006 (includes DVD)

Kaboom!: Explosive Animation from America and Japan, exhib. cat., ed. Philip Brophy, Sydney, Museum of Contemporary Art, 1994

Stefan Kanfer, *Serious Business: The Art and Commerce of Animation in America from Betty Boop to Toy Story*, New York (Scribner) 1997

Isaac V. Kerlow, *The Art of 3D Computer Animation and Effects*, Hoboken, NJ (John Wiley) 2004

Clare Kitson, *Yuri Norstein and Tale of Tales: An Animator's Journey*, Eastleigh (John Libbey) 2005

———, *British Animation: The Channel 4 Factor*, London (Parliament Hill Publishing) 2008

Norman M. Klein, *Seven Minutes: The Life and Death of the American Animated Cartoon*, New York (Verso) 1993

Esther Leslie, *Hollywood Flatlands: Animation, Critical Theory and the Avant-Garde*, London and New York (Verso) 2002

Peter Lord and Brian Sibley, *Cracking Animation: The Aardman Book of 3-D Animation*, London (Thames & Hudson) 1998

Shilo T. McClean, *Digital Storytelling: The Narrative Power of Visual Effects in Film*, Cambridge, Mass., and London (MIT Press) 2007

Lev Manovich, *The Language of New Media*, Cambridge, Mass., and London (MIT Press) 2001

William Moritz, *Optical Poetry: The Life and Work of Oskar Fischinger*, Eastleigh (John Libbey) 2004

Dan North, *Performing Illusions: Cinema, Special Effects and the Virtual Actor*, London and New York (Wallflower Press) 2008

Once Upon a Time Walt Disney: The Sources of Inspiration for the Disney Studios, exhib. cat., ed. Bruno Girveau, Paris, Galeries Nationales du Grand Palais, September 2006 – January 2007; Montreal Museum of Fine Arts, March–June 2007

Andrew Osmond, *100 Animated Feature Films*, London (BFI) 2010

Fred Patten, *Watching Anime, Reading Manga: 25 Years of Essays and Reviews*, Berkeley, Calif. (Stone Bridge Press) 2004

Ülo Pikkov, *Animasophy: Theoretical Writings on the Animated Film*, Talinn (Estonian Academy of Arts) 2010

Jayne Pilling, *Animation: 2D and Beyond*, Crans-Près-Céligny and Hove (RotoVision) 2001

———, ed., *A Reader in Animation Studies*, London (John Libbey) 1997

Chris Robinson, *Unsung Heroes of Animation*, Eastleigh (John Libbey) 2005

Robert Russett and Cecile Starr, *Experimental Animation: An Illustrated Anthology*, New York and London (Van Nostrand Reinhold) 1976

———, *Experimental Animation: Origins of a New Art*, New York (Da Capo) 1988

Andrew Selby, *Animation in Process*, London (Laurence King) 2009

Vivian Sobchack, ed., *Meta-morphing: Visual Transformation and the Culture of Quick-Change*, Minneapolis (University of Minnesota Press) 2000

Richard Taylor, *The Encyclopedia of Animation Techniques*, Oxford (Focal) 1996

J.P. Telotte, *Animating Space: From Mickey to WALL-E*, Lexington, Ky. (The University Press of Kentucky) 2010

Frank Thomas and Ollie Johnston, *Disney Animation: The Illusion of Life*, New York (Abbeville Press) 1981

Paul Wells, *Understanding Animation*, London and New York (Routledge) 1998

———, *Animation: Genre and Authorship*, London (Wallflower) 2002

———, *Animation and America*, New Brunswick, NJ (Rutgers University Press) 2002

———, *The Animated Bestiary: Animals, Cartoons, and Culture*, New Brunswick, NJ (Rutgers University Press) 2009

——— and Johnny Hardstaff, *Re-imagining Animation: The Changing Face of the Moving Image*, Lausanne (AVA Academia) 2008

——— *et al.*, *Drawing for Animation*, Lausanne (AVA Academia) 2008

Julius Wiedemann, ed., *Animation Now!*, London (Taschen) 2004

ADVISERS

Suzanne Buchan, David Curtis, Gareth Evans,
Clare Kitson, Adam Pugh, Paul Wells

PICTURE CREDITS

Page 20: Succession of Julien Pappé/Magic Films; julienpappe.free.fr
Page 24: © The Halas & Batchelor Collection
Page 25: fotopedrazzini.ch
Page 47: Étienne-Jules Marey's chronophotographic films have
been restored digitally and transferred on to 35mm film by the
Cinémathèque Française, Paris, which owns and holds these scores
Pages 54, 55: emilereynaud.fr, cnc-aff.fr
Pages 81, 85: Ronald Grant Archive
Pages 102, 103, 104: fotopedrazzini.ch
Page 105: Foto Roberto Goffi
Page 132: © Ladislas and Irène Starewitch
Pages 134, 135: © Nathalie Djurberg
Page 143: © The Halas & Batchelor Collection
Page 153: Jaromír Kallista and Jan Švankmajer; athanor.cz
Page 171: This version of *Symphonie Diagonale* was restored by
Gösta Werner in 1994, in collaboration with and support from the
Swedish Film Institute
Pages 185, 192, 193: Ronald Grant Archive

The publishers have made every effort to trace and contact the
copyright holders for the material reproduced in this book. They will
be happy to correct in subsequent editions any errors or omissions
that are brought to their attention.

ACKNOWLEDGEMENTS

We should like to extend our special thanks to the following individuals
and institutions for their invaluable support and guidance with the
exhibition research, development and realization:

Catherine Alestchenkoff, Grimaldi Forum Monaco
Karen Alexander
Steve Alpert, Studio Ghibli
Martin Arnold
Matthieu Baillard, Toei Animation
Andy Bandit, Fox
Roderick Barton, Julian Opie Studio
Sean Bean, Paramount Pictures/Paramount Digital Entertainment
Hans Berg
Agnès Bertola, Gaumont Pathé Archives
Daniel Bird
Toni Booth, National Media Museum, Bradford
Ligia Borowczyk
Marilyn Brakhage
Derek Brey
David Bullock
Fox Carney, Animation Research Library
Francesca Cattoi, Fondazione Prada
Emilie Cauquy, Cinémathèque Française
Zuzana Ceplová
Maria Chiba, Lobster Films
Ian Christie
Renata Clark, Czech Centre London
Stuart Comer, Tate
Peta Cook, Kingston Museum and Heritage Service
Mark Cousins
Tony Dalton, The Ray & Diana Harryhausen Collection
Helena Damętka, Filmoteka Narodowa Poland
Kim Donovan, Pixar

Dominique Duvergé-Ségrétin

Harun Farocki

Monique Faulhaber, Cinémathèque Française

Isabelle Favre, Toei Animation

Mark Fleischer

Jean-Baptiste Garnero, CNC – Archives Françaises du Film

Ruth Geddie

Aaron Gerow, Associate Professor, Film Studies, Yale University

Paul Gravett

Anna Gruszka, Polish Cultural Institute London

Hans Hagemeister

Michael Harvey, National Media Museum, Bradford

Derek Haugen, The iotaCenter

Julie Heath, Warner Bros. Entertainment

Stefan Hurtig

Michael Jenkins, Sikkema Jenkins & Co.

Pavla Kallistova, Athanor

Cindy Keefer, Center for Visual Music

Clare Kitson

Elyse Klaidman, Pixar

Elisabeth Konrath

David Kosse, Universal Pictures

Irene Kotlarz

Eva Lahnsteiner

Serge Lalou, Les Films d'Ici

Emmanuel Lefrant, Light Cone

Gil Leung, LUX

Jen Lewandowski, Julian Opie Studio

Sally Lewis, Aardman

Theresa Liang, Long March Space

Nicholas Logsdail, Lisson Gallery

Lu Jie, Long March Space

Roni Lubliner, NBC Universal

Larry McCallister, Paramount Pictures/Paramount Digital Entertainment

Helen McCarthy

Kristen McCormick, Disney Animation Research Library

Anne McIlleron

Bertrand Mandico

Gió Marconi

L.B. Martin-Starewitch

Jerome Mazandarani, Manga Entertainment

Nina Miall, Haunch of Venison

Nathalie Morena, Association Frères Lumière

Christelle Odoux

Seiko Ono, Planet Films

Sylvie Oudart-Saerens

Tamara Pappé, Magic Films

Danny Perkins, Optimum Releasing

Ray Pointer, Inkwell Images

Daniel Poole

Matthias Rajmann

James Rice

Mattias Ripa

Gabrielle Ruffle, Aardman Animation

Hubert Saerens

Screen Actors Guild, California

Paul Shepherd, The iotaCenter

Paul Shoefield

Rani Singh, Harry Smith Archives

Lella Smith, Disney Animation Research Library

Mike Sperlinger, LUX

Mikiko Takeda, Studio Ghibli

Atsuko Takenaka, Toei Animation

Helen Thornton

Maggie Todd

Jan Trnka

Helena Trnková

Klára Trnková

Helena Trösterová

Pascal Vimenet

Candy Vincent-Smith, Optimum Releasing

Mary Walsh, Disney Animation Research Library

Marina Warner

Dagmar Motycka Weston

Sarah Wilde, BFI

Constance de Williencourt, Cinédoc

Asuka Yamazaki, Mushi Production

Yasui Yoshio

Andrew Youdell, British Film Institute

Michaela Zöschg, Galerie Martin Janda

INDEX

First published 2011 by Merrell Publishers Limited in association
with Barbican Art Gallery on the occasion of the exhibition
Watch Me Move: The Animation Show, curated by Greg Hilty,
15 June – 11 September 2011

Barbican Art Gallery
Barbican Centre
Silk Street
London EC2Y 8DS

barbican.org.uk

Exhibition:
Greg Hilty, Curator
Alona Pardo, Barbican Art Gallery, Curator
Adam Pugh, Research Curator
Juliette Desorgues, Exhibition Assistant
Zofia Trafas, Curatorial Assistant
Sunny Cheung, Inspire Fellow
Interns: Alicja Grabarczyk, Marina La Verghetta and Annabel Potter

Exhibition design and graphic design: Chezweitz & Roseapple, Berlin

Merrell Publishers Limited
81 Southwark Street
London SE1 0HX

merrellpublishers.com

British Library Cataloguing-in-Publication Data:
Watch me move : the animation show.
1. Animated films – History and criticism.
I. Hilty, Greg. II. Barbican Art Gallery.
741.5'8'09-dc22

ISBN 978-1-8589-4558-3

Produced by Merrell Publishers Limited
Designed by Alexandre Coco
Project-managed by Mark Ralph
Indexed by Vicki Robinson

Printed and bound in Slovenia

Page 2
Winsor McCay, *Little Nemo Moving Comics*, 1911 (see page 52)

Pages 8–9
Winsor McCay, *The Sinking of the Lusitania*, 1916 (see page 142)

Page 40
Max Fleischer, *Out of the Inkwell: The Tantalizing Fly*, 1919
(see page 53)

Pages 72–73
Bob Pauley
Drawing for Buzz Lightyear from *Toy Story*, 1995
Pencil
© Disney/Pixar

Pages 96–97
Toshio Maeda
Original artwork for the manga series *Urotsukidōji*, 1986
Courtesy of the artist

Pages 120–21
Lotte Reiniger, *The Adventures of Prince Achmed*, 1926
(see pages 122–23)

Page 150
Marjane Satrapi, *Persepolis I*, 2000 (see pages 160–61)

Page 168
Harry Smith, *Early Abstractions 1–5, 7 and 10*, 1941–57 (see page 174)

Pages 186–87
igloo, *SwanQuake: House*, 2007 (see page 188)